The Painted Witch

The Painted Witch

HOW WESTERN ARTISTS HAVE VIEWED
THE SEXUALITY OF WOMEN

Edwin Mullins

CARROLL & GRAF PUBLISHERS, INC.
NEW YORK

First Carroll & Graf edition 1985

Carroll & Graf Publishers, Inc.
260 Fifth Avenue
New York, NY 10001

Library of Congress in Publication Data

Mullins, Edwin B.
 The painted witch.

 Includes index.
 1. Women in art. 2. Erotic art. 3. Painting.
European. I. Title.
ND1460.W65M84 1985 757′.4′094 85-5774
ISBN 0-88184-200-1

Manufactured in the United Kingdom.

Contents

*For beloved Anne who gave this book
life by being in mine.*

List of Illustrations

Colour Plates

1 *Faces in a Mirror*

Paintings are among the loveliest creations of mankind, and it is generally agreed that looking at them is extremely good for us. A recent pocket guide to the art galleries of the world lists 276 museums in Europe and America as possessing 'important' collections of paintings 'not to be missed'. When you consider that roughly half these galleries receive over one million visitors each year, and a few of them more than five millions, this is an enormous number of people to whom art is supposed to be doing good.

Take this line of approach a step further. Most of the pictures hanging in public art galleries have been painted by men, for men, a high proportion of them about women. This being so, these hundreds of thousands of paintings 'not to be missed' must hold up a mirror to the responses men have had to women over a period of a great many centuries. They must reflect the kind of feelings men have experienced in their company, how men have chosen to see them, what men have expected them to be, and what transformations women have undergone in men's eyes during the passage from life to art – in short, paintings represent an appreciation of one half of the human race by the other half.

More than this, we have good reason to believe that such an appreciation of women is complex and profound. Thanks to Sigmund Freud we no longer have any excuse for clinging to the simplistic view prevailing less than a hundred years ago that when an artist paints women he is offering an adoring tribute to the female sex. He is doing much more than this. Freud's perception, expressed as early as 1916, was that the artist creates out of his life of fantasy a kind of reality which others – who do not possess his gifts – are able to share and so find relief from their own repressions: hence the gratitude and admiration we feel for him, and hence – presumably – those hundreds of museums we have filled with valuable paintings, and the multi-millions of visitors they attract.

Art, then, offers a formidable body of evidence of what men have really felt about women. So far so good. But now contribute a quite different thought to the argument. Germaine Greer, in the spring-tide of the feminist movement, wrote that 'Women have very little idea of how much men hate them'. When I first read this remark in *The Female Eunuch* it stung and shocked me: it still does, as it must any man who has troubled

1

himself to read the book, or is not so complacent as to dismiss it out of hand.

The effect of dropping Germaine Greer's observation among the others is even more shocking: it is rather like a gas main exploding under a sleeping town. We, the art-lovers, are the sleepers, with our somnolent faith that art does us good simply because it is art. By what right do we assume this? Instead of beneficial, supposing art is sometimes incriminating, even dangerous. For, if men do hate women, then this hatred must be reflected in paintings.

It is the avenue suddenly opening up as a result of this conjunction of thoughts that has led me to write this book. It is an avenue that I have never walked before, yet it is lined with images I have known for much of my life, and which I must now look at with fresh eyes. How will they fare? And how will I?

To begin with, I am not so foolhardy as to make a journey without maps. I shall limit my territory to regions where I have travelled, and of which I feel in my bones that I have some understanding – Europe and North America. I am a westerner. Chinese art, Japanese art, Indian, African, Persian – my responses to these and other areas have often been richly enthusiastic but, as I suspect, also richly naive. They are not my culture and I cannot honestly say I understand the minds that have produced them. So I shall leave them out, as I shall also leave out the bark paintings of the Australian aborigines, the sand paintings of the Navahos and the cave art of the Drakensburg Mountains. The decorative and applied arts, too, I shall embrace only when these seem to have an important bearing on painting. More unreasonably, as it may seem, I shall not include sculpture either: here is a subject so vast, and in obvious and less obvious ways so different from painting, that I fear I might never reach the end of my journey. Perhaps another time. Meanwhile, my territory is western painting.

So . . . what are the questions to be asked first?

The concept of art as a provider of some kind of unspecific public good is a recent one. Public art galleries are nearly all of them phenomena of the last hundred and fifty years or so. The majority of their contents were painted originally for private enjoyment or for specific religious cults and practices. What, then, can be the nature of this new 'good' which paintings are supposed to do to us, the public, if it is true that they demonstrate a hatred of women? Does it mean that men hate women even more than formerly, since misogyny is now publicly enshrined instead of being kept private?

If this is the case, should we not stop traipsing around the world admiring and being spiritually affected by supposed masterpieces, and instead set about closing museums down since they are evidently a reflection of our worst selves, or at least stripping their walls of all pictures that glorify

2

attitudes to women which conflict with our better selves? The *Virgin of the Rocks* would have to go – along with all Virgins – as an insult to woman's natural sexuality. Rubens' colossal series on the life of Marie de' Medici: remove that as a naked insult to regality (alternatively produce a king who was painted with his penis showing). *The Naked Maja* – that has to be dismissed for exploitation (the *Clothed* and *Naked* versions of the picture are no different, after all, from those postcards you see dangling in Spanish taxicabs of ladies who dress and undress according to how the cards tilt). Poussin's *Rape of the Sabine Women* – out! Out, indeed, all rapes, abductions, martyrdoms, tortures. Most of Delacroix and Tiepolo as well: almost all Boucher and Renoir. Museum walls would finally be more naked than the pictures removed, and our improved souls would wander between well-spaced sunsets and scenes of cows grazing (though unmilked, milkmaids being a degraded class).

All but the most hard-boiled feminist would find this an absurd proposition. Even if Germaine Greer is right, and men do hate women very much, it does not follow that works of art which represent hatred are themselves necessarily hateful. The chemistry of art can and does transform the unacceptable into images of delight – sometimes. Great art is a moral force, or can be. We may read Othello and wince at the sentiments and attitudes directed towards Desdemona, but still be moved to empathy by the pain he feels: 'She's gone, I am abus'd, and my relief / Must be to loathe her. O curse of marriage, / That we can call these delicate creatures ours, / And not their appetites.'

Well, then, if Shakespeare's language can lead us to be moved to pity Othello, who murdered his wife, can the colour and draughtsmanship of Poussin or Rubens perform a similar service for the rapists of the Sabine Women, whom they painted with such relish? Can we be comforted by the assurance that to admire a rape does not necessarily make us potential rapists? If so, it is easy to suggest that this is the end of the matter and we can go on admiring seductions and martyrdoms with a clear conscience.

On the other hand, the fact that the genius of a painter may lift a work of art above hatred cannot obscure the nature of the theme he chose – or, more likely, was given to paint by his patron. It is not the quality of art as a piece of imaginative expression that is in question, but the motives for a predominance of subjects which show women in a degraded light. What conclusions can we draw about traditional male attitudes to women from the taste of art patrons and the kinds of painting they have wanted to put on their walls?

Furthermore, what do men feel – what do I feel? – confronted by such loathing for a sex which in life we may profess to love? Can it be that men admire art at least partly because it reinforces passions we do not dare acknowledge in life? And do women admire it because women collude with men in this no less than in other conspiracies for their enslavement?

3

But does art really reflect an underlying hatred of women any more than it reflects other powerful emotions that attend human relationships and human dreams? If hate is only one of these emotions, no more prominent in paintings than affection, or grief, or jealousy, or worship, or lust, then the evidence of art must weigh heavily against the testimony of Germaine Greer, suggesting that she has singled out one passion among many for largely polemical reasons?

On the other hand, if hate does predominate, are we not all in deep trouble, all the multi-millions of us joyfully improving ourselves on summer pilgrimages to artistic meccas guided by the Light of faith and the Word of the Lord Clark – if the sacrament we sip is poisoned?

I could feel no nip of poison in the air around the National Gallery – if I discounted the lead poison circulating freely about Nelson's Column and the lions in Trafalgar Square.

It was a late-December morning during that protracted slumber which settles over London between Christmas and New Year. The few people walking in the streets looked as though they wondered why they were awake, and would have preferred not to be.

'Women have very little idea of how much men hate them': the phrase was still in my head. It was arousing some uncomfortable questioning of values long unquestioned. The National Gallery is a collection I know well, and love well. It is my 'local'. I use it often for refreshment. It is also free – in spite of the efforts of the last Conservative government but one.

Today I felt different about it. I had come deliberately to test afresh my reactions to England's premier art gallery. Perhaps I had always been wrong. It had never occurred to me before that I might have passed a great deal of my life as the unknowing victim of male cultural hypnosis; conditioned, programmed to admire works of art which endorsed views quite unacceptable in life, and if not unacceptable then maybe they ought to be and indeed might be were paintings not here to endorse them. But perhaps I was wrong.

It was a disturbing thought. I would have preferred not to have it. Already I was noticing things I had not bothered to think about before. The Gallery's classical portico and Byzantine dome: two images of the Eastern Mediterranean – from Ancient Greece and the Early Church. Why? London felt extremely far from either. It is invariably the countries furthest from a classical tradition which have favoured the Greek temple as their ideal for a museum. A Museion – a Temple to the Muses of Mount Parnassus. Nine of them: all women! Was this why the architect felt he had to add a church dome – to let God in too? A male God, on top! the entrance to the National Gallery is set deliberately high: you mount towards it as to a High Altar. Turn round and you survey the congregation feeding the pigeons below. Suffer little children to come unto me.

4

I had brought a guide-book with me. It displayed a beautiful woman with bare breasts on the cover. A Tiepolo. One of my favourite pictures in the gallery. Now I winced a little at the pleasure she gave me. Exploitation? The Preface to the guide-book was by the Gallery's Director, Sir Michael Levey, a man I know and respect. Few people have written as illuminatingly about pictures as he has. 'No eye will ever exhaust the enjoyment these pictures provide,' he had written here, 'and a life-time spent gazing at them is wisely spent.'

It occurred to me that had I spent a life-time here I should, of course, know nothing whatever about life; should never have met anyone except those who work and walk among paintings; should never have known any woman at all; and this would have offered me a narrow view of the value of the pictures I was gazing at. Suppose I were to turn Sir Michael's advice on its head, and imagine I had passed my life until this moment outside the National Gallery – outside all 'Museions' – and was now entering such a place for the very first time with no preconceptions of what art was. If in life I was conditioned by a protracted form of cultural hypnosis, then I should shake myself awake and try to see what lay within these classical portals for the first time. I know nothing: then let me see.

What was it Freud wrote in that famous passage I had committed to memory? '. . . there is a path that leads back from fantasy to reality – the path, that is, of Art . . .'

But where was Art? At first there did not appear to be any. A flight of stairs, between pillars marbled like a Rorschach Test, led directly to a shop. 'Special Christmas Offer'. Slides. Framed reproductions. Postcards. Books. Then blank corridors leading left and right, signed to the Toilets. Was this the ultimate museum?: a grand entrance, picture postcards, the loo, and out.

The earliest picture in the gallery is Italian, by Margarito of Arezzo around 1262: *The Virgin and Child enthroned, with scenes of the Nativity and the Lives of the Saints.* Considering that the greatest cathedrals of Europe were already built by this time, this looked a fumbling effort. Evidently painting was slow to get off the ground. Not slow, none the less, to strike some trenchant attitudes about women and about sex. In the centre a sour-faced matron grasps her simpleton of a son. To the left, St Catherine of Alexandria is beheaded for refusing to make a Roman emperor a present of her virginity. To the right, St Margaret of Antioch survives being tortured and then swallowed by Satan for a similar slur on male prerogative. Also on the right, St Benedict, a male saint this time, punishes his own lust by rolling on brambles.

Not a very promising start.

'. . . An artist is in rudiments an introvert not far removed from neurosis . . .'

The Italian School unfolds down the western side of the gallery. Crivelli:

The Immaculate Conception; *The Virgin and Child Enthroned*. Matteo di Giovanni: *The Assumption of the Virgin*. Signorelli: *Virgin and Child with Saints*. Masaccio: *Virgin and Child*. Verrocchio: *Virgin and Child*. Lippi: *Virgin and Child*. Raphael: *Madonna and Child*; *Madonna and Child*; *Madonna and Child*; *St Catherine of Alexandria* (again). Leonardo da Vinci: *Virgin and Child with St Anne*. Etcetera. Etcetera.

So far there were several straightforward messages. Sexual desire is an affliction, but one that only men catch. In a perfect world a woman possesses no such desires: what she does possess is her virginity. Man wants this more than anything, and he expects her to sacrifice it to him on demand. But he also expects her to keep it; and in order to gain his respect she must be prepared to suffer and if necessary to die in her attempt to do so – the exception being the mother of Our Lord who is permitted to keep hers even in the most unlikely possible circumstance, pregnancy. An absurdly convoluted morality letting men off every possible hook while impaling women on all of them. If not a direct expression of hatred, here was a strong male penchant for meting out punishment irrationally.

'. . . He is oppressed by excessively powerful instinctual needs . . .'

The incense of female sanctity wafts into other rooms too. Spain, for instance – especially the paintings of Murillo and his followers: *The Birth of the Virgin*, *The Adoration of the Shepherds*, *The Immaculate Conception of the Virgin*. The sentiments are more saccharine now, but otherwise identical. It was some surprise to come across an acknowledgment of woman's sexual existence in Velasquez' *Rokeby Venus*, though we are informed that this was a unique departure for the artist, and a correction of this *bétise* did seem to be implied in the uncomfortable gaze close by of King Philip IV of Spain. Besides, she turns her back on us.

The theme of sexual unawareness on the part of women persists in the room given over to French seventeenth-century paintings. Le Nain's *Adoration of the Shepherds* offers new complications of design and technique but no fresh insights into the role and nature of women. Genuflection and downcast eyes, as before. Mignard's portrait of a marquise, and two of her children got up as Achilles and Cupid, is so ludicrous as to cast no light upon anything unless it might be the great silliness of women seen through the eyes of male painters of fashion.

'. . . He desires to win honour, power, wealth, fame and the love of women: but he lacks the means for achieving these satisfactions . . .'

I began to feel Germaine Greer was winning hands down.

Then, with Poussin, a fresh note. Suddenly an abundance of flesh. *A Bacchanalian Revel*; *The Triumph of Pan*; *The Adoration of the Golden Calf*. The ladies are inclined to simper and to gesticulate as if obeying stage directions; none the less, a male eye has identified creatures of flesh and blood who at last are not entirely numbed within a role of tearful purity. There is even the suggestion – by the regularity with which garments ruffle aside

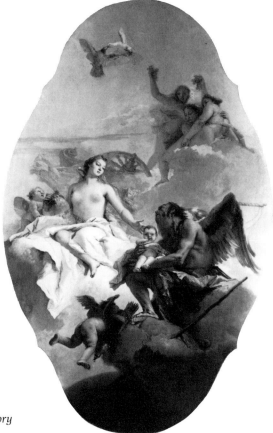

1 G. B. Tiepolo, *An Allegory with Venus and Time*

to exhibit a breast – that the ladies themselves possess a motor-power that might almost be termed sensual. All of it tightly orchestrated, admittedly, and distanced by the conventions of classical myth. Quite unreal therefore. All the same, a hint, a suggestion, that something stirs within the sub-species Woman.

The real acknowledgement here is of the propriety of male lust. No longer is this a ferment of dark and delicious guilts to be doused by rolling on brambles, but a cause for celebration – at a distance.

'. . . he makes it possible for other people once more to derive consolation and alleviation from their own sources of pleasure in their unconscious which have become inaccessible to them . . .'

The master of this distant celebration of lust is G. B. Tiepolo in the Venetian eighteenth-century room (Ill. 1). Here is the pin-up on the guide-book – her breasts bared, positively flaunted, a leg crooked naked against pink and white silks, a pearl necklace in the shadows of her neck. She is Venus, Goddess of Love, but the love she advertises is inaccessible: she is seated on the clouds: the painting was intended for a ceiling in Venice.

7

The British in the eighteenth century, Gainsborough in particular, seemed to allow their women closer than the Italians, and in general to be less fearful of them; but then, being portrait painters, they were concerned with women safely contained within a social fabric instead of free to roam and taunt men's erotic fantasies. The British were not into letting their women become marauders.

The French were more bold, but at the same time more frivolous. Women were not to be taken all that seriously: they were objects of play, either dolled up by Lancret to chatter in gardens, or undressed by Boucher and Fragonard to show off their pink bottoms and their lemon-sorbet breasts surmounted with *glacé* cherries. Precursors, all of them, of Renoir's sweetie-pies looking pretty in boats: women as the adornments of a man's world, offering him ease, delight, confirmation of his maleness, and a little sauce.

'. . . he earns their gratitude and admiration, and he has thus achieved through his fantasy what originally he had achieved only in his fantasy – honour, power and the love of women . . .'

The largest room in the National Gallery is given over to Venetian pictures from the great century of Venice, which is 1500 to 1600; the era of Titian, of Veronese, and of Tintoretto. All three of them adored painting women. And such women! Flesh falls from the skies; it invites from silken couches; it romps in green meadows; it embraces, it caresses, it needs, wants – you. Man. It is no accident that Venetian art is *the* art to which artists have turned for their ideal of what art should be, and which collectors have sought above all others. It is art at the furthest possible point from the ideal of the sanitised Madonna and the saint exorcising his lust upon brambles. It is a banquet of male lust.

I have often wondered what it must feel like to be a woman in a gallery of Venetian art. Anointed by sunlight, swooped upon by aerobatic gods, jostled by angels and fanned by peacocks, the woman in the Venetian male dream has one role, which is to be the vortex of man's sexual cravings. She is an exotic butterfly netted in the jungles of the male libido and pinned forever by his admiration. She is a collector's item; and if this is what women in their hearts may long to be, then she is in paradise and will never fall from grace. She may on the other hand seem to be no more than fine flesh in the window of a butcher's shop: prize meat to be consumed at the feast of the male gods.

In the colder climate of Flanders, Rubens' women have put on more flesh. Rubens exceeds even the Venetians in displays of nakedness: why is it, then, that feminist hackles rise less at the sight of such volumes of mammalia? Rubens ought to be the most monstrous exploiter of them all: *The Rape of the Sabine Women* (Ill. 2) is the most bestially insensitive picture in the National Gallery. Everywhere you look women are being torn from their lovers, or from their mothers. Hard Roman faces, smirking beneath military helmets, pluck them like chickens under the odious gaze of King

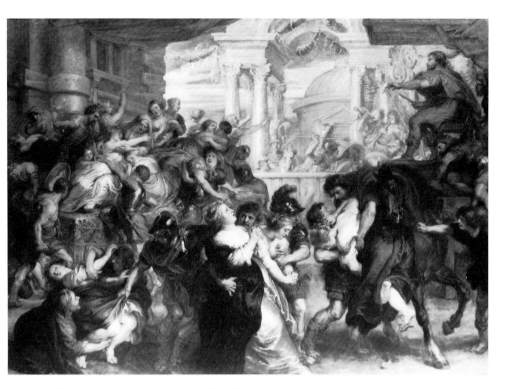

2 PETER PAUL RUBENS, *The Rape of the Sabine Women*

Romulus who has tricked them into being there. No subject could be a more loathsome testimony to male dominion over women. 'Women have very little idea of how much men hate them'. Then they have not been to the National Gallery.

And yet, the message is not a particularly brutal one after all, though the reason is not to Rubens' credit. The artist has so obviously not thought about it in brutal terms. It is even questionable whether he has thought about it at all. It is a picture about bodies. They might just as well be romping in the hay. The agonised faces are masks. All these announced passions are imposed, like studio laughter. Indeed, a few knobs turned in the painter's control room, a few flicks of the brush, and all these women could be guffawing like mad and the picture would scarcely have changed. Rubens seems to have got away with it because he does not care, and nor ultimately do we. Art has become a game in which women are the pieces, and men the players – which, you may say, has once again allowed men to have it both ways.

Lingering in front of Rubens' apparently harmless romp, a number of further questions began to turn in my brain. Rubens has taken a playfully

amoral view of what is nothing less than a 'gang bang' imposed by brute male force and sanctioned by supreme male authority: but is a playfully amoral view of such a revolting event acceptable under any circumstances, unrelieved as it is by any context of pathos or human understanding such as the most brutal plays by Shakespeare provide? Should such paintings, then, endorsing the idea of rape as fun, really be inviting our admiration in the nation's premier art gallery or in any other gallery, whoever they are by and however finely painted they may be? Assuming the attendance of the National Gallery to be divided more or less equally between men and women, did the $1\frac{1}{4}$ million men who visited the gallery last year feel that Rubens' *Rape* had done them good? And how did $1\frac{1}{4}$ million women feel about observing a 'gang bang' of their own sex treated as a wholesome painterly exercise?

There are several ways artists have depicted violent and sadistic acts. There is horrified realism, which was Goya's way in *The Shootings of the 3rd May*, in the Prado, Madrid. There is dramatic fascination – for the act itself and for its effect on the protagonists – which is how Caravaggio (himself a murderer) treated *The Beheading of St John the Baptist*, in Valletta Cathedral, Malta. And there is Rubens' nothing-to-do-with-me approach which, of the three, strikes me as the only one that is truly unpleasant because it is a moral cop-out. Rubens pleases where he has no right to please, and enjoys what only an unfeeling man could allow himself to enjoy; and in doing so he gives 'high art' a bad name. It comes as no surprise to recall that Rubens, besides being the most sought-after painter in Europe, was also a highly esteemed diplomat.

Turning from the painting, I immediately felt my knowledge and experience of Rubens in general clamouring against such an irate condemnation, and scores of his other paintings flashed into my memory which under no circumstances could I feel able to condemn in this fashion. I felt bruised and divided in a way I could not remember ever feeling before about the work of any artist. It was an uncomfortable sensation, trying to see pictures with a view untinted by cultural conditioning.

I took my troubled self for a look at some of my particular favourites in the gallery, more than a little fearful lest they too might turn sour on me, and I should be condemned hereafter to admire only a few impeccable Dutch studies of fruit and cheese.

But the effect of my feminist purge was the reverse. I have never admired Hogarth in his pawky moral vein, but his portraits are the product of a sharp and affectionate eye; and now the cockney *Shrimp Girl* (Ill. 3) seemed to be grinning even more than usual, as if delighted to find an artist prepared to look at her and paint her, high flush, bobble nose and all. It was a relief to be regarding a woman who was not one of the customary stereotypes; who was not a pained martyr or a tight-lipped virgin, a mindless doll or an airborne goddess, a target of libidinous adulation or of callous

10

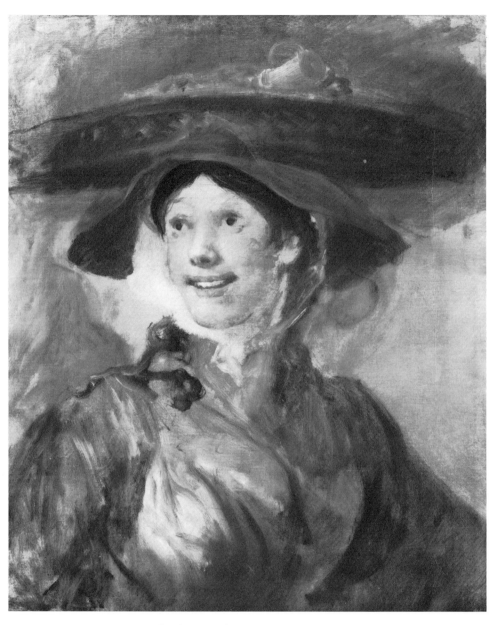

3 WILLIAM HOGARTH, *The Shrimp Girl*

seduction. The Shrimp Girl is a woman encountered: Hogarth's painting captures the surprise and delight at that encounter. She is desirable and desired without being sneakily coveted. She is not about to be raped, even in the mind. She is not the artist's property or the artist's fantasy. She is

an ordinary working girl. Hogarth has painted her as his human equal. She just *is*, in her own right.

I walked back into the room of French eighteenth-century paintings and there amidst the garden-party chatter was Watteau's *La Gamme d'Amour – The Gamut of Love* (Ill. 4). The English poet Alexander Pope was writing *The Rape of the Lock* at virtually the same time as Watteau was painting this picture, and the poem invariably comes into my head whenever I look at it: 'Oh! If to dance all night, and dress all day, / Charm'd the small-pox, or chas'd old-age away; / Who would not scorn what housewife's cares produce, / Or who would learn one earthly thing of use?' Like Pope, Watteau sees the culture of manners as a game in which people get trapped. His men are part-clown, part-Romeo; his women part-doll, part-Juliet. Here are a young man and a young woman both dressed for pretty social games. They appear to have been playing their roles to perfection: he is seated

4 Jean-Antoine Watteau, *La Gamme d'Amour*

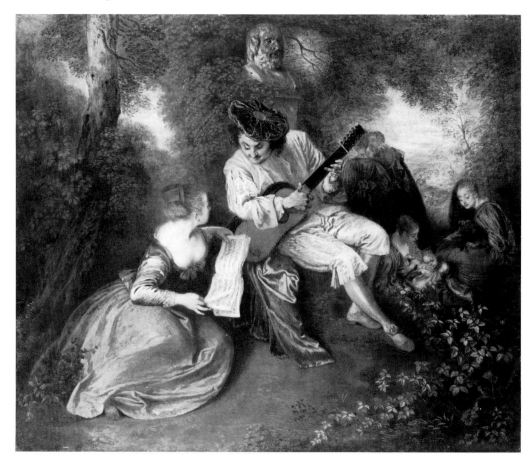

above her playing his viol or whatever, calling the tune and gazing down at her; she beribboned below him, singing, and looking up. Suddenly, through the camouflage of their roles they find themselves lost in a moment of love. The performance stops. A sweet pain stabs the silence of unplayed music as their eyes meet. It is a painting whose truthfulness cuts clean through the social twaddle, and it becomes a picture about falling in love.

In the Spanish room the wide-eyed sentimentality of Murillo made even more impressive the honesty of Goya. Goya's portraits of women, like Dona Isabel de Porcel, are among the sexiest ever painted. They are far sexier than anything produced by the flesh merchants, Titian and Rubens. They can only have been painted by an artist who was passionately attracted to women, but also understood them, liked them, and was liked by them. Goya is not afraid of women: he does not need to distance himself by enclosing them within a *cordon sanitaire* of impossible virtue or lubricious fantasy. Goya's portraits, too, are encounters – challenging encounters because the postures and stares of these women proclaim a demand to be treated as men's equal, and this is tossed at us like a gauntlet to be picked up by those who dare. Goya does dare or he would not have painted them in this way. If you half-close your eyes it is possible to see Goya's women as they might have looked from the brush of artists less confident of their own maleness: chocolate-box dolls with huge black eyes and inviting bosoms, and lips pursed to whisper 'Take me, take me, master.' Goya is not their master: he confronts us with a vision of women as mistresses of themselves, with all the pride, passion and vulnerability which that status confers.

I kept Rembrandt to the end. I used to think of him as the most beautiful painter of ugly women in the world. (Rembrandt himself, by the same yardstick, was even uglier.) But the criterion of physical beauty as a valuation of women is a male invention, in the sovereignty of which women have colluded in their clamour for male admiration. A beautiful woman is a beautiful male possession, one that invites the envy and desire of other men and so assists in the establishment of a male pecking-order, rather as a bank balance does. Rembrandt's women are not 'beautiful', because they do not perform that service. His women are never possessions; they are women he loves. There are only two of them – or only two who matter – and they are his wife Saskia, and Hendrickje with whom he lived after Saskia died; and the National Gallery has portraits of both of them. Saskia here is a golden-haired young woman regally dressed and decked in flowers: maybe she is Flora, the Roman goddess of spring (Ill. 5). Maybe she has just put on one of the exotic costumes which the artist liked to pick up in the Amsterdam auction-rooms because he and Saskia loved to dress up, and he loved to paint the result. It is a portrait of enormous affection and implied laughter. It is like a snapshot of a moment of personal happiness.

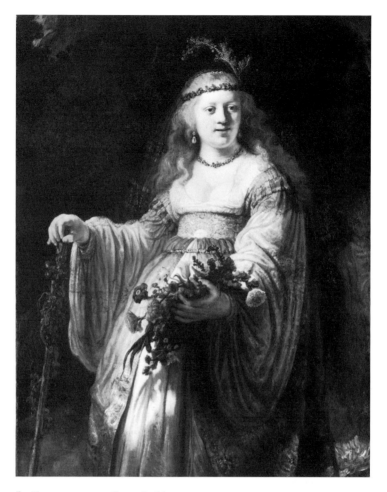

5 REMBRANDT VAN RIJN, *Saskia*

The Hendrickje portraits are more sombre. Rembrandt had reason to feel more sombre some twenty years later. He was now widowed and bankrupt. In the straightforward portrait of her seated in a chair (Ill. 6) there is no gold and there are no flowers: she has thrown a white fur wrap loosely round her body, and a coral necklace rests above her partly exposed breasts. The eroticism is understated and private. It is a private picture, done for the artist's own pleasure: he is showing her off to no one but himself. Rembrandt's delight in her heavy body is as evident as her unsmiling pleasure at being painted by the man she loves. Exactly the same deep neckline recurs in an even more moving portrait of her as a *Woman bathing by a Stream*. The loose garment this time is a voluminous shift, and she has

14

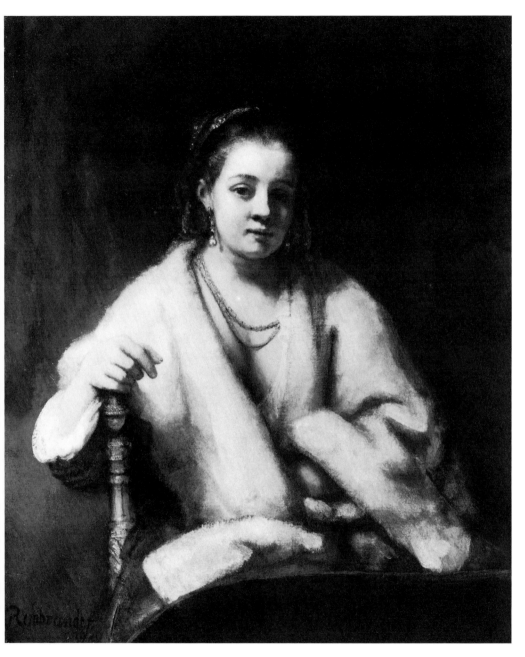

6 REMBRANDT, *Hendrickje*

hitched it high up her thighs so that she can wade in the water. Heaven knows where Rembrandt saw Hendrickje do this, or whether she posed in some makeshift bath so that he could record it. The circumstances are irrelevant because the moment is true. Rembrandt has made her look as magical paddling in her coarse shift as Botticelli's golden-haired Venus blown ashore on the waves amid roses. Art has no dimension of time; its magic lies in the wonder of a particular moment. Psychic energy is concentrated so powerfully on that moment that it feels like a revelation, something you have never experienced before, or never so intensely. With paintings in which that magic moment is the revelation of a woman, male fantasies have a habit of taking over, so that we are presented with an idealised stereotype – a deified pin-up. Rembrandt had no need of stereotypes because he could find the same magic in a sight of the rather plain woman he loved.

I walked out across Trafalgar Square and made my way home in the dank December sunlight. I tried to float my fresh impressions of the National Gallery on to the layers of memory I have of all the other art galleries I have known. And I realised that of those 276 museums in Europe and America which possess 'important' paintings 'not to be missed', I had probably visited two-thirds of them. If not quite a 'life-time' spent gazing at pictures, as the Director of the National Gallery had proposed, this did seem to add up to a huge chunk of my life. So, from all those accumulated years of regarding men's images of women, those millions of impressions received through my retinas and cortex, what evidence had I stored of how man has responded to woman?

Well, if men really hate women, then they have certainly done it in style. The art galleries of the West are so festooned with female images that anyone could be forgiven for assuming that women, not men, ruled the world. The evidence of art is unequivocal: it is that nothing in the world has held men's passions and longings in such thrall as women: neither money, nor goods, nor gods, nor friendship, nor conquest, nor kingdoms.

But what passions? What longings? Germaine Greer tells us that men hate women. And hate there is, certainly: all those rapes, tortures, and brutal martyrdoms. As well as more covert manifestations of man's hatred: the temptresses and whores, the witches and hags, the sanitised virgins and penitent sinners – images that are chimaeras of men's buried terrors of what women might do if allowed to be themselves unchecked. But balancing these hate images, art offers us the most wonderful variety of images of love – from sexual passion to comradeship in old age to a response of almost helpless rejoicing that the world can contain a creature so perfectly lovely as a woman. And in between these extremes a kaleidoscope of other male responses, not least the baleful stare of mutual indifference, recorded by umpteen painters' professional eyes for the benefit of husbands

16

who, if honest, would have preferred portraits of their wives' dowry or political connections.

The evidence of art is that men's responses to women are far more complex and ambivalent than can be labelled by a little word. If hate takes many forms, then so does love. Where painting can be a precious aid in trying to unravel these complexities is, paradoxically, through the disguises it adopts. Art codifies life by telling stories about it, and simplifies life by stripping away inessentials – the by-play and the small-talk. The result is a more concentrated and clearly defined body of human attitudes than we have in life, one which we can actually look at and examine.

And when it comes to men's attitudes to women, nothing in art has been more persistent than an anxiety to establish what it is that defines a good woman and what it is that defines a bad. This is where a debate about man's view of women has to begin, with what he has felt to be quintessentially virtuous about her, and what quintessentially vicious.

2 *Wise and Foolish Virgins*

A virgin most pure, as the prophets do tell,
Hath brought forth a baby, as it hath befel,
To be our redeemer from death, hell, and sin,
Which Adam's transgression hath wrapped us in.

My daughter filled her ten-year-old lungs with Christmas air, and in approximate unison with the rest of her school choir bounced these traditional sentiments high to the roof-beams of the parish church and down over the congregation of proud mums and dads below. An angel twinkled on the top of the Christmas tree, while round the crib kings and shepherds and all manner of farm animals gathered within the aura of a star. A focus of light rested on the perfectly good face of the Virgin.

It would have needed a stony heart not to be moved.

Some days later, in the bookshop of the National Gallery, a poster was advertising a 'Special Christmas Offer' of a new colour reproduction of *The Virgin in Prayer* by the Italian artist Sassoferrato. Here was the same sentiment, the same waxen-pale figure in white and blue, hands clasped, eyes lowered, eternally young, eternally chaste, eternally to be revered as the ideal of feminine goodness.

Our culture has made the ideal so palatable. We have been fed on it like milk chocolate since childhood. Here she remains, this utterly perfect woman, firmly lodged at the heart of some of our most cherished ceremonies and beliefs. But once you strip away the cultural packaging the ideal is a rather disturbing one. Here is a woman who is goodness incarnate, and her goodness rests on two inconsistent facts – that she was the mother of God's only son, and that she achieved motherhood without ever having sex.

Paintings have performed a wonderful public relations job for this ideal. In its purest form it is of course personified by the Virgin Mary, and yet she is by no means the only personification of it. Catholic or Protestant, Renaissance or Romantic, Sacred or Profane, the ideology of womanhood expressed in western art differs surprisingly little across cultures and centuries. Style and emphasis vary, but not the meaning. It is a powerful and persistent message.

18

A good woman is a non-sexual woman.

The sexual morality propounded by works of art can be distilled quite briefly. Perfection is female. Man has said so. The perfect woman should be a virgin, virginity being represented as the perfect state free of the taint of Original Sin. As the Christmas carol makes clear, to be pure means having no knowledge of sex, like the Virgin Mary.

Man does not impose such high standards on himself. He does not expect to model himself on Christ, even though woman is expected to model herself on Christ's mother. He permits himself erotic appetites and a need for sexual companionship. Besides, he needs an heir, as well as further breeding-stock to perpetuate the human race. Consequently she is expected to sacrifice her state of perfection in order to accommodate his needs, though any sexual activity in which she participates must be dedicated to procreation or to gratifying her husband, not to her own pleasure. And she must, of course, be entirely faithful to him.

A woman, therefore, is required to be less than perfect by the very man who has insisted on the supreme value of her perfection. Thereafter, though no longer pure, she can still be considered a good woman, but only by his consent. The woman who experiences sex without her husband's consent is damned, and sooner or later she will have to pay for it. Even if she is the innocent object of male lust – even if she has been raped – she will still have to pay for it.

There are paths of redemption open to her. A fallen woman can still be regarded as good if she is prepared to die. A raped woman is expected to take her own life out of shame: the male rapist is not because it is not seen as his fault. Alternatively, if she has engaged in sex voluntarily – even dared to admit that she enjoyed it – she can be spared provided she renounces her sexuality. She can be Mary Magdalene, who was put against a wall and stoned by men for having gratified male appetites, then rescued by grovelling at the feet of another man (the son of God) and vowing to abandon her sexual nature altogether.

The good woman, in other words, can be classified in declining order of excellence: four-star – virgin; three-star – faithful wife and mother; two-star – deflowered martyr; one-star – repentant wanton. Anything else – any hint of sexual enjoyment on her part – and she is bad. And that is that.

The generous and civilised eye that reads this creed might assume it to be the rubric of some barbaric tribe now mercifully extinct. In fact it is no more than can be deduced from a study of our great collections of art. It is precisely this altar of virtue upon which women's sexual morality in our western culture is traditionally enshrined, and from which we continue to imbibe many of our values.

Nor does the situation improve if we look at man's view of his own sexual role and rights; because it is his altar too. Man has chosen to make woman

his own moral watchdog. Since in her perfect form woman personifies goodness, he casts her in the role of guardian of the higher authority to which he himself bows – either God, the Church, the State, or in Freudian terms the authority of a father figure lodged within him as his Super-Ego. The good woman is man's appointed guardian angel: she is held responsible for keeping him good. And this means keeping him sexually under control, which it is in her appointed power to do by not tempting him. The price he has to pay for associating with a good woman is therefore to remain sexually restrained.

But – aha! – sexually restrained means sexually unsatisfied since man cannot be expected to be good all the time. It is not in his nature to do so: everyone knows that. How can he be good all the time when he is the son of Eve, the woman who brought about man's fall in the first place? Indeed, without woman, man would not have fallen at all: only a woman would have been capable of bringing about such a downfall.

So it is only natural that a son of Eve should seek release from unbearable moral constraints by associating sometimes with a daughter of Eve – that is to say, a woman with sexual appetites of her own who is by definition 'bad'. Man has need of a woman like this when he feels like being bad himself, though such compulsion is not of course his fault. It is her fault for tempting him, so she must expect neither affection, nor reward, nor respect for her attentions to his needs. And having enjoyed his bad woman to the full he can feel justified in doing what he did to Mary Magdalene, putting her against a wall and throwing stones at her. She is, after all, a bad woman and therefore deserves it; and he, not being Jesus Christ, cannot be expected to forgive her.

By any measure of justice such a polemic is a staggering example of double standards. It is an argument that a woman cannot win without foregoing all sexuality, and that a man cannot lose at all. It is the morality of a man's world.

Politically, it means that man feels entirely justified in subordinating woman to his power, since she would be dangerous if he did not – would inevitably degenerate into a bad woman if he did not insist she be good.

In this way man chains woman, but is also chained to her. He needs her and he despises her; he worships her and he dreads her; he loves her and he hates her.

This perverted concept of the good and the bad woman is as deeply engrained in our culture as any other set of beliefs.

It pervades our art, and continues to pervade it, though museums make such an ideology look like a thing of the past simply because the past is what museums are mainly about. It is true that the most intense preoccupation with the theme of women's virtue took place during the fifteenth century, and again during the period of about a hundred years following the

20

impact of the Counter-Reformation in the mid-sixteenth century. These were the ecstatic years of the Virgin, and of the radiant cohorts of virgin martyrs who came after her. Their flag flew brightly, was lowered for a while during the brief period of High Renaissance paganism, only to be triumphantly raised again under the threat of Protestantism when the Roman Catholic Council of Trent (1545–64) re-affirmed that the state of virginity was closer to God than the state of marriage. Under the impact of Romanticism, the nineteenth century expressed a fascination for bad women that was just as intense, and this preoccupation has remained alive in the present century in the work of painters as diverse as Munch and Rouault, Kirchner and Bellmer, Klimt and Picasso.

But at heart the two extremes respect the same ideology of womanhood – the good woman is sexless, the bad woman is ravenous. They are the 'heads' and 'tails' of the same coin, and the currency is western art.

A museum is not an island where culture grows. Culture is not a zoological rarity to be visited like the giant iguanas of the Galapagos, though there are experts working in museums who would have it so. Culture is not confined within the walls of palaces of art. It spreads into the streets. More accurately, it is a tidal flow, in and out. Over the centuries the culture of the streets, of daily life, and of life's dreams, has irrigated painting and has supplied artists with their imagery and their values. Only gradually have these images accumulated and become enshrined as something we think of as High Culture.

But the values of High Culture are also what we take back into the streets when we leave the National Gallery or the Metropolitan or the Louvre. It is a continuous process of assimilation and feedback. Within a quarter-of-a-mile radius of the National Gallery lies every manifestation of our own culture of the street, and it is this which will feed the museums of tomorrow if there are any. In this culture of life's daydreams there are few Immaculate Conceptions and virgin martyrs out there on the advertisement hoardings and outside cinemas; few Magdalenes and Delilahs, Venuses de Milo, and Whores of Babylon. But there are mothers in children's books who look too pure to have conceived the children they play with. There are women on television so fulfilled by discovering a soap-powder that no other fulfilment seems imaginable. There are the women, sinful with suntan, whose glance across a brandy glass is about to blow a man's best intentions sky high. And there are the women of the porno shops who will never do anything with their anonymous lives but peel like fruit and invite a man to rise and come forever from the safe distance of his home movie screen.

Where, you may well ask, lies the difference between the High Culture of museums and the Low Culture of the street? Different levels of refinement, of symbolism, of politeness, of artistry: that is all.

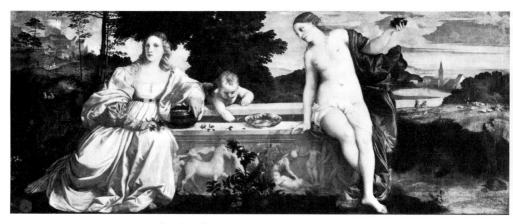

7 TITIAN, *Sacred and Profane Love*

There is a painting which haunts me. It is a painting of extraordinary serenity, drenched in that burnished sunlight with which Venetian artists embalmed the perfect world of their imagination. In the context of wise and foolish virgins it also haunts me because it is one of the rare paintings about women's sexuality to offer a viewpoint free of the contorted ideology I have just been describing.

The picture (Ill. 7) is by Titian, an artist not always given to so generous a view of women. It was painted when he was still in his twenties, about 1515, and now hangs in the Borghese Gallery, Rome.

Two women, alike in looks but neither of them specially beautiful, are seated at either end of a carved stone fountain. They are close to us, yet the fountain is set in the midst of a landscape; and since the painting is slender and horizontal, this seems to curl round the two figures in the manner of a panoramic screen. The landscape on the left-hand side is wooded and hilly, and our view of the horizon is blocked by a fortified town. On the right-hand side the landscape is open and falls away to a lake and an evening sky pierced by a church spire.

The choice of two kinds of landscape in the same picture begins to acquire significance when we see it in relation to the two figures. The woman in front of the enclosed landscape is fully clothed, so that the fortified town seems to symbolise her sexual state. The figure in front of the open land-scape, on the other hand, is naked except for a cloak furled over the left arm and a white drape across her loins; and the meaning of the spire appears to be both phallic and holy at the same time. The symbolism con-tinues. The clothed lady rests an arm on a jar which is closed, but the naked lady raises aloft a small pot or urn which is open and from which a flame rises. The meaning of the picture has grown even clearer. Then suddenly it becomes complex again when we notice that on the rim of

22

the fountain a golden bowl of water (purity) rests next to the naked lady, not the clothed one, as we might have expected. Near the clothed woman is a plucked red rose (love), and she also holds another rose in her gloved hand. Between the two figures a small child (presumably Cupid) reaches into the fountain as if intent on fishing something out of the water.

There are a number of other details (which have helped inspire the acres of conflicting interpretation that the painting has aroused), but these are the principal ones. It is a picture that is both a delight to look at and a feast for thought. It is virtually a treatise on love, by an artist who was more concerned with the theme of love than any other painter of the Italian High Renaissance.

The most intriguing questions it raises are: why is the state of nudity both erotic *and* holy? and why is the symbol of love associated with the clothed figure, and the purity symbol with the naked figure? One might think it should be the other way round. And there is a third question which needs to be answered: why is the clothed figure looking at us, or past us, while the naked figure is turning towards her as if trying to attract her attention? What is the nature of their respective glances?

Paintings do not offer footnotes or glossaries to explain the precise meaning the artist intended. That is left to scholars to have fun with. But what seems to have been Titian's meaning is this. The two women look alike because they represent two aspects of the same person; she stands for Woman Loved, or Woman in relation to Man. The woman who is clothed knows love, or she would not be holding the rose, but she has not given in to it. She is like the fortified town behind her. She is impenetrable, virginal. The naked woman has given in to love – she is a sexual woman; hence the flame she holds in her hand. What is more, she appears to be appealing to her companion to be like her – to be a sexual woman too. The clothed woman is unsure if she should, and seems to be appealing to us for advice. We are placed in the position of having to absorb the painting and to offer our answer.

What is remarkable is that the picture is not, as we might have expected, an invitation to a life of lust, which for women invariably means a life of sin. Quite the reverse. It is the naked woman, not the clothed, who has the symbol of purity by her (the bowl of water); while the church spire behind her, phallic symbol though it may be, is much more powerfully a symbol of holy righteousness. In other words – female sexuality = pure and holy.

Now, in the context of western art with its customary stereotyping of women, this is quite remarkable. The painting's title, *Sacred and Profane Love*, is a nonsense. It is not Titian's title. We do not know what he called it, but what he is clearly saying is that profane love *is* sacred; virginity, far from being the pure and perfect state, is actually inferior and even ungodly. The idea that female sexuality is next to godliness, while virginity

23

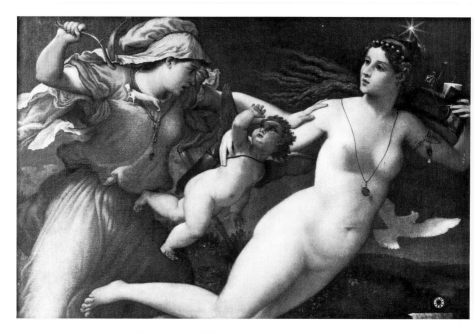

8 Lorenzo Lotto, *The Triumph of Chastity*

may be mean and prudish, is so extraordinary that it amounts to a blasphemy against the orthodox ideology of woman's role.

Titian's own career glittered for a further sixty years after he painted *Sacred and Profane Love*, but for all the peaks of imagination he scaled he never achieved quite the same noble balance of sensibilities again. Sexual appetite edged out perception of human nature: his erotic women became molls, his sexless women termagants. He became rather a flesh painter. It is hard to imagine how different European art might have been had the generous humanism of the young Titian become the standard for how male artists looked at women, instead of the exception.

But the norm has not been generous humanism. It has been sexual stereotyping, often overlaid with one hypocritical morality or another. A Venetian contemporary of Titian was Lorenzo Lotto, who is justly famous for his portraits. However, he did make one excursion into sexual morality – perhaps unwisely in his old age – and the result (Ill. 8) is a far more representative account of prevailing male attitudes. Like the Titian the picture is now in Rome, at the Palazzo Rospigliosi, and it shows the figure of Venus being thrust and beaten aside by a ferocious female who may be the goddess Diana, the virgin huntress, or she may simply represent Chastity.

Here is a pairing of female opposites not unlike the two women in *Sacred and Profane Love*, one representing acceptance of sexuality, the other rejec-

24

tion of it. But what a difference. The chaste woman, far from being touched by love and appealing for guidance as to what to do about it, clearly has nothing in her heart but self-righteous hatred and a longing to drive all erotic passions off the face of the earth. It is this gloomily clad matron whom we are being invited to admire. But are we? It is the cool figure of the Love Goddess, her nakedness enhanced by a necklace plunging between her breasts, on whom male eyes inevitably dwell. She is presented to us both as the bad woman who should be driven out and the woman we want, whereas the good woman is the sexless harridan with whom no man in his right mind would choose to spend five minutes. She is man's appointed guardian angel, or governess, from whose authority he can play truant; but he can return to the governess for protection when the bad woman feels threatening, and then enjoy seeing her punished for having tempted him.

It is the same old game.

One of the most powerful impacts painting ever made on me was on my first visit to Florence when I was seventeen. It was only a few years after the end of the Second World War: the city was serene, empty of tourists, and full of wonders – a backcloth of blue-green olive trees, the scent of jasmine, a chorus of church-bells, and everywhere dark-haired girls riding motor-scooters side-saddle. Madonnas. The paintings I mostly looked at were madonnas too. Virginity was everywhere, in the churches and in the streets. I had brought my virginity along too. It did not occur to me until many years later that there might be some connection between these various fortresses of innocence.

It was the art of the Early Renaissance which I found so appealing – the art of the hundred years or so before Titian and the great years of Venetian painting. Painting in fourteenth- and early-fifteenth-century Florence has little of the worldliness of High Renaissance or Baroque art. The ferocious chastity of Lotto's picture and the sophisticated sexual debate of Titian's are neither of them areas of human experience to have interested or troubled Florentine artists of this earlier period. Purity was not a condition to be fought for or debated: it could be taken for granted and, in an untroubled way, extolled. The cult of virginity, embodied in the figure of the Virgin Mary, could prosper unchallenged and without any apparent reference – or relevance – to our more confused values here on earth.

Is this, I wonder, a large part of its appeal? Later Italian painting presents sexuality from the viewpoint of acknowledged experience; early painting tries to avoid the issue altogether in favour of an ethereal state of declared innocence. It is only a *declared* innocence, not a true one, or the personification of this state would not be this deeply sexual image of a beautiful virgin, bride of God and mother of God's son. But the power of early Florentine painting may well lie in being able to express both the fascination and the

fear of sexuality in a form that is comforting to the spectator and a focus of Christian ritual.

It can have been no accident that in this cauldron of teenage virginity in which I roasted in Florence the artist who expressed this state of innocence most appealingly was a cloistered monk – Fra Angelico. In the 1430s and 1440s Fra Angelico took charge of a scheme to paint virtually the entire monastery of San Marco – a high altarpiece for the church, frescoes for the chapter house, more of them above doorways here and there, in corridors, and (most impressive of all) for the monks' individual cells, forty-four of them. Of all these paintings the one that has remained most strongly in my mind is a fresco (Ill. 9) of the most spartan simplicity representing the Annunciation. It is in one of the small bare cells, and shaped like a window, next to a real window – one window opening on to the world, the other to God. Mary, kneeling, is on the right; the angel, standing, is on the left. Gently moulded arches build a pattern of light and shadow above them, and just visible in the left background is the attendant figure of St Peter. The colours are muted, soft. The picture is about harmony, order, the essence of things, peace – qualities a boy stepping into manhood probably least possesses and most longs for. Here is a world stripped of discord and bounded by absolute certainty. There are no jagged edges of doubt. It is balm to a troubled spirit.

It is a picture I still love, though I hope not, as then, for reasons of sexual brinkmanship masquerading as spirituality. There is a grandeur about very simple artistic statements – like English plain-song, a Herrick love poem, a Chardin still-life, a Norman village church – which can sometimes outscale the most elaborate piece of imaginative machinery. As a statement about awe and tenderness, expressed in the simplest possible terms, Fra Angelico's painting has very few rivals.

The virginity cult also has its moments of sheer glory. What was suitable for the quiet contemplation of a monk in his cell would not do for the choir screen of a church, and Fra Angelico understood this perfectly. His *Coronation of the Virgin* now hangs in the principal Florentine art gallery, the Uffizi, and like so many pictures designed to be the focus of religious fervour it makes a lesser impact when displayed more coldly in a museum as a piece of art in the context of so much other art. Even so, it is a painting of magnetic power. The Virgin is seated next to God in an explosion of gold. She is surrounded by a heavenly and earthly choir of Christian notables, robed and haloed and supported on clouds. If the Annunciation is the intimate opening of Mary's story, then the Coronation is the public climax. They are the beginning and ending of that ecstatic elevation of the sexless female state which is the Italian Virgin cult.

What seems to happen in art is that this simple ideal of female perfection begins to feel less comfortable as the art of painting grows more sophisticated and inevitably more naturalistic. Fra Angelico's presentation of good-

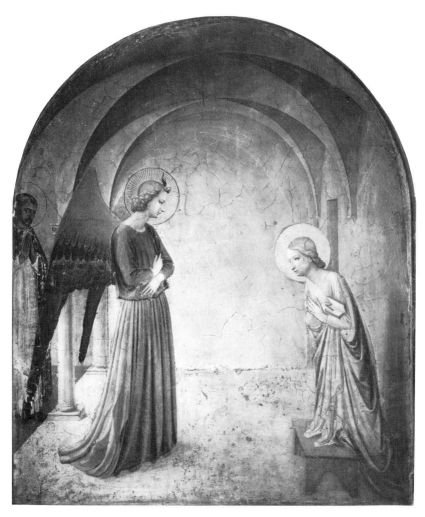

9 FRA ANGELICO, *The Annunciation*

ness asks very few questions, and this is its strength. The Virgin Mary is not a real woman but a formula for a particular concept of femininity. His art is mystical, and that mysticism depends to a great extent on limitation of means. But as painting grows more scientific in approach, more to do with how to create the illusion of a real world, our own experience of that real world begins to interfere with this rather dreamy concept. Art begins to reflect a growing awareness that the ideology of perfect goodness as personified by the figure of the Virgin is something artificial, which conflicts with all kinds of other feelings and associations that our notion of

27

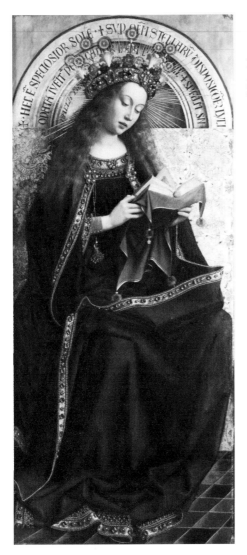

10 VAN EYCK, The Virgin Mary: detail of the Ghent Altarpiece (copyright A.C.L. Bruxelles)

a good woman arouses. Man's need for a good woman now has to be reconciled with his longing for a bad.

Flemish art, which began to flourish in the north of Europe at about the time Fra Angelico was painting his monastery in Florence, demonstrates this change. Van Eyck's Madonna in the famous Ghent altarpiece (completed in 1432) (Ill. 10) is not at all an impersonal figment of some mystical daydream. She is very real indeed: she is flesh and blood. Some actual girl, picked for her looks, must have posed for the part. She is a lovely young woman dressed as a princess and reading a book. In the worldly beauty of her face and gestures her sexuality seems to be acknowledged and our sexual response to her invited. It is impossible not to look at her this way. She appears to be waiting for life to unfold for her, rather

28

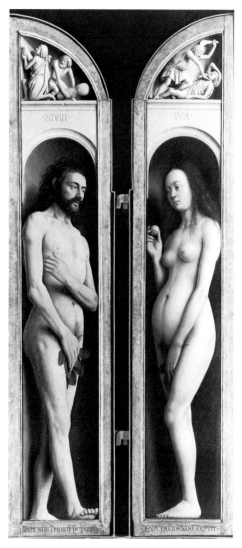

11 Van Eyck, Eve, from the
Ghent Altarpiece (copyright
A.C.L. Bruxelles)

than for a virginal eternity in heaven. But Van Eyck has resolved for us
the problem of reconciling her sexuality with her goodness by giving us
a second woman near-by on whom all our feelings of badness can be direc-
ted ((Ill. 11). She is Eve, standing in the darkness of sin over on the right
of the altarpiece. She is naked, ashamed, pregnant; she has stringy hair
and the face of a harlot; one hand holds the apple which tempted Adam,
the other covers her guilty genitals. She may be mother of us all – mother
of Mary too – but she is the bad woman; and by her presence in the picture
she attracts to herself all man's feeling of sexual disgust and guilt, so leaving
the Virgin free to be the harmless focus of our adoration. As a piece of
psychology, as well as of painting, it is very, very clever.

It is when Flemish artists tried to combine this wonderful gift for the

natural with the demands of ritual mysticism that problems occur. The painting now in the National Gallery of Washington called *Mary, Queen of Heaven* (Ill. 12), is by an unidentified Flemish artist some fifty years after Van Eyck and who probably worked in Spain. The picture was painted for a convent, so it had a specific function of relating to a community of cloistered women who had themselves rejected the world. But, being Flemish, the artist found it impossible through his training to ignore the

12 Master of the St Lucy Legend, *Mary, Queen of Heaven* (National Gallery of Art, Washington; Samuel H. Kress Collection 1952)

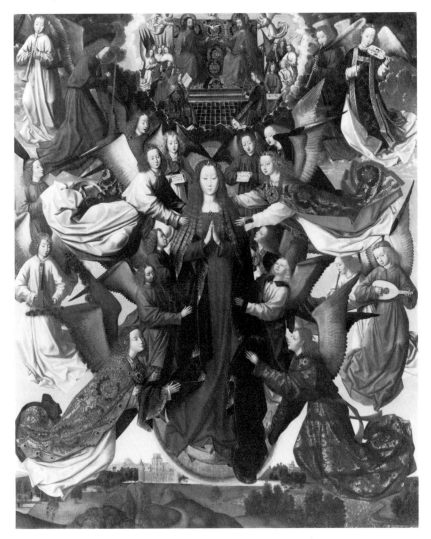

real world: it is there in the delicate landscape at the foot of the painting. It is also there in every careful detail of clothing and musical instruments which decorate this exceedingly rich composition of angels attending the central figure of the Virgin. And yet, as the personification of purity, she must not be too real, so the artist has called upon conventional devices of religious iconography to graft unreality on to her. She floats above the landscape – or, rather, seems to be held above it by the combined physical effort of angels – while she tries her best to assume an impersonality with downcast gaze and clasped hands. The result is a painting that is something of a hybrid.

The flight from the taint of Original Sin became a more hectic and more ambivalent one as artists acquired superior skills at representing women as they really are, and – more important – the skills to show what men really felt about women. The Counter-Reformation re-awakened an intense fervour for the cult of the Virgin Mary: for the professional artist this was where the money was. Painters with wives and families, worldly lives and worldly relationships, built lucrative careers advertising virginity. The seventeenth-century Spanish artist, Murillo, is an outstanding example. Virtually all his life was spent in Seville fulfilling commissions for holy works as they came to be needed by over seventy religious institutions and an even larger number of parish churches, chapels, and hospitals which this city of fewer than 100,000 inhabitants supported.

A recent full-scale exhibition of Murillo in Madrid and London made it clear that his greatest gift was for expressing the sentiments of living people. But, removed from daily life and applied to the revived soap operas of the Catholic faith, these sentiments become glutinously sentimental. Murillo's *Immaculate Conception of Los Venerables* (Ill. 13: Prado Museum, Madrid) is one of his most popular works, and looked at solely as a piece of painting it is strikingly handsome in colouring, skilfully drawn, wonderfully composed, and all the other credits that art books and catalogue entries report.

But what do we actually have in this picture? Here is the Virgin Mary who represents absolute purity. She is someone who has no association whatever with sex: she was conceived without sin, and her son is to be conceived likewise. She stands amid the clouds, fully clothed, eyes raised to heaven, hands clasped in a gesture of rapt submission to the will of the Almighty. So far so good. But look again. She is young, she is beautiful, she is an unmarried virgin, her head is thrown back, her hair falls loose, her hands gently touch her breasts, the outline of her body is just suggested by the flow of her dress, and amid the blaze of light descending upon her a blade of shadow rises from below and narrows to a point exactly where her legs part. She is in every gesture and every detail an object of male desire. What, then, were the men who knelt before her in church really supposed to feel about her? On the one hand she stands for absolute purity and freedom from the Original Sin of Eve. On the other hand she is shown

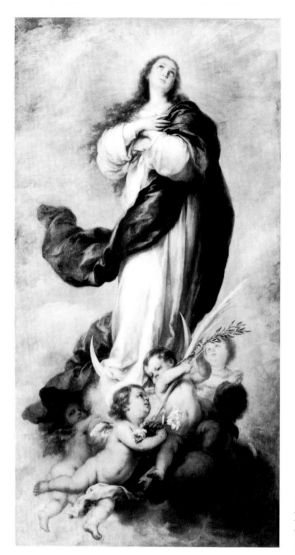

13 BARTOLOMÉ MURILLO, *Immaculate Conception of Los Venerables*

as representing everything that attracted Adam to Eve and everything a man would like a woman sexually to be: she is lovely, she is untouched, she is submissive, and she is just alluring enough to excite while remaining entirely unthreatening. And with this aerial kindergarten of babies around her she is clearly waiting to be impregnated. She will make a good breeder.

Could it be that the huge popularity of the art of the Virgin Mary during the Counter-Reformation lies in the ability of artists to reconcile in this female figure two quite opposite male desires – the longing for woman as asexually pure and sexually available at the same time?

32

Such duality of response is no doubt aggravated by the nature of the artist-model relationship which is invariably tinged with some eroticism. Murillo had not, after all, been summoned to heaven to paint a portrait of the Virgin Mary. He was paying for the services of some young woman whom it pleased him to paint in order to fulfil a church commission. It would be very surprising indeed if Murillo's sentiments towards the model standing before him corresponded even remotely to those he was intending to represent: only the most stony-hearted Jesuit could be expected to have accomplished such a feat, and Murillo seems to have been none of that. A few centuries earlier this discrepancy between the image intended and the image experienced would hardly have existed – it is hard to imagine Fra Angelico, whose representations of the Virgin were largely impersonal, needing to use a real live model, or experiencing a strong personal response while painting her if he did. But as religious art grew more lifelike and more emotionally charged, figures that had once been symbolic inevitably took on a human reality independent of the roles they were playing. The artist-model relationship began to drive a wedge between what was explicit in art and what was implicit, a process which reached its apogee in those sumptuous lip-smacking compositions with impeccable mythological titles so dear to English mill-owners in the late nineteenth century.

A further painting by Murillo extends the scenario. Another *Immaculate Conception* (he painted a great many) now in the Louvre, Paris, actually incorporates the male figures of Murillo's day who are supposed to be worshipping her. Four of them gaze up at her agog, and a fifth man gestures towards her while turning to say something to the others. The double meaning has become even clearer. If we think of this picture in the way we are supposed to, as a holy painting, then the male onlookers indeed seem to be revering the Virgin Mary with expressions of wonder and awe. But reactions to works of art are not always obedient to doctrines, and without this essential key we could just as easily read it as a rather poetical account of a slave market, with the owner showing off his wares to a cluster of gawping customers. Compare the picture to one of the most celebrated paintings of Victorian England – Edwin Long's *Babylonian Slave Market* (or *Marriage Market*; significantly it is called either) – and the Murillo appears to be much the same wolf in sheep's clothing. It is no accident that nineteenth-century art collectors combined a fascination for slave pictures with a passion for Murillo.

It comes as a shock to find images of the Madonna – an object of the highest reverence – interchangeable with images of female slaves – objects of degradation; but what works of art sometimes unmask is the depth of male hostility that may lie concealed within portrayals of supposedly virtuous women. The Madonna herself is apparently shielded from this hostility by her role as the virgin mother of Christ, our Saviour; though a Freudian

would say that she does indeed arouse such feelings because of the male Oedipus complex – the Virgin Mary is the archetypal mother we all desire, and hate because we cannot have. In any case, the hostility that is hidden from the Madonna is quite openly expressed towards her spiritual followers, who are the virgin martyrs. Again, the period with the strongest appetite for paintings of these long-suffering creatures was the century following the Counter-Reformation, roughly 1550 to 1650.

In this category of religious painting comparison with a slave market is no longer merely a hint. The virgin martyr *is* a slave – a slave to man's desires. There is no way she can possibly find release. Her virginity is rated by man to be her most valuable possession which she should keep at all cost, but it is also the highest prize which his manhood requires – to take by force what she may not wish to give. So she is lost. The virgin martyr is the ultimate personification of those two incompatible requirements – that a woman should be asexually pure and sexually available.

Consider the lot of some of the female martyrs most popular with artists. St Catherine of Alexandria was supposed to have been a fourth-century Christian virgin who was desired by the Roman Emperor Maxentius. For resisting his advances and clinging to her faith she was bound to a wheel studded with iron spikes, and then beheaded. Some portrayals show her holding a book on which is inscribed the words 'I have offered myself as a bride to Christ'.

St Ursula was the maiden daughter of a Christian king of Brittany at some uncertain date, who rejected the king of the Huns and was slaughtered for her chastity along with – so the story goes – eleven thousand virgin companions.

St Agatha was a third-century Sicilian girl who refused to present her virginity to the Roman governor, whereupon she was thrown into prison and had her breasts cut off.

St Margaret of Antioch also fell foul of a local big-wig who threw her into gaol when she insisted on remaining a Christian virgin. After the usual tortures she was visited in prison by Satan himself in the form of a dragon who swallowed her, though the cross in her hand exploded the monster and she emerged untouched. She was then beheaded.

St Apollonia was an Egyptian virgin whose experiences were similar to those above except that her particular fate was to have her teeth drawn before being burnt at the stake.

These are only a few picked out of the chorus-line of virgins who go through their paces with a monotonous lack of variation in the art of Christian Europe. They do not exactly hog the stage in this perverted morality play of Good and Bad Women, but like all good chorus-lines the show would be poorer without them and certainly less titillating. What is telling about the performance they are required to give in paintings is that artists rarely dwell on the sadism of their respective martyrdoms, pre-

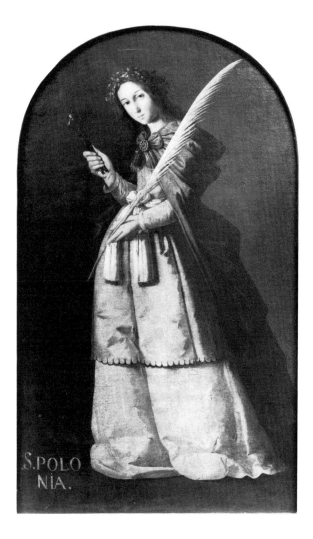

14 FRANCISCO DE
ZURBARÁN, *St Apollonia*
(copyright SDPMN/DACS
1984)

fering to offer them plaudits for their purity by depicting them as serene
and invariably pretty, displaying the instruments of their torture as if they
were jewellery or harmless toys. Zurbarán's *St Apollonia* (Ill. 14), for exam-
ple, now in the Louvre, shows a beautifully dressed lady of immaculate
composure holding up one of her wrenched-out teeth in a pair of pincers
rather as if she were about to offer a tit-bit to some pet dog. This pictorial
whitewashing is also reflected in the historical associations that these virgin
martyrs have remained coupled with: St Apollonia, whose teeth were torn
out, survives as the patron saint of dentists; St Catherine, bound to a spiked
wheel, has given her name to a firework – the Catherine Wheel; St Ursula,
because of the eleven thousand virgin companions slaughtered with her,

35

has lent her name to the Ursulines, a religious order dedicated to the education of young ladies. The name of St Agatha, the one who lost her breasts, is invoked against earthquakes because her death was greeted by such an event at the time; while St Margaret, who survived being gulped by a dragon, becomes – through a ghoulish association of ideas – the patroness of childbirth.

The requirement that a good woman combines sexual availability with asexual purity has given prominence in western art to another figure from the Christian story – Mary Magdalene. Now, the Magdalene is very far from being a virgin ripe for rape; she is the whore who repented – quite the reverse female stereotype, yet she possesses the same schizophrenic combination of qualities.

The Bible is not at all clear about the identity of Mary Magdalene. The penitent sinner who anointed Christ's feet is unnamed in Luke's Gospel. She is called Mary in St John's Gospel, but there is still no reason beyond tradition to identify her with the Mary Magdalene who was a witness to the Crucifixion, and to whom Christ addressed the words 'Noli me tangere' when he appeared to her after the Resurrection. But these biblical vaguenesses did not deter the Church and certainly did not inhibit artists who worked for the Church. In painting she personifies the bad woman made good. This is her role in Church teaching, and it is her role in art.

Let's take a look at her. She is invariably young, so that she may be presented to Christian worshippers as sexually appealing, even though in life she would certainly have been a raddled old bag. She is invariably beautiful, which ageing prostitutes are generally not. And, like the Virgin, she is often shown clasping her hands to her breast and raising her eyes to heaven – a double gesture of submission to the will of the Almighty. Titian's painting of her in the Pitti Palace, Florence, and Murillo's (Ill. 15), now in Dublin, are both of them typical of this interpretation.

It is an interpretation sharply revealing of what is demanded of a good woman. Here is a female who is cast in the role of a sinner because she has profited from that nature by gratifying male needs. Her only means of redemption – of returning to the fold as a good woman – lies in renouncing her sexual nature altogether. And yet, having renounced her sexuality for ever, she is still represented as being sexually irresistible. Titian shows her clothed only in her long golden hair, which leaves both breasts uncovered; Murillo paints her naked except for a loose robe supported so lightly by one feeble hand that the faintest breeze would blow it away. In fact, repentant though she is, and deprived of her sexuality, she is still displayed as the earliest possible candidate for rape. Her tenure of the office of Good Woman seems likely to last about two minutes.

The Magdalene is not a figure in European painting who is confined to a few hysterical years of the Counter-Reformation. She has always been

36

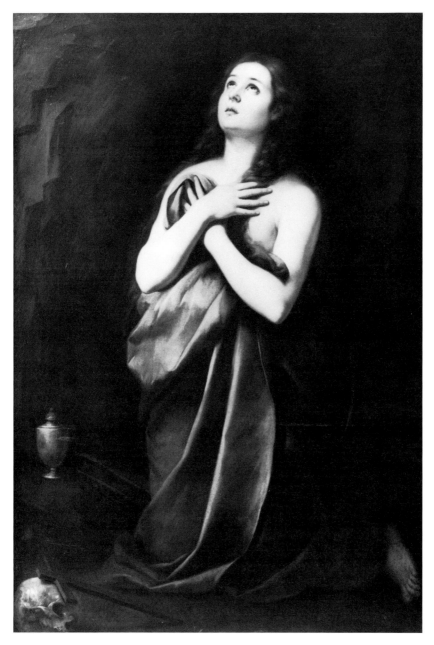

15 BARTOLOMÉ MURILLO, *Magdalene* (National Gallery of Ireland, Dublin)

with us. Like the Virgin Mary, like the virgin martyrs. Mary Magdalene is the woman who has experienced what it is like to be bad and has said No. She is Awakening Conscience. She has said goodbye to her body. She is a good girl now; man has made her good. (Some women are born good, some achieve goodness, and some have goodness thrust upon them.) Now she can make man good too, at least until he feels like being bad again. Then he can try to rape some other woman, and if she resists he can tie her to a spiked wheel and cut off her breasts until he is ready to revere her too as a good woman worthy to take her place next to the Virgin and Mary Magdalene at the feet of God.

This merry-go-round is our Christian inheritance.

What can be the nature of this hostility which male painters – including some of the greatest of them – have applied towards women? The sensibility of artists is not singular, just a personal vision, any more than a judgment of law is personal justice. It is rooted in what society believes and what society wants. There can only be one origin of so pervasive a desire to control woman, abuse woman, set her up in order to tear her down, enclose her in a labyrinth of moral strictures with so many blind exits she will never be free; and that is – fear.

Of what? What does art tell us of male fears of what women might actually do if men did not insist that they be good little girls?

3 *Man-Eaters*

The atomic bomb dropped on the Japanese city of Hiroshima in 1945 had a photograph of Rita Hayworth attached to it. Or so the story goes. Hiroshima Mon Amour – indeed!

The scenario deserves elaborating. The most beautiful, desirable woman of her time, focus of tens of millions of erotic fantasies, is cast as guardian angel of the most destructive weapon in history. She sits astride a gigantic penile missile that will produce the most powerful male orgasm ever – the atomic explosion. The rape of an entire city is between her legs. Woman has given birth to man, nourished him, seduced him, and now guides his sexual energies towards the destruction of human life which she has herself created. She is the mistress of man's sexuality, and of his doom. This orgasm is man's finale – he is literally wiped out.

The fantasy that women, and particularly beautiful women, are deadly dangerous and can usurp men's power, is among the oldest in our civilisation. According to the Greek poet Hesiod, the very first woman – the goddess Gaea or Mother Earth – persuaded her youngest son Cronus (Saturn) to castrate his father Uranus with a sickle. Uranus' genitals were hurled into the sea, and out of the foam that issued from them Aphrodite (Venus) was born. It is a macabre fabrication of ancestry for the Goddess of Love. It is also the mythological source of Freud's conviction that men go in terror of castration.

Christian writers have documented the same male fears, as well as the loathing of women that has shrouded those fears. In the Bible the Book of Ecclesiastes urges 'Give not thyself to a woman, so as to let her trample down thy manhood.' Thumb through the writings of mediaeval churchmen and the outbursts of hysterical misogyny defy belief; this one, for instance, by an eleventh-century French monk, Roger de Caen – 'If her bowels and flesh were cut open, you would see what filth is covered by her white skin. If a fine crimson cloth covered a pile of foul dung, would anyone be foolish enough to love the dung because of it?'

So steamy has been the climate of terrified misogyny that it comes as no surprise to find almost as many emasculating women in public art galleries as spotless virgins – in fact all kinds of unease seems to set in the

instant a woman can no longer be labelled a spotless virgin. It would be a simple matter to select from our museums several covens of ladies who could have ridden the atomic bomb that fell on Hiroshima: Circe, Medea, Medusa, Judith, Salome, Delilah, Artemis, Lady Macbeth, Charlotte Corday, Clytemnestra, the Sphinx, the Amazons, the Bacchae, the Sirens, the Fates, as well as sundry witches and vampires.

The role of art in all this gorgonolatry is important. A picture of a dangerous woman is powerful because it is the icon of a man's innermost terrors – the focus of a fearful kind of reverence. But being itself a harmless image, not the real thing, it also exorcises the danger depicted. Just as Medusa's deadly snake-locks were rendered powerless to the eyes of Perseus when reflected in his shield, so the female man-eater becomes safe to the spectator once she can be gazed at in a painting.

But where does it come from, this enormous sense of danger, this overriding terror, which art expresses so forcefully and at the same time exorcises? Paintings, and in particular paintings which illustrate myth, tell us a lot about this terrible danger to which men feel exposed in the face of women. What they tell us is that, however strong a man may be, a woman is felt to hold weapons to deprive him of this strength; to have powers he does not possess. Beneath the adulation man is so ready to shower upon her, and beneath the purity with which he crowns her, he nourishes the conviction that she is at heart an animal, a beast – or, if not actually a beast, then closely allied to one. The Sphinx is part-lion, the Gorgons are part-snake, the vampires part-bat: Circe turns her lovers into swine; Medea's chariot was drawn by dragons: Pasiphaë formed a sexual passion for a bull; Jupiter won Leda by turning into a swan; Macbeth's mind is poisoned by his wife until it becomes 'full of scorpions'. So, just as he feels the need to control beasts in nature, because they are savage and dangerous, man must use his superior physical strength to control the beast in woman too or she would be even more dangerous. She would kill him. He would be Hiroshima and she the bomb.

The myth of the beast in woman is illustrated in every period of western art. A straightforward version of it from our own century is one of the small water-colours into which the German-Danish artist Emil Nolde used to pour his sexual fantasies. It is called simply *Woman and Animal* (Ill. 16). Nolde possessed a Germanic feeling for the grotesque when it came to painting people, and the woman here is lying naked next to a lion. Nolde has given her a voluptuous and youthful body, and the lion wears the grin of a Prussian banker who has just bought the services of a hotel chambermaid. His tail stands upright like a gigantic penis. But she is not a pretty young chamber-maid: she has a face of predatory hatred, and above it rise wild flames of scarlet hair. Like him, she is an animal: her appeal is to the beast in man. Or, like Circe, she has transformed her lover into an animal.

40

16 EMIL NOLDE, *Woman and Animal* (Nolde Stiftung, Seebull)

17 JOAN MIRÓ, *Head of a Woman* (The Minneapolis Institute of Arts)

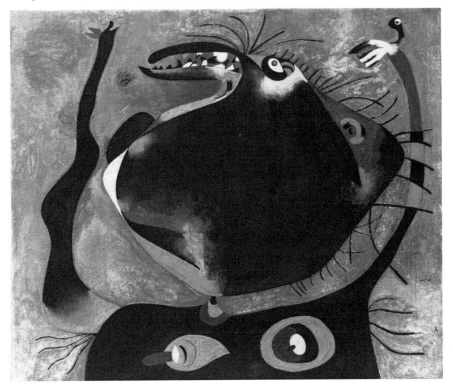

Also from the 1930s comes another disquieting image of female bestiality, *Head of a Woman* (Ill. 17) by the Spanish Surrealist Joan Miró. There is no man in this picture, and her pterodactyl-like teeth suggest that she may already have gobbled up any man within miles and still have an appetite for more. Her arms flail, and hairs sprout from her head and armpits like the strands of a whip. As with the Nolde this picture was painted under the shadow of Fascism, and the monster which Miró created may well personify Franco's oppression of republican liberties. None the less, it is female: the monster is a woman. She is the great beast man has failed to control. And she is very terrifying.

Such terrors lie deep. Some of the oldest myths we know link woman with natural forces in a way which man is ill-equipped to understand or to cope with. A Persian myth of the creation of the world, predating the biblical one, has woman and not man as the creator. She gives birth to a great many sons, but these grow frightened that if she can create life she may also take it away. So they kill her. Robert Graves points out the significance in primitive mythology attached to a woman's biological cycle corresponding exactly to the twenty-eight-day lunar cycle – irrefutable evidence, it must have seemed, of woman's bond with nature to the exclusion of men, and therefore of her superior powers. Graves relates how the Hittite moon-goddess would take an annual lover in order to bear children; but at mid-winter when the sun (symbol of male fertility) was at its weakest, the lover would be sacrificed and his flesh eaten raw by her priestesses. The supremacy of the female goddess became eclipsed about the time of Homer (symbolised, Graves says, by the beheading of Medusa by Perseus), until by the period of classical Greece man's assertion of control had led to the Olympian religion dominated by a male god, Zeus. Now the irrational and 'animal' elements in human affairs became banished to the periphery of the religious pantheon – in the form of wanton satyrs, drunken bacchantes, and cavorting maenads and nereids. Reason ruled within the city walls, unreason the kingdom of nature beyond.

This was the order of things taken over by artists of the Italian Renaissance when Greek myth again became a dominant theme of art during the century before the Catholic hysteria of the Counter-Reformation. At the centre of the Renaissance was man – his power, his intellect, his identity, his mastery of the world. At the same time, the appeal of Greek myth to Renaissance man seems to have resided to a large extent in the expression it gave to all those irrational forces and fears which had been banished beyond the city walls, but which still lingered heavily in the mind. In particular these fears focused on women – on dangerous women whose power lay in their deadly alliance with nature.

The deadliest of these women was Diana, Artemis. She was goddess of the moon, so she personified that frightening link between a woman's biological cycle and the lunar cycle. Diana was a virgin – what is more,

militantly so. She was the goddess of hunting, therefore armed and on intimate terms with wild beasts. And – in the eyes of Italian painters at least – she was also beautiful and desirable. There can be no more vivid evidence of man's fear of the predatory woman – of woman as uncontrolled beast – than the fascination painters felt for the personality of Diana.

As so often, it is Titian who has most to say about her. Of all Renaissance painters it is he who best understands, if not women themselves, then male attitudes to women. Titian has an extraordinary ability to make the spirit flesh, to project the inner world on to the outer, and to fill that theatre of the psyche with actors we believe to be living people even while we know them to be enacting stories that are fanciful and long dead.

Titian painted some of his most celebrated pictures on the exploits of Diana, and two of them are specially poignant here. They describe two moments in the encounter between the goddess and the young prince Actaeon, as told by the Latin poet Ovid. Actaeon is out hunting in the forest and by accident comes to a grotto where Diana and her attendant virgins are bathing. As punishment for espying her naked, Diana turns Actaeon into a stag, whereupon he is hunted and torn to pieces by his own hounds. A particularly nasty story, unredeemed by even a hint of moral justice; a blatant case of a woman employing her alliance with the powers of nature to destroy a hapless male.

The first picture, now in the National Gallery of Scotland in Edinburgh, shows the terrible moment of discovery: the second, in the National Gallery, London, shows Actaeon's death. The fact that both are glorious pieces of painting, which invite us to switch off our minds and enjoy them as a tableau of colour and flesh, is proof of how mindlessly hypnotic great pictures can often be. But what happens if we resist hypnosis and analyse how Titian has actually chosen to describe this appalling story?

The Edinburgh picture, called simply *Diana and Actaeon* (Ill. 18), shows the young prince at the moment of entering the scene. He is a fine figure of a man: he is muscular, athletic, and a quiver is slung across his shoulders. A hound runs obediently at his heels: nature is still under his control. But only just! We are witnessing the moment of change. What he sees has caused him to drop his bow. He is already unmanned. Before him are seven women, six of them naked, young, and more or less beautiful (the seventh, in an example of Olympian racism, being a black slave who is clothed and ugly). The naked women are seated or sprawled around a circular fountain which is set among stone arches open to the trees and the winds. On one of the arches hang the skull and antlers of a stag, symbol of Diana's role as goddess of hunting, while her role as moon goddess is identified by a crescent moon she wears in the jewellery decorating her hair. It is by this emblem, presumably, that Actaeon recognises her. Diana is white-skinned, she is fair, she is lovely and sexually irresistible; she stares piercingly at him over a raised arm. One of her attendants has tugged back a red curtain

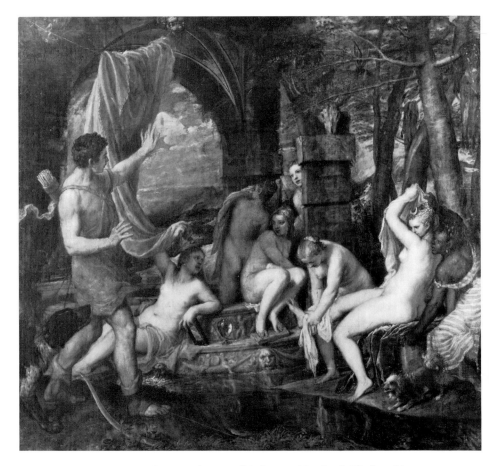

18　Titian, *Diana and Actaeon* (National Galleries of Scotland, Edinburgh)

to reveal her to him, and him to her. It reminds one of a red rag to a bull: it is a moment of fateful confrontation. Actaeon cannot escape now. The hook has been baited and he is caught. The man-eater has her prey.

Not content to show Actaeon as the innocent victim of a trick, Titian has taken pains to bait the hook with as much sexual flesh as he can load. The veil Diana raises to hide herself from his gaze alluringly reveals one breast. She is reclining on smooth red velvet. One foot is being washed and dried by an attendant as if in preparation for him. She crooks a toe invitingly, and in front of her is a mirror that has been held for her self-admiration as if she were the traditional figure of Vanity. Her entourage may be dedicated to virginity but in their every gesture they too exude coquettishness: one reclines as if on a bed; one peeps out at him from behind a pillar; another turns to display her bare back and buttocks; a fourth pretends to hide her breast but gives him a coy half-smile across a naked shoulder.

44

19　Titian, *The Death of Actaeon* ▶

This is quite the opposite of virginity helplessly paraded so that man feels it his right to take it by physical force: here is virginity armed with super-human powers and employed to destroy man by destructive guile.

But here Titian was very clever. Titian was a successful man painting for other successful men in a man's world (the picture was actually despatched to King Philip II of Spain, the artist's most prestigious client). We, the male spectators, are not Actaeon: we are expected to disassociate ourselves from him and therefore from his danger. It is not finally a picture about dangerous women at all: it is a feast of desirable flesh that has been spiced with a mere *frisson* of danger. We can enjoy the spectacle without having to suffer the consequences that are about to overtake the hero. To Actaeon Diana's look is supposed to be deadly; to us it is merely sexually provocative.

Once again, a work of art is seen to possess a crucial secondary meaning. Just as Murillo's soapy Virgins and Mary Magdalenes protest a virtue that is contradicted by their implied availability, so the virginal deadliness of Titian's Diana is contradicted by her implied promise of sexual sport. Before our eyes the goddess of hunting becomes *our* prey. And bearing in mind that men paint pictures for other men, here lies one of the most reassuring demonstrations of alchemy that art can perform: it can defuse danger. Art can itself be the instrument of control that man seeks to impose on the beast-woman. A painting is the shield of Perseus held up to Medusa.

All this makes the second picture, *The Death of Actaeon* (Ill. 19), the more compelling and more tragic of the two. Diana strides into the landscape

with one arm outstretched grasping her bow. She is no longer the white-skinned temptress but a well-muscled killer. The breast she exposes looks like careless haste, not sexual provocation. She is grim-faced. Her flighty attendants have gone, and so has the bright Venetian sunlight in which they bathed. A stormy autumnal glow touches the trees and the water like flames, and in his final moment of life Actaeon, already part-stag, raises an ineffective arm against the onrush of hounds who are already tearing at him. They are his hounds, what is more: Diana has nullified his authority, usurped it, and turned it against him. In a minute it will be all over. He will be like the stag's skull in the first picture, another of her trophies. If there is a secondary meaning to this painting then it is a caution-ary reminder to the male spectator not to cross powerful women. That breast is not for comfort or for play: it is more a breastplate than a breast – an addition to that armoury against which a man has no defence.

So, the beast in woman man must tame: he must exert his power over her. And the most ready instrument of male power over women is the penis. It is man's weapon: with it he can penetrate woman and subdue her. Sup-ported by his superior physical strength he can even impose it upon her against her will: he can rape her if he finds it necessary, not only subduing her but humiliating her too, and so become even more powerful. And yet, to be compelled out of fear to maintain such control is a frightening responsibility: what happens if the weapon should fail? Dreadful retribution follows. A woman may seize on his failure and usurp his power with weapons that are much more penetrative, much more deadly.

He may, of course, enjoy it. The nineteenth-century Romantic Movement – in literature as in art – was fuelled by the joyful sufferings to be had at the hands of women who had usurped man's power and turned it against him. The French poet Baudelaire could write, in *Les Fleurs du Mal*, 'There's not a fibre in my body keen / That does not cry: *Satan, I worship thee!*' The English poet Swinburne, another expert on joyful suffering, held that man's highest ambition should be to become 'the powerless victim of the furious rage of a beautiful woman'. The term 'masochist' dates from this period – from the Austrian writer Leopold von Sacher-Masoch, who was Swinburne's exact contemporary and whose stories and novels on the theme of men enjoying punishment by women brought a putrid glamour to the long tradition of the *femme fatale*. Freud, a generation younger, analysed masochism as an instinct more primitive in man than sadism: it was a willing submission to fate. And Freud located such cravings for punishment in deep sexual fears. Freud is awarded the accolades for having unveiled the subconscious and made us aware of its meaning and its power over us: yet a great many European artists who were Freud's con-temporaries without having access to his researches dwell with a disturbing frankness on the sexual nature of man's submission to deadly women –

Klimt, Munch, Von Stuck, Le Douanier Rousseau and Gustave Moreau among them. Freud was the analyst of what already lay revealed around him in paintings. All over Europe artists were wrenching from within them a terrified fascination for dominating women. In the troubled studios of turn-of-the-century Paris, Vienna, and Berlin, artists were setting down their nightmares; and out of the dark were emerging all the phantasms which Renaissance man thought had been tamed – the witches and vampires, sirens and sorceresses, Fates and Amazons. The beast-woman had only slept. Now she stirred again, and suddenly it was as if half the painters in Europe were clutching their genitals lest Mother Earth come along with a sickle.

Artists even embellished earlier painted images with meanings never originally intended. One of the most arresting works of art to come out of the French Revolution is the painting now in Brussels called *The Death of Marat* (Ill. 20) by the French artist Jacques-Louis David. Marat was a popular political journalist in Paris and a prominent member of the revolutionary Jacobin Convention. David, also a member of the Convention, was a right-hand man of Robespierre and a friend and political colleague of Marat. David was actually chairing a meeting of the Convention on July 13th, 1793, when the assassination of Marat was announced. David was promptly called upon to honour the popular martyr with a painting recording the event, which he publicly agreed to do. He hurried to the scene to sketch the murder as realistically as possible – accompanied, incidentally, by Madame Tussaud who made a wax model of the dead man's head.

David's painting, done immediately after the visit, has the shocking naturalism of an event witnessed and deeply felt. Marat reclines slumped in his bloodstained bath-water where he has been writing on a makeshift table. The dagger lies on the floor. A pen is still in his hand, the note he was writing still held between the limp fingers of his other hand. His muscular body lies across a white sheet splashed red. The scene is lit by a powerful lamp out of the picture to the left, but the light falls only on the scene of the crime: the background remains in murky, sinister darkness. The roughly nailed wooden crate which Marat has been using as a table bears the inscription 'À Marat – David', as if burnt in with a hot poker. Everything is starkly, brutally simple, undecorated. It is a picture that puts me in mind of all senseless political murders – of Gandhi, of Martin Luther King, of J. F. Kennedy, of Sadat. It is a painting which stands for them all.

What it is not, though, is about women. David saw this as a purely political assassination. Charlotte Corday was a fanatical supporter of the rival Girondins, and he did not even include her in the painting. It is this absence of the female element which makes it so revealing to see how two artists reinterpreted David's picture during the present century: Munch and Picasso.

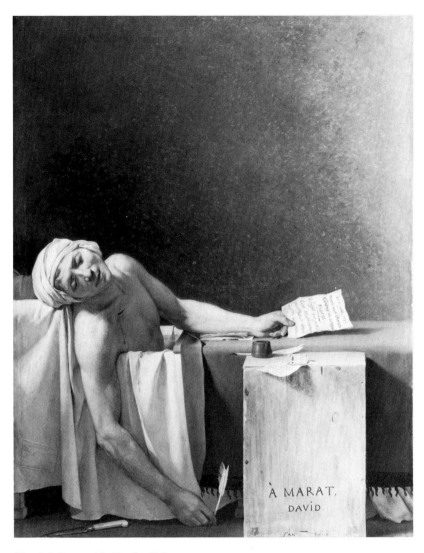

20 J.-L. DAVID, *The Death of Marat*

Both painters introduced the figure of the female assassin – naked! –
and both therefore transformed it into a sexual murder. Charlotte Corday
becomes a modern Judith, a Clytemnestra, a Diana, a Lady Macbeth. In
Munch's painting (Ill. 21), done in 1906, Marat lies on a bloodstained
couch. There is no pathos, no realism; he is scarcely a focus of interest.
All the artist's attention is transferred to the figure of the murderess stand-
ing in the full light in the foreground. She is impassive, rigid, bare. She

48

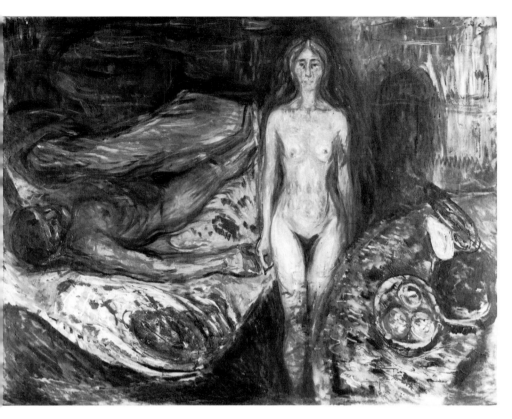

21 EDVARD MUNCH, *The Death of Marat*

is like all Munch's solitary female figures, a sentinel of menace. Her bait is the promise of joy, but her reward for man's attentions is his destruction. She is lethal because she is sexual.

Freud wrote that man 'has the habit of projecting his own inner feelings of hostility on to the outside world, that is, of ascribing them to whatever objects he dislikes, or even is unfamiliar with. Now woman is also looked upon as a source of such dangers and the first sexual act with a woman stands as a specially perilous one.' Munch's painting is an illustration of just how perilous that sexual act can be felt to be. But it is nothing whatever to do with the scene as described by David. Political tragedy has turned into sexual psychosis.

Picasso's version (Ill. 22), painted in 1931, pays rather more lip-service to the original than does Munch's. Certain details are recognisable, in a distorted and caricatured form – the bath, the slumped figure, the sheet, the blood, the scribbled note, even the darker background of the room. Picasso has managed to include a French tricolour, draped over the end

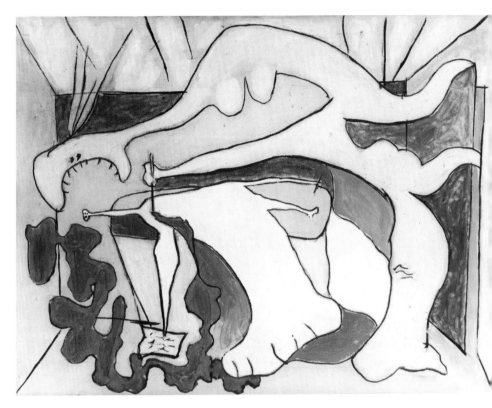

22 PABLO PICASSO, *Woman With Stiletto* (copyright DACS 1984)

of the bath, in what is presumably a spirit of political whimsy. So far it is not a particularly serious picture. But now look at what else Picasso has chosen to add. Here, wafting across the scene like some rattlesnake out of hell, is this manic female, all breasts and fangs, who plunges the dagger into Marat's heart while her teeth are bared to snip off her victim's tiny head as if it were a child's lollipop. All other elements in the painting pale beside this horrific confrontation. Picasso has turned the assassination of Marat into a painting about male belittlement: here a sexual battlefield in which the weapons are all female.

This was the moment in Picasso's life when his pictures became loaded with images of pain. They are about pain experienced, a kind of rape, but with the rapist female and the victim male: women's heads like man-traps gape and scream, mouths are bared to display jagged teeth, sometimes with a knife for a tongue. These are some of the most violent accounts of erotic warfare in the iconography of modern painting. Distorted and fragmented figures snap at one another in a tangle of mutilated limbs as if they are embattled land-crabs. *Figures by the Sea* (Ill. 23), painted in the same year

50

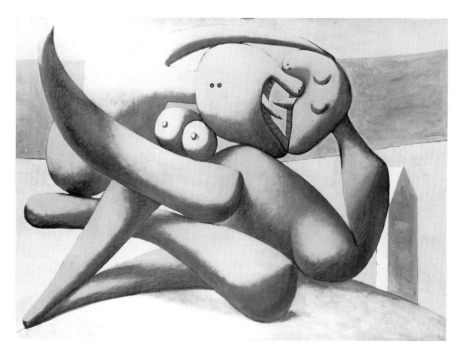

23 PABLO PICASSO, *Figures by the Sea* (copyright DACS 1984)

as the Marat picture, is the largest and most disturbing of this entire series
– disturbing because the seed of the idea must have been the sight of two
people embracing on a summer beach, and Picasso has turned a scene of
hedonistic rapture into a battle to the death between gigantic crustacea
cast up by some primaeval tide.

Picasso, as he so often does, lifts standard imagery from the lexicon of
European art and jolts us into reacting to it afresh. These paintings have
the effect of making us look again at all pictures of women brandishing
weapons. Art frequently conveys its meaning in metaphor: the bare truth
may be too naked for comfort. I can recollect no paintings of physical castra-
tion, but there are hundreds which mean precisely that. Women in art
who brandish swords, knives, stilettos, are employing male phallic weapons
usurped from men and turned against men – weapons, what is more, far
more deadly than the male penis because they are invulnerable, they are
made of iron or steel. In the Marat picture, Picasso gives us the sexual
metaphor twice. The stiletto plunged into the heart is the traditional
metaphor. Then he gives us the modern, Freudian metaphor too: the
woman's head with mouth gaping wide to bite is the vagina with teeth,
the *vagina dentata*, and Marat's own head (symbolically minute) stands for
the male penis about to be bitten off in the sexual act. Maybe he is also
thinking of the female mantis who consumes her mate as part of the sexual

51

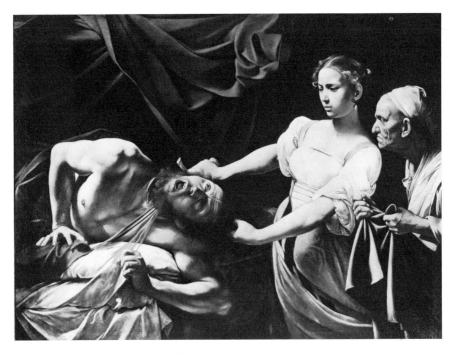

24 CARAVAGGIO, *Judith and Holofernes*

rite, or of the black widow spider who bites off her partner's head after intercourse: Picasso's imagination rarely encourages interpretations that are either singular or precise. He alludes, he draws analogies, he disturbs, and he leaves the rest to us.

What Picasso leaves us with is his re-statement of the great fear that has flickered in men's nightmares – the fear of destruction at the hands of voracious women. It is this fear which had sponsored innumerable paintings of Judith beheading Holofernes, of which Caravaggio's version (Ill. 24) in the Palazzo Barberini, Rome, is the most shockingly bloodthirsty. And the same fear is vested in paintings, just as numerous, of Delilah shearing Samson's locks, and of Salome bearing the dripping head of John the Baptist.

Salome's weapons, though, are not the same as Judith's or Delilah's or Charlotte Corday's. Judith uses her sexuality to exhaust Holofernes, and then brutally kills him. She is able to usurp male power unaided. Salome cannot. She can only use her sexuality to make Herod give her what she wants. Hers is power that derives from a man. It is pussy power: she dances, she entices, she seduces. And she dances in and out of Renaissance painting as a more enigmatic figure than Judith or Delilah, because it is not always clear what she is supposed to represent. It is either gratification or destruction, depending on whether the artist identifies with Herod or with John

52

25 GUSTAVE MOREAU, *Salome Dancing*
(copyright SDPMN/DACS 1984) ▶

the Baptist. Possibly it is this sinister ambiguity of role that makes Salome among the most popular of the dark goddesses to whom the Symbolist painters were drawn in the late nineteenth century, Gustave Moreau most of all. Moreau painted her again and again, invariably as the prototype of some Montmartre night-club vamp he may have peeped at or dreamed about. Her most seductive pose is in *Salome Dancing* (Ill. 25), where she snakes before us in a jewelled crown, a négligé embroidered with a lotus flower, and a black attendant beside her. At her feet rests a black panther – beasts obey her (just as they obey Diana); even beasts that are black, the colour of Satan. It is all heady stuff for a middle-aged bachelor who

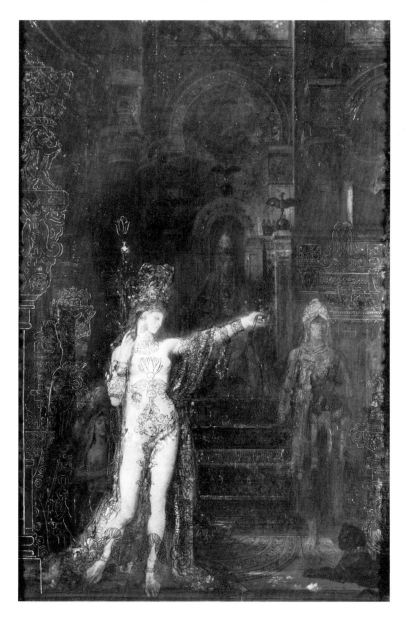

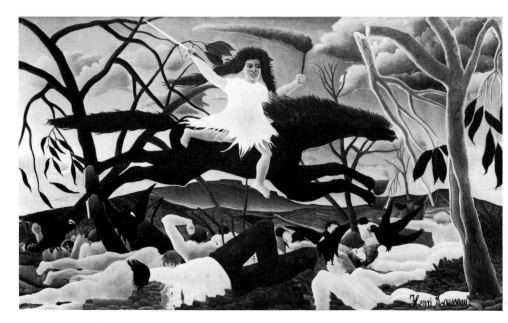

26 HENRI ROUSSEAU, *War* (copyright SDPMN/DACS 1984)

never said Boo to a woman in his life. His pictures tell us very clearly why.

Moreau's younger contemporary, Henri Rousseau, also had his dark goddesses. These are generally variations on the theme of the beast-woman – she charms snakes, she lies asleep next to a lion, she beckons creatures from the jungle: but in one painting she careers before us like an avenging angel. The painting is *War* (Ill. 26), and she is the deadly instrument of war, riding her black horse with sword aloft across a landscape of mutilated male corpses.

Artists have frequently painted the rampage of castrating women as a kind of hell on earth. But in mediaeval art the danger of the powerful sexual female is sometimes represented – or at least suggested – as hell itself. It is not unusual in early Christian painting to find hell depicted as the Greek mythological Hades, with Pluto and Persephone – King and Queen of the Underworld – seated in the mouth of Hades, which is often literally a mouth. In Homer, and widely in classical Greek art, Pluto is not simply King of the Underworld, he is also god of fecundity because he controlled the fertility of the Earth, his kingdom. The fusion and confusion of Greek myth with Christian ethic seems to have supplied this imagery with a chillingly anti-sexual and anti-woman bias never originally intended, so that the Greek mouth of Hades becomes a monstrous *vagina dentata*. The early Christian

54

writer Tertullian even refers to woman as 'Janua diaboli' – 'the gate of the devil'. In other words, Sex = Hell. At least, sex with a woman equals hell.

This equation between sex and Satan is drawn repeatedly throughout the Middle Ages, and although it loses some of its sulphurous fumes during the Renaissance it still surfaces in late-sixteenth-century England in the sonnets of Shakespeare. Sonnet 129 opens with the famous paeon to celibacy 'The expense of spirit in a waste of shame / Is lust in action . . .' Lust is 'murderous', 'bloody', 'full of blame', 'savage', 'extreme', 'rude', and 'cruel'; and the sonnet concludes with the unequivocal lament that 'none knows well / To shun the heaven that leads men to this hell'. A woman's vagina is the mouth of hell, no less!

I find myself peering into all this slime of misogyny for some just cause. It seems incredible that woman's sexuality – woman's love – should appear so horrifically menacing to men that it should have to be represented by bloody knives and tearing fangs. Why such a dung-heap of imagery to defame a woman's genitals? What is so wrong with sex, with love, that it should be so hellish? None of the conventional targets of blame – St Paul, puritanism, a celibate priesthood, male fears of impotence – seem quite substantial enough.

Perhaps the pathology of misogyny is too deep-rooted to invite rational explanation, and I should just accept that one half of the human race – my own half – has used the other half as a scapegoat for all the mess it has made of its power; that women have always been the dumping-ground for male rubbish because men have nowhere else to dump it. Yet, even while accepting that this may be so, I see another motivation for this Sex/ Hell equation floating on the slime, and a hint of it lies in another of the sonnets of Shakespeare – the Dark Lady sonnet (No. 144) that begins 'Two loves I have of comfort and despair'.

The theme is sexual jealousy within a triangular relationship between two men and a woman. Platonic love between men has been corrupted by heterosexual love: the poet's 'female evil' has tempted his 'better angel' from his side. He suspects they are making love – 'one angel in another's hell'. The female vagina as the mouth of hell, again! But there is more to it than moral corruption. Hell carries another meaning. The poet will only know if they have made love when 'my bad angel fire my good one out'. Shakespeare may have been thinking of hell-fire, but much more specifically he was certainly thinking of the burning fire of venereal disease – either *chaude pisse* (gonorrhoea) or St Anthony's Fire (syphilis).

One day somebody will have the art world reaching for its smelling-salts with a study of the effects of disease on the making of art. Paintings look so sanitised in the air-conditioned galleries of Europe and America; it is hard to put ourselves in the shoes of mediaeval weavers creating the enormous Apocalypse tapestry at Angers within a few years of the Black Death,

or of Grünewald creating the Isenheim Altar at Colmar so that patients dying of syphilis might prostrate themselves before it in their hell – just twenty-two years after Columbus' sailors had brought the disease back from the New World and spread it through the whorehouses of every port in Europe.

These are not today's experiences of art, yet they are among the experiences out of which, and for which, art has been made – and without which a great deal of art would not have been made at all. The diseases of love deserve to be taken into serious account when we consider the images of sexual fear and loathing which male artists have planted on women, just as the persistence in art of the platonic ideal of male love needs to be understood in relation to the hazards that attended love between man and woman. The sixteenth and early seventeenth centuries saw painters recounting with unprecedented realism the ravages of Judith and Circe, Delilah and Artemis, and this era coincided with the severest epidemics of syphilis in European history. Students at Padua, Italy's leading medical school, were being taught that the new disease was transmitted to healthy men by unclean women, no account being taken of the unclean men they caught it from. The presumed source of infection was soon extended from the genitals to the mouth and the breasts, so that all the main erogenous zones of a woman's body became sources of danger to men; and the Church was quick to fan the widespread fear by pronouncing that all this was a punishment visited upon women for being carnal. In short, venereal disease may not have been responsible for men depicting women's sexuality as hellish and lethal, but it certainly supplied the most painful endorsement of an already hysterical prejudice.

In comparison, the pin-up photograph of Rita Hayworth dropped with the atomic bomb on Hiroshima begins to seem quite playful.

4 *Sinners*

Man's retaliation to woman as a man-eater is to damn her as a sinner. Her sexual appetites threaten his manhood, his supremacy over her, even his life: therefore in self-preservation he must cast her out like a devil. She is bad. A sexual woman is a bad woman. In consequence she must be punished – preferably sadistically – though if man feels charitable she may escape with nothing worse than being raped, or prostituted, or enslaved. She may even, through man's great mercy, be forgiven.

The weapon enabling man to rise again from impotence to power is the unchallengeable authority of the Bible. The finger points at Eve – the first woman, pilot of man's downfall and disgrace. That original transgression permits any fault or flaw of character to be placed to woman's account; and the charge is unanswerable. A woman is . . . whatever man chooses to label her: she cannot deny it because there, first in her line of ancestry, stands Eve – guilty, naked, and ashamed.

Eve. How we have loved her, and loved her sin; have ogled her sinful body and leered at her shame. There would be no strip-clubs without Eve, no soft-porn movies, no girlie calendars, no book-shops for adults only, no rugger-club jokes, no Yorkshire Rippers. It is hard to imagine life without her. Who is she? Let's take a look at her.

In European painting, the first characteristic of Eve is that she is naked. She has to be naked, of course, since there was no clothing in the Garden of Eden, and nothing to be ashamed of about nakedness until the moment when she and Adam ate the fruit of the Tree of Knowledge. The question then arises, why should the very first gift of knowledge be an awareness of the shame of being naked, so that they 'sewed fig leaves together and made themselves aprons'? After all, they had neither of them committed any carnal sin: the Bible makes it clear that Adam and Eve had no sexual intercourse until after they were thrown out of the Garden. Sexually they were still spotless: the Original Sin they committed had nothing to do with sex at all – it was disobedience. So why should they be ashamed of their bodies? The Book of Genesis leaves this entirely unexplained. The only explanation must be a deep-rooted Hebraic tradition equating awareness of nakedness with sin – innocent nakedness, like a child's, is all right, but full adult knowledge of it is sinful. It is this tradition, sanctified by the Bible

at the very beginning of the story of man, then stoked and enflamed by the early fathers of the Church, which becomes the crux of moral teaching embedded in all Christian painting and indeed in us all.

So far the equation of nakedness and sexual shame seems to work indiscriminately for both man and woman. But it does not. Since the first disobedience was Eve's, not Adam's, it is inevitably she who carries the blame once that first disobedience is interpreted as a sexual sin. The accusation of lust is laid firmly at her door. She is the temptress, Adam the innocent dupe who trusts her and is led astray.

This is the Eve of countless mediaeval and Renaissance portrayals of the Temptation and Fall. She is the Eve of Van Eyck's Ghent Altarpiece (see Chapter 2), with the sullen face of a whore, lank stringy hair, and one hand covering her guilty vagina. And she is the Eve of a small panel painting in Vienna of the Temptation and Fall by another Flemish artist of the fifteenth century, Hugo van der Goes (Ill. 27). Here the tradition of regarding nakedness itself as shameful actually distorts the biblical account: Eve is shown holding an apple in one hand while she plucks another for Adam. Neither has yet tasted the fruit of knowledge, and therefore can have no knowledge of shame. Yet Adam has already placed his hand over his genitals (with the strained expression of a policeman trying to cover a streaker with his helmet), while a conveniently tall iris blossoms in front of Eve's vagina. Conceivably the artist was compressing two episodes into a single image; none the less the implication of fundamental naked shame is the one that carries most strongly to the spectator. And as if to cover the charge that this first transgression was the serpent's fault and not Eve's, Van der Goes, in common with many mediaeval and Renaissance painters, has given the serpent the torso and head of a woman – even though the Bible uses the generic 'he'. In other words, the original sinner was female, whoever you choose to blame.

This mediaeval tradition of equating nakedness with sin – and particularly female nakedness with carnal sin – is rooted in Hebraic thought and in the hysterical misogyny of the early Christian theologians. It is a tradition that is often pinned on to Protestantism, along with just about every other life-denying human trait. Unfairly so. Christian painting for churches is by definition Roman Catholic or Byzantine. Van Eyck and Van der Goes were both Catholics, as indeed was the most lurid exponent of fleshly sins – Hieronymus Bosch. All three artists were safely in their graves before Martin Luther nailed his protests on the church door at Wittenberg.

It is not a Protestant tradition so much as one that flourished wherever the non-Christian, classical tradition of the nude was weakest or nonexistent – in Northern Europe, in Spain, and (somewhat later) in the Spanish kingdom of Naples. In Central and Northern Italy, where the example of Greek and Roman art was most powerful, images of nakedness were invariably warmed by the classical tradition of the nude as an expression

58

27 HUGO VAN DER GOES, *The Temptation and Fall*

of ideal beauty. Here was a view of the naked body, male or female, quite at odds with Christian theology and its obsession with carnal sin. From the time of Masaccio (who was the Florentine contemporary of Van Eyck) the nude in Italian painting is rarely a metaphor of human shame, it is a confident expression of physical perfection: it is not unnatural, it is the most natural of all states of being. To be naked is not to be ashamed in Eden, it is to be in the company of the Olympian gods on Mount Parnassus.

This classical tradition, grafted on to Christianity, did not lend itself easily to expressions of physical disgust or leering prurience. Hence the relatively few Italian images of Eve. The art of Italy simply does not feed that kind of sense of sin. One of its miracles is that here, at the very heart of the Christian Church, pagan classicism managed to hold a warm-blooded supremacy over the flesh-hatred and misogyny of the Church fathers. The answer is, I suppose, that whatever the tone of theology, in practice the Roman Church prior to the Counter-Reformation was far from flesh-hating and woman-hating, and so in its moral laxity and corruption it performed a gigantic service to art and to the millions of us who enjoy it. If you want to ogle Eve, you go north, beyond the reach of Greece and Rome.

The primal sin of lust having been laid at Eve's door, it became easy to dump upon woman the responsibility for all manner of other sins and vices, each of them emanating from her supposedly indiscriminate appetite for sex. Again, the authority of the Bible justifies the harsh sentence man passed on her, and a potent example is the Book of the Revelation. One of St John's visions was of Babylon, the city of sin. His vision of Babylon was not of some urban cess-pit seething with corrupt and self-indulgent men and women all signalling their candidature for hell; the city was sym-bolised for the apostle by the single figure of a woman – the Whore of Babylon. Woman's sexual promiscuity was at the heart of it all. Eve's cor-ruption of Adam has spread like an infectious disease to encompass the corruption of an entire city.

The Whore of Babylon has exerted a strong impact on European minds largely through the services of art. The process is circuitous and strange. Because of the power of its imagery the Book of the Revelation was an important reference for moral teaching during the period of renaissant Christianity in the early Middle Ages once the pagan ravages of Huns and Goths, Norsemen and Moors, had been withstood. But most people could not read – except churchmen – and Bible teaching could only be effected through sermons and through images. In 776, at the height of the Moorish invasions of Spain, a Spanish monk and scholar called Beatus of Liébana produced a document designed to uplift the morale of Christendom. This was his celebrated *Commentaries on the Apocalypse*, which was an eluci-dation – a kind of de-coding – of the wild images of the Book of the Revela-tion, including of course the Whore of Babylon. The impact of Beatus'

document on the beleaguered Church was enormous, but only a few literates had access to it. Then, during the later Middle Ages, the first great wave of church-building threw up a need for striking moral images that could be carved on church portals and capitals, and painted around the walls, as simple aids to Christian teaching. So artists began to illustrate Beatus' *Commentaries*, and it was these vividly illustrated manuscripts which became primary sources of mediaeval church art. In this way the imagery of St John's visions became an everyday primer for illiterate congregations; and, along with 'Death on a Pale Horse', 'The Grapes of Wrath', and 'The Four Horsemen of the Apocalypse', 'The Whore of Babylon' became famous throughout Europe.

All Christendom became instructed that corrupt living was exclusively the legacy of this whore. This is how St John describes her.

> ... the woman was arrayed in purple and scarlet colour, and decked with gold and precious stones and pearls, having a golden cup in her hand full of abominations and filthiness of her fornication ... For all nations have drunk of the wine of the wrath of her fornication, and the kings of the earth have committed fornication with her, and the merchants of the earth are waxed rich through the abundance of her delicacies ... Therefore shall her plagues come in one day, death, and mourning, and famine; and she shall be utterly burned with fire: for strong is the Lord God who judgeth her.

When you consider that the Book of the Revelation was among the most passionately scrutinised moral documents of the Middle Ages, and among the most popular sources of church art, it is not surprising that the lustful propensities of 'bad' women became common knowledge, and the provocation of militant self-defence by men. This was the climate of male embattlement which led to nearly ten million witches being burnt in Europe during the Middle Ages on the grounds of liaison with the devil – a longer span of time than Nazism in Germany, but a considerably smaller population.

Art has treated the Whore of Babylon more gently than the written and spoken word, and it is not hard to see why. Among the most famous images of her is in tapestry, one of the gigantic woven panels that make up the late-fourteenth-century Apocalypse tapestry (Ill. 28) at Angers. Here she sits, 'the great whore that sitteth upon many waters' – the 'many waters' cleverly designed as wavy blue lines trapped in a series of what look like irrigation channels beneath her feet. The purple and scarlet robes have faded white with time, but the bright jewellery still ornaments a waist-band from which a long golden tassel dangles to below her knees, matching the even longer golden hair flowing below her waist. In her right hand she tends it with a comb, while gazing at herself in the mirror she holds in her left. She is hardly beautiful, but that is a limitation of the weavers' art: she is certainly appealing. And here demonstrated is one of the con-

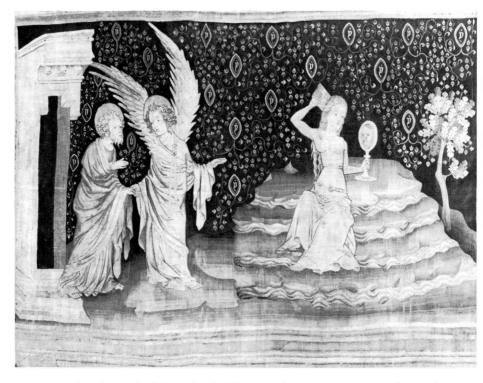

28　The Whore of Babylon: detail of the Apocalypse tapestry, Angers (copyright CNMH/DACS 1984)

tradictions of moralising art. The written word (like the Book of the Revelation) may rant against wicked women and how they corrupt whole cities with their fornication: but paint them – or weave them – and the moral outrage melts before the evidence of the eye. The Whore of Babylon, after all, has to look like a woman capable of leading 'the kings of the earth' and 'the merchants of the earth' to fornication: 'the abundance of her delicacies' has to be apparent or no one will believe the tale. But if she is appealing to kings and princes she will also be appealing to us, and we will envy the kings and merchants more strongly than we will condemn her actions. This is the Christine Keeler syndrome, and it makes hypocrites of us all.

So the designers of the Apocalypse tapestry did what artists generally do in such circumstances: they diluted the severity of the crime so that we might be more easily forgiven for desiring her. They turned the Whore of Babylon into the culprit of a relatively minor vice, Vanity. Throughout western art the female figure of Vanity is invariably just such a soft option. The artist invites us to pay lip-service to condemning her, while offering us full permission to drool over her. She admires herself in the glass, while we treat the picture that purports to incriminate her as another kind of glass – a window – through which we peer and secretly desire her.

Compare the Whore of Babylon (condemned to hell-fire for evil on a massive scale) with Memling's coyly seductive figure of Vanity (Ill. 29) (guilty of nothing worse than self-admiration) and with any modern pin-up of a girl gazing in a mirror (a bland object of erotic admiration), and there is no difference whatever between the three. The condemnation of art can never be the condemnation of the moral sermon because it is a sensuous medium and invites a sensuous response. A picture of an attractive woman remains appealing however strongly the artist may seek to disapprove of her – just as poisoned food does not look poisoned if you paint it. To this extent art is invariably a mitigating force in any moral condemnation of women.

On the other hand, by giving misogyny an acceptable mask it is frequently more insidious than the more open assault of the written word. Take a look at some of the women whom artists have enjoyed presenting to us as temptresses – daughters of Eve and heiresses of the Whore of

29 HANS MEMLING,
Vanity

Babylon: it is intriguing to speculate how many of them would strike us as temptresses at all were it not for the sensuous appeal their images offer us. Helen of Troy, obviously; likewise the Sirens, Calypso, Circe, and so on. But what about Angelica, the daughter of a king of Cathay who did nothing at all except meet the lecherous gaze of an impotent old hermit who cast a spell over her in order that he could undress her while she slept? What about Bathsheba, a soldier's wife with no record of infidelity or even flightiness, who found herself summoned to King David's bed after he had played Peeping Tom while she was washing herself? Or Susanna, another married woman caught bathing unawares and who became the victim of attempted blackmail by two men? And Danaë, shut away in a tower by her father to keep suitors off, only to be duped into sleeping with Zeus in the unscrupulous disguise of a shower of golden rain? None of these four – Angelica, Bathsheba, Susanna, and Danaë – is in the smallest degree a temptress according to their respective literary and mythological sources; but given flesh in paintings they most frequently become so. Their story offers artists a pretext for depicting them nude, and their nudity itself becomes a sexual provocation, both to the ravishers and Peeping Toms in the picture, and to us who gaze at them. So, while art may dilute moral condemnation of women by emphasising their erotic appeal, by the same means it creates sinners where no sin exists.

Danaë is one such sinner created by art. The Greek myth of her adventure with Zeus, retold by the Latin poet Ovid, is clearly inclined to arouse sympathy for the girl rather than for the randy and deceitful god; so much so that she became widely quoted in the Middle Ages as a symbol of chastity, even as a prefiguration of the Virgin Mary since she was a virgin impregnated solely through divine intervention.

But look at how she is treated by painters. The first artist to tell the story of Danaë seems to have been Jan Gossaert (called Mabuse), who was a Fleming, in a picture dated 1527 now in the Alte Pinakothek, Munich (Pl. II). Gossaert had visited Italy and become interested in classical subjects, and he was responsible for introducing these themes to Flemish painting. What Gossaert did not bring back from Italy was the classical tradition of regarding the nude as an image of perfection and divine beauty. His art continues to reflect the northern tradition of Van Eyck and Van der Weyden, in which the naked female form is invariably tainted with sin. Gossaert's Danaë, pretty and appealing though she is, bears this indelible stain: in fact this is precisely why she *is* so appealing. She is intended to look wicked, and this is the way we are invited to look at her – as a temptress. She has bared her breast to catch the golden rain, knowing perfectly well it is a lover in disguise. Her legs are parted, her eyes raised, her mouth puckered, her nipples hard. She is a girl about to do something she ought not to do: she is naughty. Gossaert is pretending to censure her while inviting us to be her lover, her Zeus, her god.

The transformation from figure of pathos and chastity (which Danaë was in myth) to sexy little tart (as she is in this painting) may seem like an isolated case of trivialisation, and nothing is easier than to admire her pretty young body and bother no more about it. But there is more to it than this. Gossaert's picture demonstrates how painting, because it is a sensuous medium practised by men for other men's pleasure, has this propensity to impose a view of women quite at odds with the stories it illustrates. The Danaë legend – like the legends of Angelica, Susanna, and Bathsheba – is about male lust. The vast majority of paintings that illustrate these legends are about female lust. What painting does more than any other art form is to bring to the surface a male conviction that all women want is a man's penis; that all their tragic predicaments and virginal weepings are a sham, and that Zeus or King David were really doing them a good turn by leaping upon them – sentiments which Renaissance painters share with quite a few twentieth-century judges presiding over rape cases. Reproductions of Gossaert's picture might be usefully handed out to the British judiciary as illustrations of the rightness of its view.

It seems a perfectly reasonable view, what is more, looking at this pert figure of Danaë so obviously enjoying what is coming to her from heaven in a shower of gold. Man's eyes can be guaranteed to regard her with warmth and pleasure, at least so long as he feels like being bad. On the other hand, the moment he decides to be good again, her fortunes will change dramatically: the same little lady warm with sex will find herself spitted by demons and with a toad on her vagina in the torture-chambers of another Flemish painter and contemporary of Gossaert, Hieronymus Bosch.

With the greater confidence of the classical tradition of the nude, Italian painters treated Danaë with a refreshing absence of the Flemish sense of sin, and treated her more stylishly. Titian used her for one of his most dignified displays of flesh, now in the Prado. There she lies awaiting her Olympian lover with that cow-like passivity the artist favoured in women about to receive male attentions.

Less well known is Correggio's version (Pl. III) in the Borghese Gallery, Rome. There is none of Titian's heavy-fleshed calm about Correggio's Danaë. She is pert and sprightly, positively wriggling with excitement on her couch of cushions, her eyes fixed on her parted thighs which a winged Cupid (to make it seem like true love, not rape) is hastily unveiling for her visiting god. Two more little *amoretti* play with Cupid's arrows by her bedside. How sweet and coquettishly stupid it all is. I gaze at it, then turn to Kenneth Clark (*The Nude*) to see what his lordship has to say about it: 'incredibly *dix-huitième*, and late *dix-huitième* at that . . . with her rococo complexity of movement and subtlety of expression'. How the perfumed handkerchief of scholarship does flutter in front of art, particularly sexy art.

Not every painter turned Danaë into a sexual candy-bar. At least, not

quite every painter: Rembrandt (Pl. XXI), as usual, saw both sides of the argument – saw what it might have felt like to be Danaë as well as why Zeus desired her. But I shall keep Rembrandt in reserve until the end of this book: he does not belong here among the confectioners. Gossaert's and Correggio's vision of the pretty little coquette is the one later artists latched on to. Tiepolo painted her in the eighteenth century like a *poule de luxe* reclining under a shower of gold coins tipped over her by a randy Zeus waiting his turn on a cloud. Then at the end of the century an absurdly self-important French Academician called Girodet emphasised the whore image even more strongly by having her actually gloat over the gold, and added a mirror in her hand so that she could be not just a beautiful prostitute but a figure of Vanity too. Finally in the Vienna of Freud Gustav Klimt made no bones at all about her motivations by having her masturbate in her sleep, fingers tensed in orgasm and gold cascading like semen between her legs.

It is a revealing degeneration of a myth. From symbol of chastity and prefiguration of the Virgin Mary, Danaë becomes by degrees a flirt, a whore, and a sensualist. The shower of gold which begins as a rapist's disguise becomes a client's payment and finally the actual sperm of love. What the transformation reveals, and which perhaps nothing is capable of revealing quite so nakedly as art, is the male proclivity to reduce all female predicaments to a hunger for sex – give her a mind-blowing orgasm and she will be perfectly all right. All of which, of course, is 'incredibly *dix-huitième*, and late *dix-huitième* at that'.

The biblical story of Bathsheba has undergone a very similar transformation in the hands of painters. The tale occupies less than one chapter of the Book of Samuel, and concerns a disreputable episode in the sexual life of King David. During a lull in one of the interminable wars fought between the Israelites and neighbouring tribes, David went up to the roof of his house and from there saw a beautiful woman washing. On inquiry she turned out to be the wife of one of his most loyal soldiers. Undeterred, David sent for her, took her to bed, made her pregnant, and promptly arranged for her husband Uriah to be killed in battle. He then married her, and in due course Bathsheba become the mother of Solomon. The Lord, not surprisingly, was 'displeased'. Artists have been less censorious.

The abject passivity of Bathsheba is consistent with all 'good' women in the Bible: it is only the 'bad' ones like Delilah who show any capacity to act of their own initiative. It is the long-suffering passivity, in the interests of being mother of Solomon, which elevated her in the eyes of theologians: in the Middle Ages she was seen as a symbol of the Church itself. The mediaeval Church also found it easier to forgive David than God had done, discovering in him a prefiguration of Christ himself: needless to say, had the roles been reversed and Bathsheba acted as David, she would have been condemned as a murderess, mother of Solomon or not.

66

Emphasis on the divine goodness of Bathsheba began to alter – as with Danaë – the moment artists began to take over the role of interpreters, rather than mere illustrators of mediaeval texts. Again, what provoked the change was the ingredient of male lust in the story. As with Danaë, lust gradually became transferred from the man to the woman. This was easily accomplished by concentrating on the moment when David espied Bathsheba bathing. At first, painters played down her role as sexual temptress by depicting her clothed. But by the seventeenth century her clothing was beginning to slip. In the 1630s Rubens (Ill. 30) painted her full-breasted and bare-thighed, jewellery entwined around her wrist and a hand-maiden combing out her golden hair. She is seated in full display in the forecourt of the royal palace, leaving us in no doubt whatever that her purpose in being here is to catch the eye of her ruler. She turns her head to receive David's letter with the mischievous expression of a scheming woman whose plot has worked. The message of the painting could hardly be clearer: what else could little David have done going frantic up there on the roof, and

30 PETER PAUL
RUBENS, *Bathsheba*

31 SEBASTIANO RICCI, *Bathsheba Bathing*

would not every man with balls have done precisely the same? How can
a man be expected to be good if a woman behaves like this? The only hint
of impropriety is the wild-eyed expression on the face of the black servant
delivering David's message, as if he alone were aware of what is really
going on.

Perhaps for this reason later artists frequently suppressed the messenger,
or left David's initiative out altogether. In this way full responsibility for
the seduction rested on Bathsheba herself. Again the exception is Rem-
brandt, whose Bathsheba in the Louvre (Ill. 107) shows her grasping the
note as if it were a tragic document, the expression on her face eloquent
of a fate she feels powerless to avert. In this face we know that her marriage
and her personal happiness are over; that from now onwards she is to
be the possession of a king and the mistress of history. Rembrandt's is a
tragic statement; most artists interpreted the story as striptease. In the early
eighteenth century the Venetian painter, Sebastiano Ricci (Ill. 31), painted
Bathsheba as a wealthy sex-pot. Instead of Rubens' solitary attendant, she
now has five, one of whom holds up Vanity's mirror while others hover
around with jewel-cases, perfume-jars, silks, flowers, and all the rest of the

68

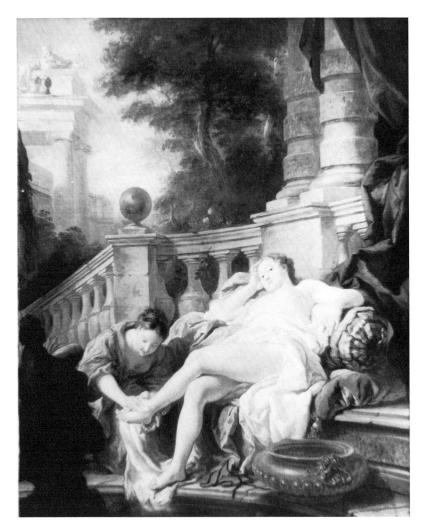

32 JEAN-FRANÇOIS DETROY, *Bathsheba*

paraphernalia of seduction. So insignificant is the messenger bearing the note from King David that for some time the picture was understandably taken to represent the Toilet of Venus. Bathsheba's metamorphosis from bride of history to woman of pleasure is completed by the account of her left by the French eighteenth-century specialist in amorous subjects, Jean-François Detroy (Ill. 32). She lies slumped upon cushions on the steps of a summer-house, one hand supporting her head heavy with boredom while down at the far end of her leg a maid dabs a foot. She gazes at us with the sour contempt of one who knows we cannot pay her price: the man

who can pay, David, is nearly falling off the roof to get a better look. This is not a painting about myth or history, or about tragedy, certainly not about love. It is quite simply about sexual purchase, the price of a woman.

The transfer of responsibility for lust from men to women made the aphrodisiac frivolities of eighteenth-century painting possible, and only the most dour killjoy would wish it all assigned to the rubbish-tip. But because it is a male attitude of mind it has also had some horrifying manifestations in societies less light-headed than the court of pre-Revolutionary France and the Venetian palaces in the twilight of the Republic.

In turning woman into temptress man confers on himself two rights – to enjoy her if he pleases, and to punish her if he pleases. Detroy's Bathsheba, parading her sensuality before an excited King David, is one face of the coin. On the reverse she becomes one of that regiment of harlots being dragged to damnation on scores of mediaeval and early Renaissance altarpieces set up to teach congregations the consequences of their sinful lives.

There is never any question about who is to blame in these paintings. Rogier van der Weyden's altarpiece (Ill. 33) at Beaune of the Last Judgment, painted in the mid-fifteenth century for the Chancellor of Burgundy, illustrates this distribution of blame most eloquently. In the central panel St Michael holds the scales of justice. Two symbolic nude figures await the outcome below. On the side of the 'virtues' a man raises his hand in salutation: on the side of the 'sins' the figure raising hands in supplication is a woman. And in the right-hand panels we see her dragged away by her locks – a profoundly sado-erotic image which we are invited to lust over even as we condemn her. Her loose veil of hair is tugged by a male hand towards the daggers of flame that pierce the rock around her; her whole body is tensile and writhing, jabbed by those same blades of fire. In fact the punishment of damnation is described as a kind of rape. Cast as temptress by man, she has been enjoyed by man, punished for it by man, and now in her pain of hell she is enjoyed vicariously once again; while from a po-faced figure of Christ in Majesty flows an inscription taken from St Matthew's Gospel which makes the judgment on her seem utterly impartial, 'Depart from me, ye cursed, into everlasting fire, prepared for the devil and his angels.'

The equation of damnation with rape requires an insidious and circular argument. As the daughter of Eve woman is always the temptress. She gratifies man when he feels like being bad. For this she must be punished, and her punishment becomes a reiteration of her role as a carnal being, except that now she gratifies the devil. But what is the devil if not the reincarnation of the bad man she has gratified on earth? In this way man enjoys it both ways by being alternately her gratified victim on earth and her punisher in the after-life: the pleasures he obtains from her are thus

70

I HIERONYMUS BOSCH, *The Garden of Earthly Delights*: detail

II JAN GOSSAERT (MABUSE), *Danaë*

III Antonio Correggio, *Danaë*

IV MAX ERNST, *The Robing of the Bride*

V RENÉ MAGRITTE, *Rape*; Menil Foundation Inc., Houston, Texas, © ADAGP, Paris, 1984

33 ROGIER VAN DER WEYDEN,
central and right-hand panels of
Last Judgment altarpiece, Beaune
(copyright CNMH/DACS 1984)

unceasing. And it is here that works of art function to male advantage particularly effectively. In hell man may apparently be enduring a mayhem of torments: punishment has to be seen to be served to all sinners. Yet so long as woman is there too, nakedly fondled by toads and by slithery black fingers, it is the demons and torturers with whom the male spectator is invited to identify. The bad human male who enjoyed her on earth merely becomes the bad demon – the fallen angel.

The picture which elaborates on this morality more vividly than any other was painted by a Flemish compatriot of Van der Weyden half a century later, Hieronymus Bosch. This is *The Garden of Earthly Delights* (Pl. I), the most celebrated sexual phantasmagoria in European art. The right-hand panel of Bosch's altarpiece describes the holocaust of hell in which human sinners are tortured everlastingly with the instruments of their own debauchery. And here in this zoomorphic torture-chamber is the same sado-erotic image of a young woman. Naked, with eyes closed, she lies slumped at the foot of the devil's chair. On her breast clings a black toad – sign of a witch, colour of the devil. Next to her sits a black demon whose four-fingered claws are pressed round her body, one claw on her belly, the other under her breast. If she were to open her eyes she would see her own face reflected in a mirror. The mirror tells us her sin: it is Vanity. No worse than that: the same mirror of self-admiration that eighteenth-century artists were to offer as a glamorous accessory to Danaë and Bath-sheba who were not sinners at all, merely beautiful women desired by men. But in the climate of mediaeval misogyny a peccadillo becomes a deadly sin. Her punishment is to contemplate her own face distorted in a convex mirror that is embedded in the backside of a kneeling monster, while another monster caresses her body. In hell she is the passive recipient of attentions which on earth her beauty invited.

If this seems harsh punishment for nothing worse than vanity, look at her role in the main central panel of the painting. Here is the real world represented as a delicious pleasure-garden, a psychedelic holiday-camp in which the human race indulges freely in all those debaucheries for which it is soon to be tortured in hell. *The Garden of Earthly Delights* is a celebration of the joys of sin; and one sin over-rides all the others. It is Lust. Bosch is obsessed with Lust. He was an artist who very clearly perceived what it took Freud four centuries later to articulate in words, which was the primacy of the sexual drive in man's pursuit of his aims. Freud called it the 'libido', and he saw it as the driving force most likely to be blocked by the repressive forces of civilisation, hence its emergence in all manner of deviant forms including that form of sublimation we know as Art.

Bosch not only seems to have understood what Freud called the 'libido'; he also experienced as a painter the effect of society's repressive forces upon it. His sexual fantasies in *The Garden of Earthly Delights*, and in other altar-pieces he painted, are the result. The High Command of those repressive

forces in Bosch's day was the mediaeval morality of the Roman Catholic Church. But Bosch himself, at the same time as giving the most vivid expression to the 'libido', was also an employee of that Church and a mouthpiece of its morality. He perceived the primacy of the sexual drive, and he condemned it. All the mediaeval obsession with nakedness bubbles over in this picture; all the horrified fascination which celibate churchmen have felt for the naked state; all that moral control which sought to define the virtuous man as the one who can do without sex. St Paul's admonition '. . . if ye live after the flesh, ye shall die' positively thunders out of the painting at us. And who is to be blamed for this over-riding sin of lust that fuels all other sins? Look again at Bosch's central panel: it seethes with pert naked females stretching their white limbs like amorous stick-insects and revelling in their role as temptresses. We are back to the Original Sin of Eve, the sin which was disobedience but which the Church always interpreted as sexual temptation. Here she is in the left-hand panel of *The Garden of Earthly Delights*, still in her innocence but not for long. Here in the central panel are all her daughters fulfilling their destiny as corrupters of man. And here in the right-hand panel is the havoc she wrought and her punishment – the devil's rape.

So, though that punishment appears harsh for a mere figure of Vanity, she is intended to be seen as responsible for all the debaucheries on earth. Her sin is her sex, and her punishment is the violation of that sex: she is raped by a demon who is also the demon in all the men who gaze on her.

Fifteen hundred years of Christian misogyny lie behind this painting – of fear masked as contempt, self-doubt as self-righteousness, lust as blame. Such utter psychic confusion. I am reminded of St Augustine of Hippo's prayer: 'Give me chastity – but not yet.'

The devil's rape was a form of punishment belonging to a particular mediaeval morality, and it presents itself in European painting only so long as art functions as propaganda for that morality. In southern Europe this was prior to the rise of humanism in the thirteenth century: in the north, where hysterical denunciation of women by the Church was much more vigorous, it lasted considerably longer, and was kindled again in the sixteenth century by the purging spirit of the Reformation.

The rise of humanism in Italy, and the rediscovery of the non-Christian civilisations of Greece and Rome, opened up to painters the treasure-store of classical mythology. Here were rapes galore: gods and demi-gods, kings and princes, warriors and satyrs – they were at it continually. To a culture sodden for more than a thousand years with Christian misogyny, here was a cornucopia of fresh themes in which women were punished for their beauty and for the lust they aroused in men. What was more, the classical myths carried one enormous advantage over stories of Christian judgment

and hell-fire, both to the painter and to the men who commissioned paint-ings: they were entirely free of male suffering and male guilt. Instead of the devil's rape, it was now possible to present rape as healthy sport. Man could violate woman and be a hero. He was not in hell, he was in Arcadia. His manhood was not downtrodden but uplifted. He could be the sun-god Apollo pursuing nymphs into the sunset: he could be Zeus masquerading as a satyr, a bull, a swan, a cloud, in order to ground his prey: he could be Hercules and have fifty virgins in a single night: he could be Priapus equipped with an organ of gigantic proportions.

The discovery that rape was a sport, and the rapist a hero, gave European painting a massive injection of vitality. Woman as temptress was no longer confined to a string of emaciated daughters of Eve being herded into hell, or sallow virgin martyrs signalling their purity with raised eyes. Now that the sport was on, there could be a handsome feast of flesh. It could be Lucretia, a virtuous wife, raped by the son of the Roman tyrant, Tarquin. Or Europa, daughter of the king of Tyre, raped by Zeus as a bull while she played by the seashore. Or Proserpine, daughter of the corn-goddess, raped by Pluto while she was picking flowers in a meadow. Or Io, daughter of the king of Argos, raped by Zeus as a cloud. Antiope, wife of the king of Thebes, raped by Zeus while she was sleeping. Or Leda, wife of the king of Sparta, raped by Zeus in the form of a swan. Here was a rich store of possibilities. If artists wanted a good chase there was also the nymph Daphne, the one who got away, pursued by Apollo until rescued by being turned into a tree. If numbers were called for, there were Diana's virgin nymphs, always ready prey for marauding satyrs. And the daughters of Leucippus, raped by the twins Castor and Pollux, themselves the progeny of Zeus' rape of Leda. Or, if really large numbers were required, then there was every artist's favourite gang bang, the rape of the Sabine Women by the young men of Rome.

With such plentiful sport, not surprisingly the very word 'rape' has lost all sense of outrage in connection with pictures. And so, you may say, it should, art not being about that sort of thing at all, but about . . . well, we all know – don't we? – we art-lovers. It is about beauty, about harmony, colour and line, form and composition, brush-work and chiaroscuro, life-symbols, inner meanings; about universal things, eternal things – every-thing that makes us feel so cultured.

Certainly, our scholars and critics – even the best of them – find it hard to write about 'rape' pictures as though they were about rape at all. Pro-fessor Kerry Downes, writing about Rubens' *Rape of the Daughters of Leucip-pus* (Ill. 34), describes the scene as an 'abduction which resulted in marriage'. 'Romance, not violence, is the key-note,' he goes on. 'The group is composed like a free-standing sculpture, isolated in space by the low hori-zon and distant landscape, and touching the ground only at a few points of balance . . . the group is no less securely woven into the picture surface,

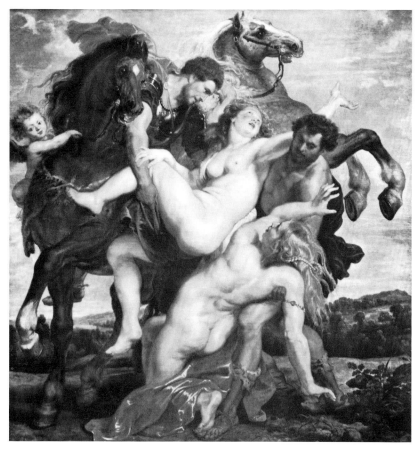

34 PETER AND PAUL RUBENS, *Rape of the Daughters of Leucippus*

for under the marvellous free pattern of figures lies a lozenge superimposed on a rectangle.'

This is the language of analysis, appropriate perhaps to a man who has made Rubens the subject of study for thirty years. What is said is perfectly valid, and may contribute to an understanding of the formal qualities of the picture. But it might just as well be a still-life.

An alternative to the cool language of analysis is the sweet language of perception. Here is Professor Frederick Hartt on another 'rape' picture, Correggio's *Jupiter and Io* (Ill. 35): 'The contrast between the soft, trembling warmth of Io's flesh and the mystery of the attack from the cold yet divine cloud increases the startling intensity of what is clearly a representation of sexual climax – one of the most vivid ever painted, and yet so frank, so open, so direct, so real, that it cannot conceivably be classed as pornography.' And Kenneth Clark on another Correggio 'rape' picture, *Jupiter and*

35 CORREGGIO, *Io Embraced by Jupiter* (*Jupiter amd Io*)

Antiope: 'as our eye follows every undulation it passes refreshed from shadow to light. The arm on which she rests her ecstatically sleeping head is clouded with shadows and reflections. Every form has the melting quality of a dream.'

There is nothing actually wrong with any of these three statements. It would be an easy matter to turn up a thousand publications on European painting and find several thousand other such statements with which there is likewise nothing wrong. But the language of art history is the language of connoisseurship: its evaluations are invariably within the unquestioning acceptance of a culture. It is what it does not say, does not question, that is the weakness of art history. Writing about the nature of a culture I find myself aware that the museums of the world could be hung exclusively with pictures of women being tortured and raped, and the language of scholarship would remain the same. Why our civilisation has produced these pictures, and why we continue to revere them – this is forbidden territory too uncomfortable to trespass upon, and perhaps too dangerous. Pillars of culture might be shaken, and experts whose sense of security rests upon that culture might get hurt.

In terms of painterly skills the 'quality' of these three pictures is not in question. The Rubens is among the most sumptuous examples of flesh painting in all art: this harmonious tangle of figures piled up in front of us is a triumphant Baroque balancing act which evokes instant admiration from any audience familiar with the course of European painting since the High Renaissance. To stand in front of it in the Alte Pinakothek, Munich, is like facing an altarpiece raised to the god of flesh. To the layman it invites astonishment, awe, suspension of disbelief; to the student of art history it must also invite huge respect because it is impossible to imagine any painter performing this feat more skilfully.

Yet, all the niceties of connoisseurship cannot hide the fact that it is also a picture about rape. Rubens' *Rape of the Daughters of Leucippus* (sorry, 'abduction which resulted in marriage') is an outstanding example of how the conventions of art allow the skills of a great painter to make an ugly act seem beautiful, and thereby lodge in our minds the view that the act itself is beautiful – that rape is fair sport. The first convention is that the two daughters are naked in life. But this is not life, it is art: Rubens has borrowed the classical tradition of the nude, in which nakedness was an asexual expression of perfection, and has used it for a sexual purpose. He has wanted to show us why Castor and Pollux felt compelled to carry these women off. In doing so he has absolved the men altogether by turning the women into voluptuous temptresses who get what they deserve. And to absolve us from any inclination we might have to pity them, Rubens makes them collude in the whole enterprise by putting up a purely token resistance while their faces show that they are enjoying every minute of it. Here the second convention comes into play. Holding the reins of the

rapists' horses are a pair of angels. Since the traditional role of angels in European painting is to escort souls to heaven, their appearance here can only be to endow this cheerful escapade with the moral blessing of the Church. In other words, everyone can feel perfectly all right about it – the two women are temptresses; they get the treatment they ask for; Castor and Pollux are only doing what every virile young man would do; and God gives it his benison. Now we can get on with admiring it as a splendid piece of painting.

Rubens marks an important stage in the treatment of rape in paintings. Previously the sport of rape had on the whole been private. It had even been tender: Correggio's Io, for all the absurd conceit of a woman being sexually embraced by a cloud, is actually about orgasm. Correggio's Antiope is likewise private: a voyeur's vision of a naked woman lying asleep. Even Titian parades his ravished Europa with the discretion of a few clothes to render her a little less culpable. But with Rubens it becomes a field-sport, and after him there is no looking back. J.-L. David's vast *Rape of the Sabine Women*, painted at the end of the eighteenth century, ennobles the exercise of a heroic male feat of arms. In the early nineteenth century Delacroix, in the *Abduction of Rebecca*, turns it into a blood-sport, the victim swooning away as male muscle bears her off amid the gun-smoke and massacre of battle. The very notion of rape has become synonymous with deeds of male glory.

After all this mindless posturing that sought to elevate the male libido to the status of hero, twentieth-century rapes in art possess at the least the virtue of psychological honesty. Picasso's view of women could be fecklessly varied, but was invariably consistent in its two extremes. A woman was either a creature of divine loveliness to be worshipped, often impotently, or she was an object inviting sadistic rape. In the latter category come his *Minotaur and Nude* series of coloured drawings, done in 1933, which suggest brutal pastiches of Rubens, or alternatively Rubens without the wink of respectability. Six years later Max Ernst created one of the most disturbing and cryptic modern images of violation, *The Robing of the Bride* (Pl. IV). The central figure of the woman is hooded with the mask of an owl, symbol of wisdom, bird of the night, while nestling above her exposed breasts grins the reptilian-like head of a demon strongly reminiscent of those toads which mediaeval artists painted on women's bodies as the sign of a witch. Temptress, daughter of Eve, whatever she may be, the punishment for her sexuality is quite clearly denoted by the priapic arrow aimed straight at her vagina. Cupid's arrow has become an instrument of sexual violence.

Even more disquieting is the series of paintings which another Surrealist, Magritte, made with the title *Rape* (Pl. V) during the '30s and '40s. They are all variations on a single visual pun, which is that a woman's naked body duplicates itself as her face. The first impact is one of shock – that

soft breasts should become bulging eyes, the belly-button an absent nose, the genitals a mouthful of hair. Soon it becomes clear that what is violated is not the woman herself but the spectator's association of nakedness with physical beauty and sexual desire. Here is nakedness presented in so uncomfortable a form that it arouses shock and disgust too. It is an image which unlocks a Pandora's Box of male fears and revulsions, awakening a response to woman's nude state not unlike the response evoked by those early sado-erotic representations of Eve and the Whore of Babylon. It is the re-awakening of the male sense of sin, the burden of which is transferred to the naked female body. With Magritte's *Rape* the wheel of misogyny has turned full circle.

In painting, the urge to punish women for their dangerous sexuality is usually masked. Because one of the primary functions of art is to give pleasure to the senses, fear and hatred of women often masquerade as appreciation, even as love, certainly as desire. Gossaert's *Danaë* (Pl. II) does not look like a picture about punishment; neither does Ricci's *Bathsheba* (Ill. 31). Both of them are. Just occasionally there have been moments in history when the moral climate has invited expressions of quite open hostility towards women in painting, and invariably these have been moments when men – the ruling element of a society – have felt under the most enormous pressure, and have needed a scapegoat so badly that it could not be hidden, even in art.

Late-nineteenth-century England is a heavyweight example. For men of the ruling classes here was a period of unprecedented wealth, unmatched moral self-righteousness, and unparalleled sexual hypocrisy. Only bad women were supposed to enjoy sex: good women closed their eyes and thought of the Empire. Good men venerated the good women as goddesses and guardian angels: bad men went a-whoring. But of course they were the same men. The pressure on them was colossal because in this society of such vaunted virtue the only kind of sexuality that could be enjoyed by men was dirty, sinful. This was what desirable women were. Victorian men tried to disperse this pressure through elaborate codes of social behaviour which distracted the mind, and an infinite clutter of possessions which distracted the eye: none the less the art they bought in huge quantities and at huge prices precisely mirrors their dread of the sexuality of women and their need to despise and hate women who possess it. Whether it pretends to be about woman's naked purity, or whether it is about prostitution and slavery – two areas of which nineteenth-century artists were inordinately fond – Victorian painting is to an enormous extent obsessed with defilement. It enshrines the misogyny of fear.

In our own century the art of Weimar Germany, between the two world wars, reflects a more brutal hostility towards women – a hostility never sugared with adoration in the manner of Victorian painting. Nowhere in

36 OTTO DIX, *Three Women*

art are expressions of physical disgust so frank as the prostitute pictures
of Otto Dix (Ill. 36). They reek with hate, and they reek with self-hate
because the military, economic and moral collapse of the German nation
had been a male responsibility and a male failure. This is the unbearable
pressure upon men. Men rule, and they have made a mess of it. Women
have become the scapegoat: in a society where there is no gain women
can still profit. Their revolting appearance matches the corruption of the
trade they ply. That men should pay to enjoy such dugs and bellies is a
measure of their own willingness to be corrupted. In this modern Babylon
there is still a Whore of Babylon to take the blame.

In the background of these modern chimaeras rises a spectre which more

than any creation of man's imagination has identified the male horror of woman's sexuality let loose – and that spectre is the witch. We do not burn women any more, though the most abusive language a man can use pays tribute to the enormous threat her sexuality still poses: 'fuck off', 'screw you', 'cunt', 'get stuffed'. But for centuries witch-burning was customary; it received the blessing of the Church and was indeed instigated by the Church – the same Church that commissioned altarpieces we revere as masterpieces of art.

Some twenty years before Hieronymus Bosch painted *The Garden of Earthly Delights* (Pl. I) he had made another altarpiece – likewise now in the Prado Museum, Madrid – called *The Hay Wagon* (Ill. 37). When folded, it shows a figure of Everyman wandering through this world of sin. Unfolded, the altarpiece reveals the cause of this sin (Eve, naturally), then its manifestations in the form of a rabble surging round a hay-cart, and finally the punishments meted out in hell. Here in this final panel is the familiar landscape of torture, with zoomorphic demons subjecting humans to an eternity of pain; and in the centre of this holocaust is the prone figure of the prime cause of it all. Her arms are bound behind her, and a demon reaches down to hoist her to her fate. She lies naked except for a black

37 HIERONYMUS BOSCH, *The Hay Wagon*: detail

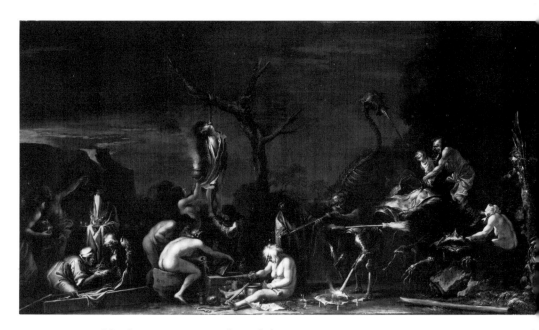

38 SALVATOR ROSA, *Witches and Their Incantations*

toad clapped to her vagina. She is the sexual woman. She is a witch. She will be burnt.

Bosch painted *The Hay Wagon* between 1480 and 1485, at the very moment when Roman Catholic misogyny was at its most hysterical. In 1484 Pope Innocent VIII issued his infamous Witch Bull, giving the seal of Vatican approval to the persecution of people suspected of liaisons with the devil. A tiny proportion of the culprits were men, but the overwhelming majority were female. Acting on Pope Innocent's bull, two Dominican inquisitors called Sprenger and Kramer produced an encyclopaedia of demonology known as the *Malleus Malificarum*, or *Witches' Hammer*, a manual of sadistic fantasy that should be required reading for all students of the art of this period.

'All witchcraft', announced Sprenger and Kramer from behind the celibate walls of the Dominican Order, 'comes from carnal lust, which in women is insatiable.' No official document ever set out so nakedly as the *Witches' Hammer* the punitive terror of the sexuality of women in which Christian morality is steeped, and of which we are the inheritors. It was a terror fanned by a celibate priesthood and made widespread through sermons, through literature and through paintings. The witch was the devil's bride; she was the antithesis of the nun who was the bride of Christ. Her group orgies were even defined by the language of the nunnery, 'coven' being a variation of 'convent', meaning an assembly. The bride of Christ

indulged in no sex; the devil's bride indulged in too much, could never have enough. She could make a good man impotent, whereas the devil possessed a gigantic penis that was forever erect. The devil alone could satisfy her. He was black and they copulated together in darkness. And so on and so on, in a diarrhoea of male fears of inadequacy which seem hard to credit from the sophisticated platform of the twentieth century. And yet this was not the Dark Ages, it was Renaissance Europe – a noble landmark of our culture and civilisation: so much so that it feels like an act of gross disrespect to point out that while the Sistine Chapel in the Vatican was being decorated by Botticelli and Michelangelo a quarter of a million women all over Europe were being dragged to the stake with papal blessing.

These two events may appear wilfully disconnected, no more relevant one to another than the coincidence of Lincoln Cathedral being built at the same time as the exploits of the Emperor Genghis Khan. But there is a connection: they are the twin aspects of a prevailing view of women. In the south one aspect caught the light; in the north the other. But they are the same.

In Italy, Renaissance artists who served the Church by and large painted women who were ideally good: they were madonnas, saints and martyrs. They are lovely because they are pure, and they are pure because they have no sexuality of their own, even though they may arouse it. They have complied with the male definition of what a good woman should be: accordingly they have received the glorious benediction of high art in reward. And in art our approval of them lives on. Because we admire the art so much, we admire them. Who can regard a Botticelli Madonna, or a Raphael Madonna, and not feel that they are good? To do otherwise would plunder our deepest convictions about the nature of truth and goodness, and the power of art to extol it, upon which many of our cultural values rest.

Now reverse the coin and look at how artists in northern Europe, at exactly the same moment of history, portrayed women who disobeyed that male ethic by acknowledging their own sexuality. Immediately they turn into monsters of depravity who are a threat to man's state and salvation, and who must consequently endure the just punishment of hell-fire and the devil's rape. Because art has enshrined our definition of a good woman, it also enshrines our definition of a bad; and by the same cultural values we accept it. But in accepting these twin definitions we are also accepting – elevated as high art – a view of women so depersonalising, so crushing of all independence of nature, as to betray a most profound male anxiety over what women might do if allowed to possess a nature they could call their own.

This too – along with Botticelli and Raphael, Titian and Correggio, Bosch and Van der Weyden – is our inheritance.

5 _Mistresses_

No artist expressed more warmly than Renoir man's delight at having tame women at his disposal. His friend Théodore Duret put it very simply: 'I doubt if any painter ever interpreted woman in a more seductive manner ... They would be ideal mistresses – always sweet, gay and smiling ... the true ideal woman.'

Free, woman was dangerous; she was a sinner and a man-eater. But under man's strict surveillance she can become useful again. Her sac of poison has been removed; now he can relax in her company and begin to enjoy her as a giver of pleasure. She can be allowed to exercise her wiles and her charms without threat. By owning her, man can delight in her, dream about her, pick her up and put her down at will. He can flatter her, worship her. He can even love her.

Renoir would have concurred entirely with his friend's view of the ideal woman. In his life, as in his art, he knew precisely what he wanted from women, and had no hesitation in bemoaning the declining standards in their passivity. 'In former times,' he wrote, 'women freely sang and danced in order to be winsome and pleasing to men. Today they must be paid off; the charm has gone.' He himself married a peasant girl many years younger than he in order to ensure that the charm at least would not go from his house. Renoir's art is a celebration of these values, and his phenomenal popularity among business tycoons in our own times is a measure of male nostalgia for those idyllic summers when women supposedly did nothing but sing and dance, smile prettily in the sun, or lie back and wait for favours. To afford a Renoir is to afford a dream of owned flesh which life itself will not interrupt.

A lot of art is a window on to just such a dream. Neither literature nor music can perform quite the same service because neither can suggest the alternative physical reality which painting conjures up so convincingly. A picture does not have to be played, or turned on; it does not have a beginning and an end. It does not switch itself off. It just _is_ – like life itself. It lives with you, and you in it. Furthermore, you can actually own it; and ownership of the art object confers ownership of the art experience. The colossal value of a Renoir nude enhances this experience by implying that she is a reward offered uniquely for a man's success in life's battles.

An actual beautiful woman may bitch, sulk, stale, and inevitably grow old: a Renoir will not. Neither, you may say, will she make love. Indeed not, but this is not what she is there for. We are in the realm of fantasy, not life; as Freud pointed out, the artist is employed by those who have the money to buy his talents precisely because they do not have the means that he has to construct a reality out of the fantasy within them. It is here, rather than in the purely venal motivation of collecting for investment, where the voracious appetite for art among the rich lies. Nothing – neither real estate nor a merchant bank nor an oil-well – is in the end worth as much as the experience of an idyll that is yours and yours alone: and no idyll is more lovely than that of the perfect mistress. The dream of fair flesh.

But what forms does this dream take, and what do they tell us about the nature of the dream?

Art turns people into objects. We gaze at pictures: they cannot move, though they may move us. The same inert substance – paint – defines a woman's breasts as describes the bowl of oranges on the table beside her. No tactile reference can distinguish between the two, only what the mind of the spectator brings to what he sees. Less obviously, the same chemistry works the other way round: precisely because the substance is the same – paint applied to a flat surface – art can imbue inert things with a sensuality normally associated only with flesh. Hence the appeal of still-life paintings: a Chardin group of kitchen pots and pans carries a charge no real kitchen utensil can possibly possess: a Manet spear of asparagus is no longer the cold, slimy object we know on a plate, but something rather exciting to look at. Cézanne's apples are a good deal more luscious than his women, and when he instructed a female sitter to 'sit like an apple' I feel I know exactly what he meant; in fact I would have preferred it if Madame Cézanne had managed to look more like an apple and less like Madame Cézanne.

This propensity of art to turn people into objects, and to animate objects with sensations normally associated with people, has been of crucial importance in the iconography of women as sexual beings, and therefore in establishing the archetypes that we have inherited of what a sexual woman should be. Because a picture is still, and because the same substance of paint describes everything in that picture – flesh, foliage, or fruit – all sensual encounters have a tendency to be described in terms of objects. Sexual woman becomes quite naturally a Love Object: art creates an ideal of female passivity. It is no accident that one of the most famous and influential of all paintings of sexual woman, Giorgione's *Venus*, in Dresden (Pl. VI), depicts the Goddess of Love lying asleep.

Pondering on this inter-relationship in painting between sexual women and inanimate objects set me reading what some of our more perceptive scholars and critics have written about the way female sexuality is presented in art. Professor Linda Nochlin has pointed to the popularity during

the later nineteenth century – Renoir's and Cézanne's era – of photographs with gently pornographic overtones of pretty fruit vendors, carrying titles like 'Buy my apples'. Edward Lucie-Smith, in his recent anthology of paintings entitled *The Body*, reaches for the same analogy when he describes Renoir's female nudes as 'ordinary as a flower in full bloom, or a ripe fruit'.

But the master of the woman/fruit analogy is Kenneth Clark. His celebrated book on *The Nude* is populated with it. Here are some ripe examples. The seated nude in Giorgione's *Concert Champêtre* is painted 'with an unprejudiced sensuality as if she were a peach or a pear'. The same artist's *Sleeping Venus* is 'like a bud, wrapped in its sheath, each petal folded . . .' Of Raphael's *Three Graces*, 'These sweet, round bodies are as sensuous as strawberries.' Rubens' Graces are 'hymns of thanksgiving for abundance, and they are placed before us with the same unconscious piety as the sheaves of corn and piled-up pumpkins which decorate a village church at Harvest Festival'. Of Titian's *Sacred and Profane Love* (Ill. 7), 'The evening light of the Veneto . . . is now made to include that tender fruit, the human body.' And of an early Greek carving of a Crouching Venus, 'the plastic wholeness of her pear-shaped body has delighted all the ripening suns of art – Titian, Rubens, Renoir – till the present day . . . the perfect symbol of fruitfulness, feeling earth's pull, like a hanging fruit.'

Buds, flowers in full bloom, ripe fruit, hanging fruit, apples, peaches, pears, strawberries, pumpkins. What exactly is this compulsion to turn a woman's body into the contents of a greengrocer's shop? Flowers, after all, are plucked. Fruit not only ripens, it is consumed. We bite it, throwing away the core. I cannot help feeling that responding to women as though they were food expresses a great deal of oral aggression in the guise of sensual appreciation. To be fair, it is also a natural and truthful response to the representation of women as Love Objects: any sexual response is hard to put into words without finding an analogy with some other and more simple pleasure, and it becomes even harder when that response is not to a living person at all but to a woman represented as a still image, an object presented for our contemplation.

What is food for thought – to pursue the analogy – is the extent to which men's view of women's sexuality in general has been conditioned by ever increasing exposure to images of women. Until the invention of the camera the representation of women as objects was confined to paintings, engravings, and book illustration: now the town-dweller, at least, probably encounters as many images of women as living ones – in newspaper and magazine photographs, advertisements on bill-boards, buses and Underground stations, and of course in films and television (although in these last two the images of women do at least move and are to that extent less object-like). Here, opening up, is a vast area of perceptual psychology which lies far beyond the scope of this book; and, fascinating though it is, I feel I should stick to the region most familiar to me and look at the way artists

86

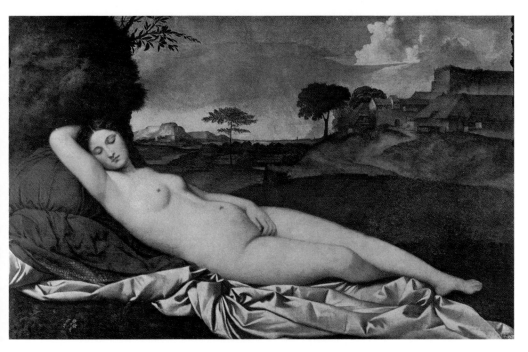

VI GIORGIONE, *Sleeping Venus*

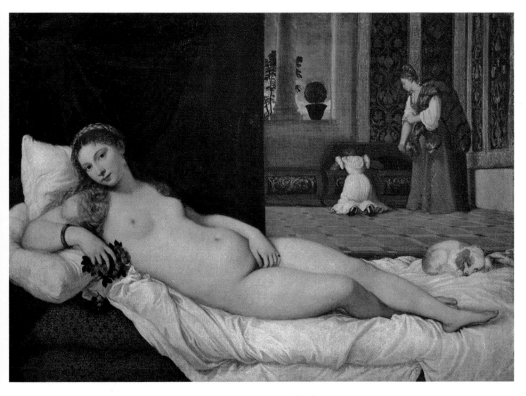

VII TITIAN, *Venus of Urbino*

VIII EUGÈNE DELACROIX, *Woman with a Parrot*

IX JEAN-AUGUSTE INGRES, *Odalisque as Slave*

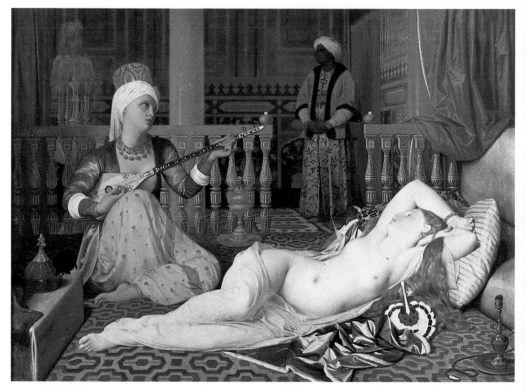

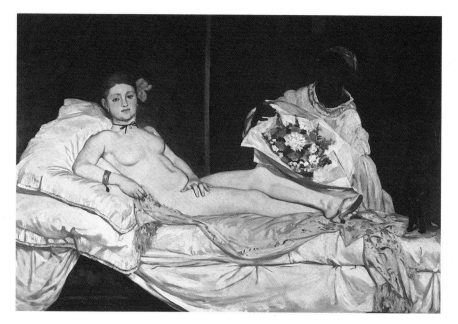

X EDOUARD MANET, *Olympia*

XI PIERRE-AUGUSTE RENOIR, *La Boulangère*

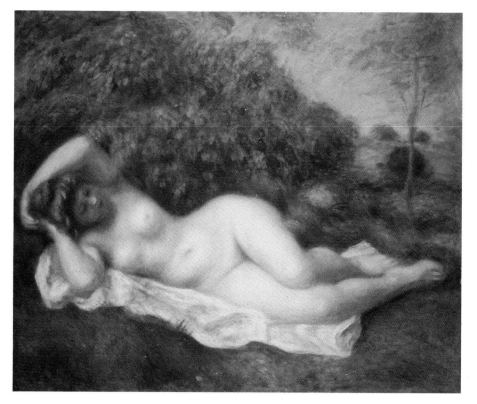

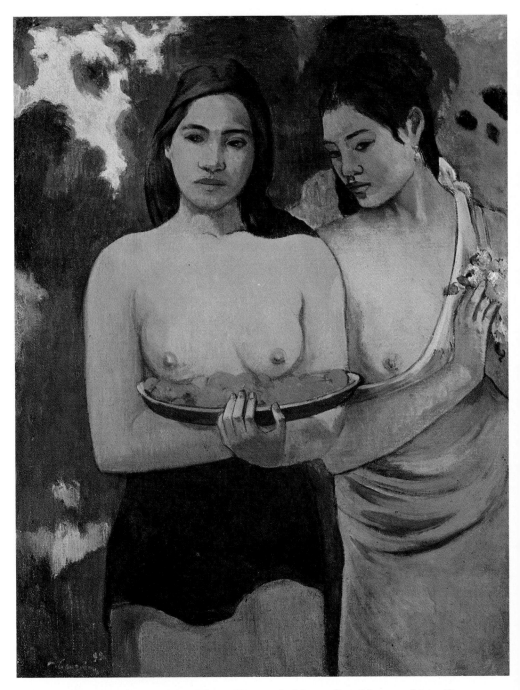

XII PAUL GAUGUIN, *Two Tahitian Women*; the Metropolitan Museum of Art, gift of William Church Osborn, 1949

have chosen to paint women as Love Objects; how they have constructed realities out of men's dreams of fair flesh.

To a large extent the art of the female Love Object mirrors the status of women in history. 'Society has always been male,' wrote Simone de Beauvoir; 'political power has always been in the possession of men.' A woman is a man's property – or she has been for most of the time spanned by the paintings we see in public art galleries. The authority for man's ownership of her is that most impeccable of sources, God: 'he shall rule over thee' was his judgment upon Eve after the Fall. The daughters of Eve filled the same subservient role: 'And it came to pass, when men began to multiply on the face of the earth, and daughters were born unto them, that the sons of God saw the daughters of man that they were fair . . .' Men – notice! – are the sons of God, but women are the daughters of man. Man, as the creator of woman, can therefore identify with God, the supreme Creator. Michelangelo's Sistine Chapel ceiling illustrates man's position in the hierarchy with sublime and arrogant confidence. The male artist is also, of course, a creator: Michelangelo, as interpreter of God's truth, becomes himself a kind of god.

The Book of Proverbs spells out the regimen expected of women in Hebrew society: she must be prepared to share her husband with other wives, and with concubines; she can be divorced on his whim; she must expect to be stoned if she proves unfaithful; and she should of course be prepared to slave on his behalf. St Paul, gentler towards women than is often supposed, none the less insists that woman has been created for man's benefit and must therefore obey him. All this is right and just because God said so.

The Greeks were less concerned with the status of women, largely because their subservient role was taken for granted and therefore hardly worth talking about. In the eighth century BC Hesiod's advice to men on marriage was that it was best to 'buy the woman, don't marry her. Then you can make her follow the plough if necessary.' In classical Athens women enjoyed the same legal and political rights as slaves. They received no education, by and large, and tended to be regarded as irrational, over-sexed, and of low moral calibre. The orator Demosthenes explained the role of women in the world's first democracy in these words: 'Mistresses we keep for the sake of pleasure, concubines for the daily care of our per-sons, and wives to bear us legitimate children and to be faithful guardians of our households.' The plays of Aristophanes do suggest that women wielded what today would be described as pussy-power, and were capable of being militantly disruptive of male order. All the same they were excluded from all higher echelons of culture and debate, and debarred by their sex from attaining that state of moral perfection which was obtainable only through pederasty – a boy cared for and instructed by an older and wiser

man. This male bonding yielded Greek ideals of love and of beauty in which women played no part. Perfect love was between males; perfection of form was a male body: in fact until late in the fourth century BC Greek sculptors depicted men naked, but women clothed – the reverse of the standard procedure that was to be followed in the West.

The Romans merely absorbed Greek social and hierarchical values as far as the status of women was concerned. In pre-Imperial Rome women could be legally murdered by their husbands if they were caught committing adultery, and divorced for mere tipsiness. Nor did Christianity change anything, Roman law and practice becoming the foundation of the European social system, to be reinforced in the later Middle Ages by the steady rise of male dominance through wealth and property.

Now look again at Giorgione's *Sleeping Venus* (Pl. VI). She is heir to all this. Only a culture that was entirely male-dominated could have produced such an image. It is hard to see her this way because she is so much else besides. From this peaceful figure stretched naked before a summer landscape was born the noblest tradition conceived by western artists, which is the tradition of the classical female nude. Without this tradition European painting would be immeasurably the poorer; a dimension of the human spirit would remain unacknowledged and unexpressed; it would be like poetry without the sonnet or music without the fugue. And it is Giorgione's creation; and very largely because of it Venetian painting, more than any other, was to become the standard by which new painting came to be judged for the next four centuries. Giorgione's Venus – painted just a few years after Leonardo da Vinci's *Mona Lisa* but far more historically important than the *Mona Lisa* – is one of those landmarks by which we measure the path of our civilisation.

She is all this. And yet – she is passive; she waits; she is unclothed, one hand on her vagina; she has no existence except to be adored by men's eyes; and she sleeps as though in sleep she joins men's dreams of her. Her realm is in men's fantasies. She is both goddess and man's ideal mistress. She is elevated above the state of man, but she is entirely submissive to his needs and to his longings. She is Sleeping Beauty waiting to be awakened by her prince.

When I gaze at Giorgione's Venus I am aware that I am putting myself in the role of the prince who falls in love with her: but at the same time I am aware that she represents an ideal of woman of which I feel in part ashamed. I do not actually believe that the woman I want should be passive, should wait for me, should have no existence other than for my eyes, or should need me to waken her. Do I love this image, then, because I am trapped within a perception of woman which my awareness of its arrogance is not enough to dispel, or because some alchemy present in what we call 'art' elevates my pleasure in her to some plane on which such considerations are irrelevant?

This is not a question that is customarily thought necessary or proper to ask of a great masterpiece. Art sanctifies. But what exactly does it sanctify in a picture like this one? John Berger has proposed a simple experiment to demonstrate how a spectator's response to such paintings is always presumed to be male. Substitute, he suggested, a male figure for any female nude; then notice the violence which this transformation does to the assumptions of the spectator. If I do this with Giorgione's Venus, and change her into a naked man asleep clutching his genitals, I do indeed feel a shock. Perhaps if I were homosexual I should feel a thrill. But I do not. It is like suddenly seeing the Frog Prince in place of Sleeping Beauty. I want to laugh: the image looks ludicrous. Perhaps this is because I am embarrassed, or perhaps it is because the pose and mood of the Giorgione Venus are perceived as so quintessentially female as to render any such transformation incredible.

What Berger's experiment does make clear is how evasive it is to claim, as art scholars have generally claimed, that this painting in some rarified way manages to transcend sexuality. It does not. Sexuality is what it is about – sexual roles. Serene and breathlessly wonderful it may be, but it is a male vision of woman as Love Object. It is a vision, what is more, graced with the attributes of a stereotype created by man to embody female sexuality in the form he feels most comfortable to cope with. Here is a vision of femininity stripped of all uncomfortable reality – uncomfortable because a real sexual woman has needs, opinions, appetites, moods, may be physically demanding and altogether a frightening proposition; hence man's need throughout history to control her, deprive her of intellectual and political status, and treat her as a chattel. At the same time, to have such a humbled creation growing fat and old about the house must have been extremely boring to men accustomed to rule the world, or that part of it which Renaissance bankers could lay their hands on. So, the enormous service which Greek mythology performed was to offer Renaissance artists and their patrons a pantheon of voluptuous goddesses to whom none of the trappings of reality need apply. They could be sexual without being dangerous, passive without being boring, and beautiful without ever growing old. In the Renaissance nude, artists and patrons found their erotic icon – the point of focus for an adoration of women which in life remained largely unsatisfied, and in art remained unexpressed until that time.

And what is this hunger to adore women, so richly satisfied by Giorgione that the *Sleeping Venus* should have become the model to which so many artists turned for four hundred years? In the absence of paintings by women in sexual adoration of men, it is hard for a man to get a perspective on it, while women have grown so accustomed to viewing themselves in this role in art that they have become numb to any thought of an alternative. What is more, the picture looks so respectful of women – she is not being raped, carried off, martyred; there is no black toad on her genitals, only

89

her own modest hand. It is easy to assume that she is being flattered. Actually it is the other way round: it is not she who is being flattered, but we who adore her. What in all men's dreams of women could be more flattering than to contemplate the beautiful Goddess of Love herself – the very personification of female sexuality – lying submissively in wait for the kiss of our love? To have plucked from mythology a goddess, Venus, who in her Olympian origins was aggressive and very dangerous indeed, and turn her into Sleeping Beauty only waiting to submit to the touch of our love, is a remarkable achievement of the male ego. And it is another of those revealing transformations of myth which characterise so much of the art we respect.

In pretending to flatter women, then, the guise of myth offered rich scope for artists to flatter themselves and their patrons. It was a marvellous male device. Kings took rich advantage of it. Paintings of royal mistresses posing or frolicking as nymphs and maenads are a feature of every schloss and château. My own favourite hangs in the Château de Chenonceaux, near the Loire. A picture by the eighteenth-century court artist to Louis XV, Carle van Loo, shows the Three Graces in saccharined imitation of Raphael (Ill. 39). The graces are naked barring a few strategic wisps; they carry roses, and jewels in their hair, and each presents a different angle to the spectator so that the composite view is of a single, naked, and lovely girl enjoyed in the round – which in life was not so far from the truth. They were actually three sisters who succeeded each other as the king's mistress. The pert little Grace on the left is Madame de Mailly who occupied the royal bed during the 1730s but was too plain to last very long. The ravishing girl in the centre is the Marquise de Vintimille who succeeded her sister in the 1740s and (according to Nancy Mitford) was 'even less of a beauty and much less nice', and died in childbirth to the king's great grief. Louis then went back in tears to Madame de Mailly who adopted her sister's baby ('le demi-Louis'), whereupon His Majesty fell in love with the third sister, the Duchesse de Châteauroux – the one on the right. She was both beautiful and ambitious, and compelled the king to exile her eldest sister from court, only to die of pneumonia answering another tearful royal summons while she was sick. There was also, incidentally, a fourth sister in the royal entourage – the Duchesse de Lauraguais – who was excluded from Van Loo's little confection either because she failed to make the royal bed, which sounds unlikely, or because respect for Greek myth limited the number of Graces to three.

The sycophantic frivolity of eighteenth-century court painters awarding Olympian status to their masters' amorous escapades was capped in more pompous fashion in the nineteenth century by painters who sought Olympian status for themselves at the Paris Salon. It was a century that adored supine women, and no women in nineteenth-century art are more supine than those of Ingres. In his monumental *Jupiter and Thetis* (Ill. 40),

90

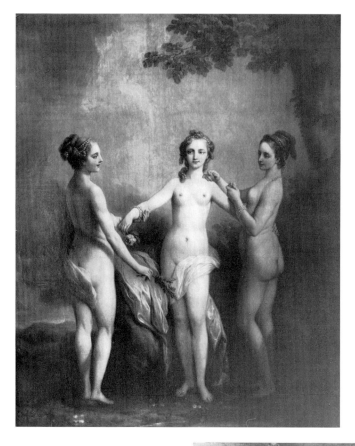

39 CARLE VAN LOO,
The Three Graces

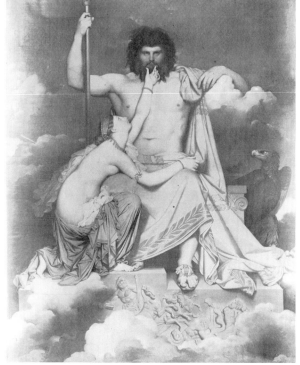

40 JEAN-AUGUSTE INGRES,
Jupiter and Thetis (copyright
CNMH/DACS 1984)

in the museum at Aix-en-Provence, Ingres possesses at least the honesty – or perhaps it is only colossal vanity – of openly acknowledging it to be men who are flattered by all this mythologising of women. Here the king of the gods is the bulwark of the painting. On his golden throne, sceptre in hand, arm on a cloud, he smirks straight at us with his vast chest puffed like a boxer between rounds, while the adoring figure of Thetis coils itself across his knee. With one arm – peculiarly detached from the rest of her body – she reaches for his splendid mane of a beard. Her breasts press against his thigh and her other arm performs a graceful loop exactly across his groin. Oh, do not laugh; this is high art, and no artist aimed higher than Ingres. He was very, very serious about this sort of thing, and no one at the French Academy, where he ruled as if he really were Jupiter, would have dreamed of mocking the great man for the humourless enormity of his self-aggrandisement.

Greek myth created the art of the fantasy mistress. And it made gods and heroes of the men who enjoyed fantasy mistresses or at least enjoyed possessing them on canvas. But the cult of Greek myth did not only take the frivolous path which led to Van Loo, or the grotesque form which culminated in Ingres. Giorgione's *Sleeping Venus* was heir to a more serious breed of fantasy. Sumptuous piece of male self-flattery it may be, and a bare-faced admission that man's ideal woman is a passive Love Object. None the less, Giorgione's painting is a masterpiece, not in *what* the artist has represented but *how* he has done it. Lyrical intensity has its own perfection, and the *Sleeping Venus* must rank with the description of Cleopatra given by Shakespeare's Enobarbus as one of the supreme lyrical accounts of erotic bewitchment in our culture. Whether either are finally as moving as Shakespeare's Cordelia or Rembrandt's Bathsheba is quite another matter.

By displaying Venus asleep and submissive Giorgione implicitly placed beside her a time-clock. One day she had to wake. No creature so flattering to men's gaze could be allowed to sleep like that for ever. Sooner or later Sleeping Beauty would attract her prince. But look at Giorgione's Venus as though you were daring enough to be that prince, and ask yourself what will happen the moment you have kissed her. This is almost as disconcerting as having to imagine her to be a man. What expression will she wear? Will she be horrified, surprised, melt with joy, or perhaps be disappointed? Well, we know, because after thirty years the prince appeared – one with a special interest in her since as a very young man he had painted the landscape before which Giorgione placed her. He was Titian, and the painting is the equally famous *Venus of Urbino* (Pl. VII) now in the Uffizi Gallery, Florence. Titian painted it for an Italian duke and it is the first of many recumbent Venuses the artist was to paint for the European aristocracy throughout the second half of his long life.

The most striking effect of waking her is to remove her from the daydream

of myth and place her physically in life. She is no longer an untouchable ideal; she is someone's actual mistress. The fact that she was not Venus at all but an artist's model, and therefore certainly a Venetian courtesan, suddenly makes itself apparent. Even where Titian has retained Giorgione's posture, the meaning is changed. Her left hand that covers her vagina no longer does so out of unconscious modesty which seems almost innocent. Now, aware of our gaze, she places her hand there as a deliberate gesture of concealment: she does not belong to any of us, but to whoever has brought the roses she holds in her other hand, who owns the palace hung with tapestries in which she reclines, who pays for her two servants in the background and for the rich clothing they are even now bringing out for her to wear, and who gave her the little dog to keep her company while he was away on matters of state or whatever. Even the pale drapes on which she lies have an altered function: in Giorgione's painting they fulfil the purely formal role of setting off her pale skin; now they cover a bed of love – somebody else's!

By domesticating Giorgione's dream Titian established one of the most abiding trends in the art of the female Love Object. The *Venus of Urbino* is an image of woman owned; and since she is owned by somebody else, and yet she gazes at us, we the male spectators are cast in the role of voyeurs. We are understudies pretending to step on stage as Don Juan while the principal actor is absent. And so art has become an instrument of pleasurable envy, pleasurable because the voyeur may enjoy sumptuously in his imagination what he will never have to put to the test in life. In this way the danger implicit in an actual sexual encounter is held at bay, and the painting can flatter the spectator by casting him as superstud while never asking him to prove it. The impact of Titian's Venus on both the art of the nude and of the nudie hardly needs stressing. Art academies would have been impoverished without her. There would be no centrefold spreads in soft-porn magazines without her either; the difference lies in the level of sophistication and artistry, not in the nature of the human response the image invites.

The element of danger in female sexuality which could be safely flirted with was no more than hinted at by Titian, and was not fully exploited by painters until the first half of the nineteenth century. Throughout Europe this was an era of bourgeois entrenchment, with the role of art patron now falling to a new breed of self-made bankers and industrialists for whom the acquisition of high art was a badge of newly found rank and respectability. Public respectability and secret prurience are often seen to walk hand in hand, and the art of no other age so consistently combined high tone with low purpose – that peculiarly nineteenth-century hybrid of Olympus and the brothel. If the Council of Europe were ever to find wit enough to mount (*sic*) an exhibition entitled *Recumbent Venus*, the nineteenth-century rooms would look like the most sophisticated insult to

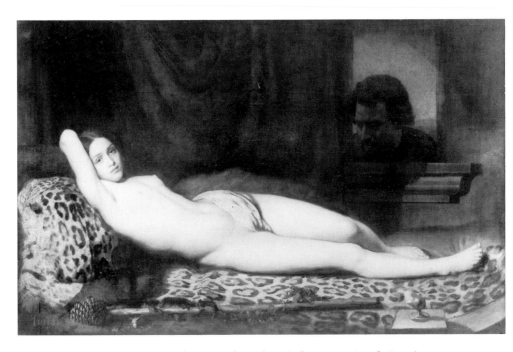

41 FÉLIX TRUTAT, *Reclining Bacchante* (Musée des Beaux-Arts de Dijon)

women ever devised; and I would dearly love to hang personally an immodest favourite from the Musée des Beaux-Arts at Dijon entitled *Reclining Bacchante*, by one Félix Trutat (Ill. 41).

 She is a beautiful girl, and I trust M. Trutat paid his model well for imitating the pose of Giorgione's Venus in his lugubrious studio, with her right arm stretched uncomfortably above her head. But apart from the loveliness of the model what is interesting about M. Trutat's little footnote to the Venetian Renaissance is the change of emphasis wrought by the passage of three hundred years. Nineteenth-century respectability has got rid of her left hand altogether. Where Giorgione and Titian had her resting it over her vagina, Trutat, with a gesture of prudery quite out of keeping with the rest of the painting, has substituted a wisp of material. She should, of course, have been quite bare, pubic hair and all, but this would have been too much in an age with a special horror about pubic hair in art. Its animal connotations would have suggested an aggressive sexual drive in women which the century was at such pains to deny, except in whores.

 Yet the rest of the picture emphasises precisely that very animality. First of all, she is not Venus but a Bacchante, one of the uncontrollable attendants of the god Bacchus who were responsible for tearing the unfortunate Pentheus apart in their orgiastic rage. Furthermore, she lies on a

94

tiger-skin, more evidence of sexual woman's liaison with the wilder forces of nature: clearly she can be expected to do to her lovers what tigers do to their prey. What hope, then, for the gloomy admirer within the picture who has poked his head through the window to peer at her? He will surely go the way of Pentheus: whereas it is upon us, the male spectators, that she turns her lustrous gaze. It is those dark eyes that award us the most flattering of accolades: we are man enough to tame the beast in her.

It is this kind of painting which demonstrated the nineteenth-century male view of women, and which reinforced the rightness of that view in the eyes of the respectable citizens who bought paintings or gazed upon them. The official view of women was enshrined in official art about women, and official art wrapped itself in the sanctity of the Renaissance masters and in the supposedly universal truths of Greek mythology. Painting became an advertisement that gave a clean bill of health to a misogynist conspiracy.

Even though it was the century which gave birth to socialism, the condition of women remained what Juliet Mitchell has described as 'an area of silence'. Karl Marx, after all, was serviced by his wife and family quite as slavishly as industrial capitalism was serviced by the workers Marx sought to liberate. That other great polemicist of nineteenth-century social revolution, Pierre-Joseph Proudhon, quite openly despised women and treated his own wife as a mildly irritating necessity, rather like cough mixture. Proudhon's friend, the artist Courbet, himself a part-time revolutionary, viewed women's position in an artist's life with a kind of utilitarian contempt: 'An artist who marries isn't an artist, he's a sort of jealous proprietor ... who says "my wife" as he'd say "my stick" or "my umbrella".'

When even those who were trying to smash social patterns could display such unconcern for women as human beings, it is hardly surprising that Freud, who grew up amid this ethos, should write a few decades later that the erotic life of women was 'veiled in an impenetrable obscurity'. How could it be otherwise when every convention of nineteenth-century society drew across women's sexuality yet another impenetrable veil? Trutat's wisp of drapery across his bacchante's pudendum was a *cache-sexe* that protected the ignorance and the arrogance of one half of the human race towards the needs of the other half.

It was into this world of men that Edouard Manet dropped his bombshell that was the *Olympia* (Pl. X). The explosion caused by its appearance at the Paris Salon of 1865 is one of the best-documented art scandals in history. The idiocies of the French press, coming so soon after its hysterical reaction to the Salon des Refusés two years before, tarnished the profession of art critic with an implausibility from which it has never recovered (except in the eyes of those who practise it), rather as the plausibility of the Roman Catholic Church in relation to science has never recovered from its treatment of Galileo.

But why should she have been regarded as a 'female gorilla' and the picture itself a piece of 'excrement'? Why should the painting have become so famously wicked that when Manet fled temporarily to Spain the customs official at the border actually summoned his wife and children to see for themselves the infamous creator of the *Olympia*?

True, there were connoisseurs whose fine feelings were bruised by what seemed like vulgarised allusions to Titian's *Venus of Urbino* (Pl. VII) – the same white linen, the girl's pose, position of her hand, even the same division of the room into two parts separating exactly at her crutch. There were prudes made uncomfortable by the obvious sexual connotations of the black cat, black servant girl bringing flowers (from a black lover?), by the generous size of the girl's breasts, by the provocative teetering of her slipper, and by the general air of an expensive brothel which really should not be allowed to pollute an art salon. And there were ordinary unthinking habitués of such occasions who were simply accustomed to extravagances of this kind being veiled as classical myth, not exposed as facts of life.

But none of this explains why customs officials five hundred miles away on the Spanish border should treat the artist as if he were a travelling peepshow. The reception of Manet's *Olympia* was an explosive confession of the fact that men expected flattery from beautiful and subservient women, and expected works of art to supply this flattery. What was outrageous about Manet's canvas in 1865 was that it was not an instrument of flattery at all; rather, it was an instrument of challenge. *Olympia* is not a fantasy goddess, neither is she the expensive property of some absent prince submitting her nakedness to our regard. She is steadily regarding us; it is not we who are doing the sexual appraisal – she is. So she is not the ideal supine mistress; she is active, and she is waiting for a good lover. That steamy female sexuality which in the ridiculous Trutat picture stroked the superman in every male spectator, now seems aggressive and disconcerting. To the nineteenth-century peacock the experience of encountering an image of such erotic self-confidence in a woman – and what was more, a woman posing as a Renaissance goddess in the manner of Giorgione and Titian – induced a state of ungovernable panic.

In his recent book *Bodies of Knowledge* Professor Liam Hudson has pointed out that only three years earlier the Paris art public had accepted with scarcely a murmur Ingres' picture *The Turkish Bath* (Ill. 42). Here was a cornucopia of female flesh in every conceivable posture of sexual anticipation. The painting even includes lesbian fondling. The juxtaposition of these two pictures is revealing of what was considered acceptable erotic behaviour by women. The Manet set a black cat among the pigeons by representing woman as sexually active, and therefore a threat. But the Ingres ruffled no feathers at all (though some did feel it to be a bit ripe for an eighty-two-year-old painter) because in all this gaggle of flesh there is not a woman among them who has any function or any identity other

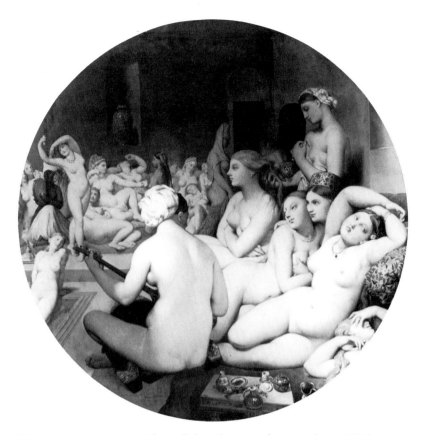

42 JEAN-AUGUSTE INGRES, *The Turkish Bath* (copyright SDPMN/DACS 1984)

than that of waiting to be of service to a man. This was what the ideal woman was for, and this was what the ideal of the nude in art had become.

The shock-waves caused by Manet's *Olympia* cleared away many of the more absurd hypocrisies governing what was acceptable and unacceptable in the convention of the painted nude. The most obvious effect was the gradual demise of Greek myth as the disguise which made genteel pornography look like high art. But in shedding the disguise of myth, the convention of the reclining nude began to look extraordinarily forced. Woman did not naturally lie naked in the Provençal landscape adopting the pose of Giorgione's or Titian's Venus, and when Renoir asked the local baker's wife to do so (Pl. XI), the result may inspire all those luscious fruit analogies beloved by art scholars but his painting does look decidedly odd. Whereas Giorgione's Sleeping Beauty will stir only when her prince bestows on her a kiss of love, Renoir's blonde in her back-garden Arcadia will dress in time to pocket her fee and prepare her husband's *gigot*.

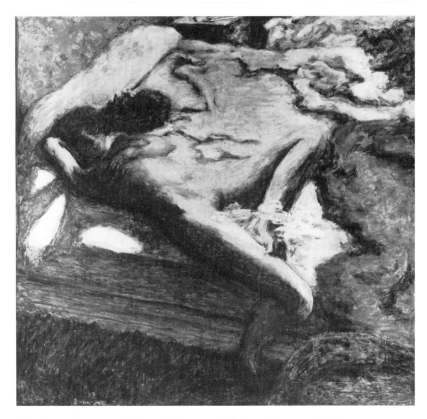

43 PIERRE BONNARD, *Woman dozing on a Bed* (copyright DACS 1984)

Both roles, of course, are equally passive. The active sexuality introduced by Manet's *Olympia* flourished not in Renoir's Mediterranean sunlight but in the interiors of Left-Bank Bohemia painted by a younger and more liberated generation – Bonnard, Modigliani, Matisse. Bonnard's *Woman dozing on a Bed* (Ill. 43) absorbs the whole convention of the reclining nude – Giorgione's Sleeping Beauty, Titian's pale flesh on white sheets, Manet's black cat – but has transformed it into a statement about love-making. In four hundred years the image of the recumbent mistress has progressed from the sleep of innocence to the sleep of satiety.

There was no public rumpus over Bonnard's picture because the public was not invited to look at it. *Woman dozing on a Bed* was painted within the closed circle of Paris Bohemia, and not for connoisseurs to peer at through their monocles. It therefore presented no threat to that corpus of art-lovers who still expected paintings to illustrate cloud-cuckooland. Manet committed his indiscretion much earlier, before that art public had

98

been softened up, and he committed it in the very cathedral of cloud-cuckooland – the Paris Salon. Only ingenuousness can have induced him to believe he would get away with it.

The academic art of the nineteenth century represents the furthest and safest distance from reality at which man has ever set his creative talents – and therefore the furthest and safest distance from an acknowledgment and perception of women as sexual beings. But nineteenth-century artists disguised their unease about women's sexuality in fantasies other than those of supine mistresses pretending to be Greek goddesses. The century also brought to an absurd climax the fantasy of the harem.

In itself this was nothing new. The idea of the harem – or, if not literally a harem, then a corral of available women – has held an irresistible appeal for male painters in all societies that have permitted the nude as a valid subject of art. Indeed, so appealing has it been that a number of classical myths have become progressively more distorted as painters vied with each other to add more and more nudes. The myth of the birth of Venus, first magically interpreted in painting by Botticelli (Ill. 44) as a single naked figure blown gently towards us by the winds, becomes retold by Boucher

44 SANDRO BOTTICELLI, *The Birth of Venus*

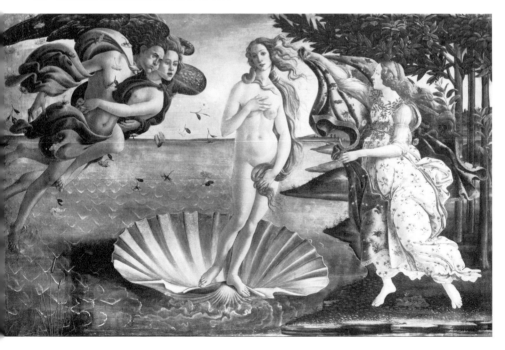

45 FRANÇOIS BOUCHER, *The Birth of Venus*

in the eighteenth century as a nudist bathing scene (Ill. 45). The myth
of Galatea undergoes a similar change. This story of the sea-nymph in love
with the handsome Acis found its first great interpreter in Raphael who
portrayed her with no sexual emphasis as a half-clothed figure being drawn
through the water by dolphins. By the seventeenth century Poussin has
transformed the scene into a watery life-class, and a hundred years later
Boucher turned it into another of his marine romps.

The fantasy of the harem is the fantasy of sexual plenty. It is the ultimate
flattery of being invited to choose. The English early-nineteenth-century
artist, Thomas Rowlandson, caricatured the ludicrous male vanity dis-
guised within so much high art in a print showing tier upon tier of winsome
ladies parading apparently as far as the horizon before a rampant pasha.
The scene is a *reductio ad absurdum* of the most popular of all classical myths
among artists, the Judgment of Paris.

In Greek mythology the Trojan prince, Paris, is invited to award a golden
apple to the goddess he considers the most lovely – Venus, Juno, or Athene.
In awarding the prize to Venus, he receives from her the promise of the
most beautiful mortal woman in the world, who turns out to be Helen.
So in origin the Judgment of Paris is not just a beauty contest; it is also

46 PETER PAUL RUBENS, *The Judgment of Paris*

a tragic moment because its outcome is the abduction of Helen and in consequence the destruction of Troy. Significantly the tragic aspect of the myth is virtually ignored in European painting – even though without it the myth would never have existed. Its popularity in art has rested on the opportunity it offers for presenting three women competing for the sexual favours of one man. Rubens (Ill. 46) painted the scene a number of times, always as a pastoral exhibition of flesh; and not surprisingly the theme was sugared by Renoir (Ill. 47) towards the end of his life with even less concern than Rubens for its historical and tragic meaning. Once again, classical myth has become distorted in the interest of supplying male painters and art patrons with flattering images of women's bodies.

This fantasy of sexual plenty reached its high noon – predictably – in the nineteenth century. Every country in Europe poured official honours on to artists whose stock-in-trade was to decorate classical myth with a

101

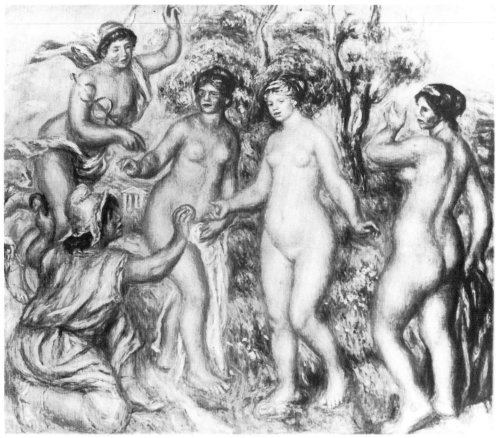

47 PIERRE-AUGUSTE RENOIR, *The Judgment of Paris*

48 ADOLPHE BOUGUEREAU, *Nymphs Bathing*

chorus-line of teenage models with depilated pubes and skins like icing-sugar, posing as sirens and sea-nymphs. In paintings like William Bouguereau's *Nymphs Bathing* (Ill. 48), nineteenth-century male terrors of female sexuality sought refuge in numbers, and in the delectable dream of purity waiting to be spoiled.

But even the nineteenth century eventually grew tired of sea-nymphs. Classical mythology as a theme of painting was losing its vibrancy and its inner reality as the achievements of the Renaissance and the Baroque receded further and further into the past: the great themes swept up by Titian and Rubens were degenerating into posturing heroics in a sea of splashing flesh. As images of the fantasy mistress, sweet little pin-ups insipid with innocence lacked a certain voluptuous flavour, the power to make the male blood race. Nineteenth-century connoisseurs needed spicier meat.

They discovered it in what we have come to call the Third World, and in particular in the world of Islam. Here was a rich vein for painters and their patrons grown jaded with outworn classical myth. It was a real world, or so they believed. It was exotic and hedonistic. Most important of all, in its relations between the sexes it echoed in reality those ideals of male control and female passivity which the nineteenth century held so dear. And it was all true: there really were harems, houris, and slave-markets – travellers and travelling artists like Delacroix in Morocco and J. F. Lewis in Egypt had found them. Even artists who had scarcely travelled at all except to Rome, like the great Ingres, still found their imaginations to be fecund with images of the new paradise.

What a fertile place it was. The discovery of the exotic has invigorated much of the art of the last hundred and fifty years. The paintings of Delacroix are fuelled by an excitement at the animal vigour and passions located outside the boundaries of western civilisation. Ingres also looked beyond those boundaries and found in the world of Islam not the animal vigour Delacroix sought but a perfumed langour that bewitched his fancy. Lesser painters like Gérôme and Chasseriau followed the direction of his gaze; then towards the end of the century Paul Gauguin went beyond the mere search for exotic themes and committed his life to the primitive civilisations of the Pacific islands. By the twentieth century the exotic was in full flood. Gauguin's Polynesian paintings led Matisse and Derain to the colour revolution we know as Fauvism. African tribal art played a crucial role in the evolution of Cubism. German Expressionism throbbed to the rhythms of African dance. Everything that had been dismissed as savage became exciting precisely because it was savage. The irrational was worshipped by the Surrealists because it was irrational and therefore truer to the chaotic nature of human experience. The art of children fascinated Klee and Picasso because it was untutored, unclouded by competence; it bubbled from the spring. The art of madmen, the art of imbeciles, the art of neurotics, the art of social derelicts muttering in basements and lonely cottages: each

contained a drop of the true spirit unrefined by civilisation. Art went wild, and swept up in its savage dance all the rules and values which for centuries had determined what art should be.

And in all this what happened to man's dream of fair flesh? At first very little. Delacroix's *Woman with a Parrot* (Pl. VIII), of 1827, is a romantic young man's version of that traditional image – the woman owned. It could be a painted version of a Byron sonnet. The heavy sensuality of the picture is not generated by the girl, it is imposed upon her by the way the artist has described the rich drapery around her, and by the languid pose in which he depicts her. In herself she is nothing beyond a Love Object, and the aura of the harem merely spices the flattery offered to the male spectator who can identity himself as the owner of this prize piece of exotic flesh. This flattery is even more explicit in Ingres' *Odalisque as Slave* (Pl. IX), painted fifteen years later, because here the harem is not merely a hint, it is a physical reality described detail by detail. The richly textured interior, the fan against the heat, the minstrel sweetening the air with love music, the man's hookah placed where he will shortly lie, the black servant waiting to signal his arrival – everything about the painting is an overture to the imminent moment when this collapsed creature will be roused from her torpor to perform her sole function in life which is to be possessed by the man who owns her. Both pictures, the Delacroix and the Ingres, are landmarks of nineteenth-century painting in their different ways, and both of them earn this distinction at the cost of eliminating from the male perception of woman everything that might acknowledge her to be alive.

So far the cult of the exotic has done little beyond perfume man's pleasure at mastering a supine female. And it is here that the contribution of Gauguin is so decisive. Standing in front of these nudes by Ingres and Delacroix, which culture has taught me to admire, I have found myself wanting to apologise to women I love and respect for the price their sex pays for such masterpieces. Yet in front of Gauguin's Tahitian nudes (Pl. XII) I have never felt any such need. Neither have I when confronted by the monumental nudes of Picasso painted in the early years of Cubism under the impact of African carving, though by everyday standards these would seem as uncomplimentary to women's bodies as the nudes of Ingres are uncomplimentary to their minds. I have not even felt a twinge in front of the grimacing sluts which the German Expressionists were so interminably fond of painting. Why?

The exotic has two faces. One is a mirror; the other is a mask. It reflects or it grimaces. The exotic women painted by Ingres threw back at nineteenth-century society a glamourised vision of itself. Its social values remained intact, confirmed. The Parisian connoisseur surveyed these drooping odalisques and felt rewarded: it was like going to a fashionable nightclub. The Polynesian women painted by Gauguin were no less glamourised: life in Polynesia was never remotely like this. None the less

they were perceived as natural, and in Gauguin's canvases this naturalness was offered as a challenge to western social values, not an endorsement of them. Gauguin interposed between the male voyeur and the female Love Object a view of women whose nakedness was a normal state of being; and in being presented as normal it conferred no flattery whatever upon either painter or spectator. In Gauguin the image of the female nude became a focus of human wonder, and of the most intimate inquiry into the nature of human relationships – as it had been in classical Greek art, and briefly again during the Renaissance, but less and less since.

Gauguin redeemed the art of the nude by freeing it from the service of male erotic fantasy to which European painters had increasingly consigned it with such brainless and gargantuan appetite. He gave the nude a mind again, and invited the spectator to use his own. In this way he prepared us all for Picasso's dryads, Modigliani's caryatids, the bathers of Matisse, and the viragos of De Kooning. We owe it to Gauguin that the twentieth-century nude no longer invites those interminable fruit analogies so beloved by art critics. Gauguin left fruit where it belonged – on a tree – before the serpent in us started all those fantasies of delicious dread by offering it to Eve.

6 Clothes-Pegs

In between love-making, the mistress is allowed to dress; and naturally it is more complimentary to the man who owns her if she dresses beautifully so that other men will envy him, and dresses expensively so that other women will envy her for being his property.

Paintings have paid elaborate court to these twin needs. There is a subtle and important difference between a picture of a man in fine clothes and a picture of a woman in comparable finery. A man's clothing enhances his stature as a man: a woman's enhances her value as a man's possession. Even if she is a duchess, or an heiress, her splendour is still the reflection of some man's success, not her own. She is a prize, a prized object. The more lavish her costume and jewellery, the more nearly is she a work of art herself; and as the subject of a portrait, handed down to family posterity in a gilt frame, she becomes quite literally a work of art. The transformation is complete.

The artistry of her painter matches that of her jeweller and dressmaker. I cannot think of any notable painter of women who has not possessed outstanding skill at describing costume; and often this is the skill that really counts because a woman may be defined in a painting much more by what she wears than by what she is. Florentine fifteenth-century portraits of women, such as Domenico Veneziano's *Young Lady* (Ill. 49), in the Berlin Gallery, tend to be stereotyped profiles with little or no attention to facial expression or individual characteristics: the face looks like a cut-out left almost blank because this is not what matters. The profile is beautiful enough, and yet we neither know her nor would be likely to recognise her again were it not for the rich brocade dress she wears. Here is the artist's skill in full display, in the service of displaying her. We take in that she is young, that she is blonde and pretty; but what we actually remember is the exotic gold and madder-red garment that adorns (and hides) her body. This is her distinctive feature, and it is this that gives her status. She is a rich man's woman.

In the century between Veneziano's *Young Lady* and Bronzino's portrait of *Eleonora of Toledo with her Son* (Ill. 50), in the Uffizi Gallery, lies the whole of the Florentine Renaissance. Painters now had at their disposal all the skills they might require to breathe life into still human images: they were

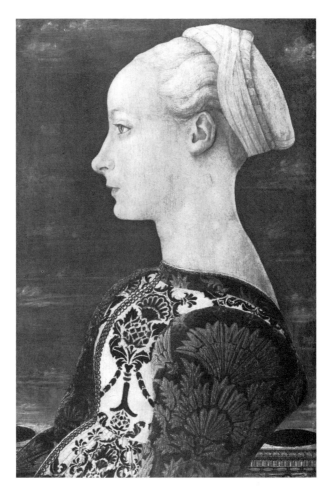

49 DOMENICO
VENEZIANO, *Young Lady*

no longer cut-outs. Perspective, light and shade, proportion, anatomy, even psychology – these were available bodies of knowledge that could be applied. There was to be no comparable breakthrough in the representation of how people looked until the invention of the motion camera. And yet the relative importance of person and clothing remains just the same in the Bronzino as it was in the Veneziano. In fact the disparity is the more noticeable because Eleonora *is* represented to us as a human being – her cheek and chin modelled by shadow, the ivory-cool presence emphasised by a light halo-effect around her head, the mouth intelligent and quizzical (will she laugh? will she dismiss us?), and the right hand laid softly on her son's shoulder. Yes, she is real, and it is a tribute to Bronzino's genius as a portrait-painter that she should appear so, because the picture is not specially about her but about the amazing brocade costume that hangs

107

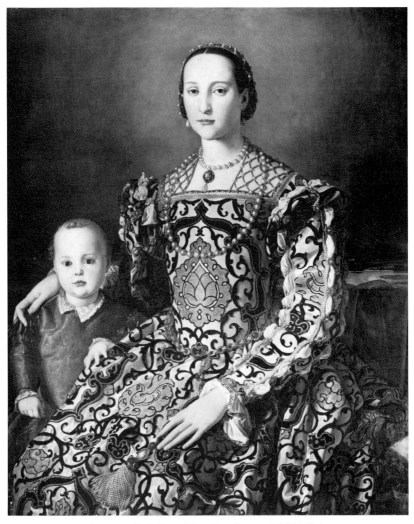

50 BRONZINO, *Eleonora of Toledo with her Son, Giovanni de' Medici*

upon her and the pearls of great price that festoon her like a chain. It is these things that define the picture and define her. She is the wife and property of Duke Cosimo I of Florence. Naked she might have been Venus; with a bow and quiver Diana the Huntress; bedecked with flowers she might have been Flora; in a plain garment nobody at all. She is beautiful, she is interesting, she is intelligent, she is loving; the irony of all these attributes is that they are entirely secondary to the role in which Bronzino has been expected to cast her, which is that of ducal treasure. The skills of the Renaissance painter have served primarily to enhance her status as a work of art.

The more elaborate these skills, the more valuable the female work of art will look, and the less the reality of the woman within is likely to intrude on the eye. English miniature painters who were contemporary with Bronzino made much of this truth in their small-scale art. A miniature not only shrinks a human being to insect-like proportions, it was often designed to be worn actually as jewellery. The wife, the mistress, the owned woman, becomes a tiny trapped creature like a fly caught in amber. Isaac Oliver's portrait of Frances Howard (Ill. 51) is larger than most miniatures – she is five inches across – but she is still the minute possession of an aristocrat whose titles claim ownership to two entire English counties, Essex and Somerset. Her husband the count could wear her like a badge on his travels between one county and another. The artist has wrapped her prettily just as though she were a mere extension of the vast jewel she wears at her neck, his skills lovingly bestowed on the wrappings in which her precious anonymity is laid. From within clouds of exquisitely delicate fluff she is allowed a single human gesture: she places one hand over her heart as a signal of faithfulness to her lord and master, though with clothes like this it is hard to imagine faithlessness being feasible without a team of maids even if she had contemplated such a thing. She is physically imprisoned by the finery that ennobles her.

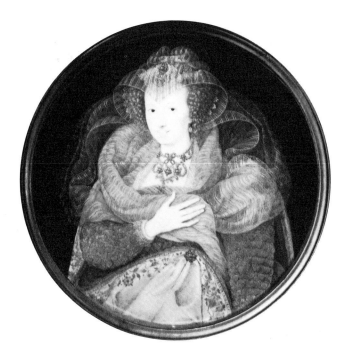

51 ISAAC OLIVER; miniature of Frances Howard, Countess of Essex

What has crept into the art of the female clothes-peg is the spirit of the absurd. There is a touch of the absurd about all clothes, both male and female, because they are the outward manifestation of social pretension, and the more pretentious the society invariably the more absurd the clothes. Because women have been men's primary objects of social display the element of absurdity is more pronounced in women's fashions than in men's; and as the male rulers of Europe grew richer during the sixteenth and seventeenth centuries, the expensive materials that they hung upon their ladies began to take on ludicrous proportions. Mariana of Austria, as painted by Velasquez (Ill. 52) in about 1652 and now in the Prado Museum, is decked out in a manner that was obviously thought fitting for the daughter of the Holy Roman Emperor and the queen of the most powerful monarch in Europe, Philip IV of Spain. Poor grim-faced eighteen-year-old, politically hijacked into a maudlin foreign court, she is rendered immobile by this cage of lace and black velvet, her guts crushed by a bone straitjacket, and her head clamped into a yoke of wax and feathers.

The most natural human reaction to pictures like this is to smile. In fact, face to face with Mariana of Austria in the Prado, this is what I have noticed people generally do – those, that is, not too awestruck by the name Velasquez to permit themselves such levity. We know, what is more, that our smile is the smile of history: it would all have seemed perfectly acceptable and normal at the time, we say, and clearly it was acceptable or women would not have worn such clothes, however subservient they were to the male society that kept them. We feel it to be an absurdity that can be put down to an amusing eccentricity inherent in the partnership of fashion and wealth.

And yet, look again at the way Mariana is dressed. How hostile it is. Why should it be that fashion takes the form of a cage immobilising and crushing the body of a woman? Clothing has become a kind of control; more than this, it has become a genteel expression of mockery. And the more fashion becomes a display of men's inordinate wealth hung on to women, the more absurd the fashion and the more elaborate the mockery. A scale of male hostility seems to be operating here that is directly related to money; and in this husbands, dressmakers, and painters collude, while pretending to flatter. The husband requires his wife to be the showpiece which his status demands. The dressmaker shows off his skills to advance his own status. And the painter of course does likewise. At every stage the woman, under the guise of being made more beautiful, is actually rendered more helpless, more negative, and more ridiculous. And in the end all three – husband, dressmaker, painter – can stand back and agree 'How foolish she is, and how vain'.

The artist's part is the most passive of the three in that he is required to paint what he sees – he does not create the fashions that he paints. And yet his skills, and the delight that nearly all great painters have taken

110

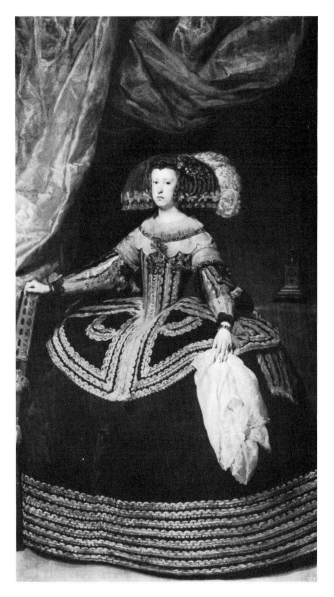

52 DIEGO VELASQUEZ,
Mariana of Austria

in describing women's finery, have contributed no little to swelling the admiration men have felt for women transformed into ludicrous *objets d'art*. The painter's role is that of magician-cum-propagandist. He serves princes, and he services their tastes. He raises the mockery of women to the level of an accomplishment that we all feel compelled to admire. In valuing him – and if he is Velasquez we can hardly do otherwise – we find reasons to value whatever he does. As with Titian's love objects, and Rubens' rapes,

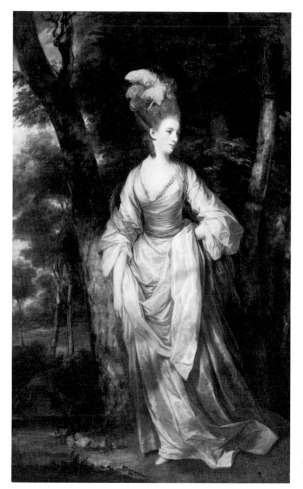

53 JOSHUA
REYNOLDS, *Mrs
Carnac* (Reproduced
by permission of the
Trustees of the
Wallace Collection)

the reputation of an artist can sanctify the unacceptable to such an extent that it can feel philistine even to question it.

In the art of the eighteenth century it becomes easier to detect and to acknowledge the mockery being hung around women in the guise of fashion. This is partly because much eighteenth-century painting is elaborately frivolous so that we are less easily persuaded to take it seriously; and it is partly because women's fashions themselves reached a new peak of absurdity. Never had the ruling classes been so wealthy as in pre-Revolutionary France and eighteenth-century England. The greater the wealth the greater the requirement that women should display it, and that artists like Reynolds and Lawrence, Drouais and De Troy, should excel at miraculous effects of silk and lace. Only painters with a quite exceptional gift for portraiture – such as Gainsborough and Fragonard – peered through

112

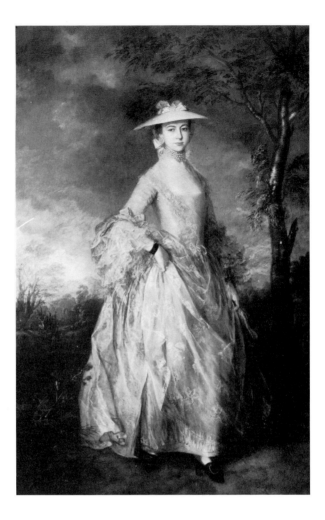

54 THOMAS
GAINSBOROUGH, *Mary,*
Countess Howe

the snowdrift of costume and located a woman here and there.

An extra dimension of mockery was often provided by landscape settings of stupendous inappropriateness. Sir Joshua Reynolds' portrait of Mrs Carnac (Ill. 53), wife of a brigadier in Bengal, has her supporting a tower-block of hair and ostrich plumes amid a summer woodland that she could no more stroll in than she could bend down to adjust her shoe-buckle. By invoking nature, Reynolds emphasises how totally she is deprived of it.

Reynolds' contemporary, Thomas Gainsborough, served the same fashionable clientele with – superficially – the same extravagances of artifice. Why is it, then, that I can look on Gainsborough's portrait of Countess Howe (Ill. 54) with delight and affection while Reynolds' Mrs Carnac makes me irritated? Both painters, after all, dedicate a formidable skill to presenting their subjects as art objects trussed and trimmed for inspection. Both

are the apotheosis of the expensive woman owned. And both are pinned helplessly to a landscape they could never walk: Countess Howe is given rough weather she could probably not even survive – certainly not without severe damage to her frills, her countenance, and to that amazing scimitar of a hat. The difference is one of perception. Reynolds has treated Mrs Carnac with the enormous solemnity of a society courtier, and in doing so has obliterated her with his manners. Gainsborough on the other hand has begun with the person – shrewd, sharp, gazing at the artist straight in the eye – and then has decorated her with all the craftsmanship at his command but in such a way that it is fashion itself which is ever so lightly mocked, and not she. Gainsborough clearly likes women, understands them, and in her gaze there is an acknowledgment of a rapport between them that seems almost a conspiracy – the artist has his role to play, and she hers, but she can see through it and so can he. There is even the hint of a body that the artist is clearly aware of under that long swoop of pink. Beneath Mrs Carnac's cage of silk heaven knows what Sir Joshua – the respectable bachelor – imagined might reside: perhaps nothing at all, since she has no identity at all beyond that provided by the nonsense she wears.

So far, all these painters of women as clothes-pegs have been men. But there was at least one woman painter of this period who encroached successfully enough on to male territory to have won herself an international reputation. She was Elizabeth Vigée-Lebrun, who rose to become official portraitist to Queen Marie-Antoinette, and after the French Revolution took herself to St Petersburg where she found even more fashionable fame at the court of the tsars. As an artist she was never in Gainsborough's class, or even in Sir Joshua's. What is interesting is to see how her portraits of women differ from those of her male contemporaries merely through offering a female view of her own sex. *Lady folding a Letter* (Ill. 55), for example, is a study of a woman who in clothes and social rank is not very different from Mrs Carnac or the Countess Howe – ostrich plumes, expansive hat, elaborate hair, lacy cuffs, and all the rest. And here the similarities end. She is not an *objet d'art* at all, a valuable possession, an immovable monument set down in her husband's acres. She is not mocked by what she wears or by the social role she plays. She is pert and lively, not as imperiously beautiful as the countess but very much herself, not prepared to show us the letter she has just written because it is none of our business, but awarding us instead a twinkle of the eyes and a bright half-smile. If Mrs Carnac had smiled like this Sir Joshua's grand illusion would have cracked, and if it had been the countess she would have given the game away. The difference is, once again, of perception: of how a woman is looked at and the role she is given to play. Mme Vigée-Lebrun, artist of limited skills and human insight though she was, never looked at a woman as a *thing*.

Much of the candyfloss that decorates portraits of women in the

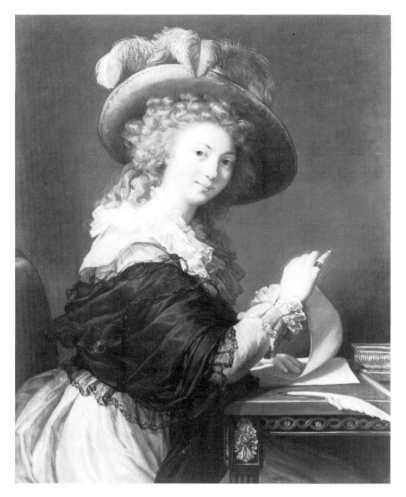

55 Elizabeth Vigée-Lebrun, *Lady folding a Letter*

eighteenth century melted away in the twin fires of the French Revolution and the Industrial Revolution. Money passed into new hands – plainer hands on the whole. Patrons became split between those who wanted art which endorsed ancient values in a world of unprecedented social change, and those who responded to painting because it echoed a brave new world. There were fewer of the latter – at least until American industrial wealth threw up brave new patrons in the 1880s; hence the colossal difference between the affluence of fashionable academic painters in the mid-nineteenth century and the penury suffered by the young Impressionists. This sort of disparity had never existed before: there had only been unfortunate individuals (Hals, Rembrandt, Fragonard, Blake among them) who

115

for a variety of reasons either fell out of favour or never sought it. But suddenly here were several generations of artists who, far from servicing the pretensions of fashionable society, found themselves pitted against those pretensions and enduring a bitter struggle to survive at all.

Not surprisingly, art slid down the social scale. And this crash in social and financial standing affected the kind of women artists painted and the way they chose to paint them. Artists who were no longer employed to service the traditional ruling classes were no longer called upon to paint countesses and the wives of well-heeled colonial brigadiers. They painted their own wives and girl-friends; they painted waitresses and small-time actresses, the postman's daughter and the girl who served in the corner flower-shop. None of these could afford high fashion and few of them even low fashion: what they wore supported no social rank and was no advertisement at all for the status of any man. They wore just what they wore.

Yet this is putting it too simply. The Realism of Courbet and Manet, and the Impressionist movement which grew out of it a decade or two later, did put women back on earth and describe them in terms of their day-to-day life rather than as the stuff of male dreams. But not always. The women in their often impoverished lives did put on fine clothes, and their artist-lovers and artist-husbands enjoyed painting them in their borrowed finery just as Gainsborough had enjoyed painting the high fashion of his countesses.

The difference lay in what those fine clothes meant. A picture like Claude Monet's *Women in the Garden* (Ill. 56) was painted in 1866 when the young artist had no money whatsoever. The fact that one would never know this from looking at the picture tells us quite a lot about why Monet painted it. Here is a fantasy no less than Reynolds' *Mrs Carnac* is a fantasy – but it is of a different kind. Reynolds painted Mrs Carnac as she really was, the very embodiment of high fashion, then gave her a setting of make-believe landscape that would make her appear to be some sort of queen of nature immensely flattering to her husband who was not a king of anything but only a modestly successful colonial army officer. His was a fantasy of social pretension. Monet's landscape on the other hand is entirely real and rather modest – a small suburban garden outside Paris where he actually set up his easel with the aid of a trench and pulley to accommodate the sheer size of the picture (nine feet plus). Monet's fantasy is directed purely at the women themselves – four of them. Unlike Mrs Carnac they are not dressed as they really were at all. They are all in fact the same woman, Monet's future wife Camille. He has dressed her up in four different costumes with appropriate wigs, has studied the effect in four different poses, and has put them together as if they were four separate people. He has taken a real garden and made it into a dream – a garden of love or, to put it less charitably, a garden of dolls.

116

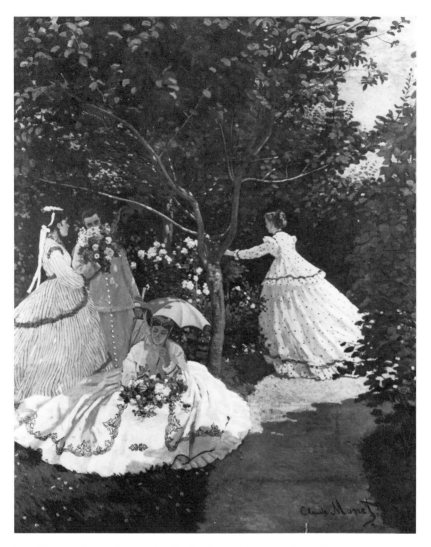

56 CLAUDE MONET, *Women in a Garden* (copyright SDPMN/DACS 1984)

But then the Impressionists, with the notable exception of their mentor Edouard Manet, were much more concerned with women as objects than as people. Pissarro liked them at a distance anonymously strolling the Pont-Neuf or bent over the crops. Renoir liked them obsessively of course but invariably as pretty things dolled up for an outdoor occasion, or dressed as odalisques and Spanish dancers, or giving their breasts to babies or the sun. Degas only liked them doing things, either dancing or washing. Cézanne liked them as architectural lumps. Sisley never painted them at all, and Monet soon ceased to except occasionally as surfaces to reflect the sunlight, and even these came to offer less scope than the surface of a haystack or his waterlily pond.

117

57 PABLO PICASSO, *Woman in Blue*

So the society clothes-peg gives way to the doll. Fine clothes no longer
reflect social and financial status; they are to dress up in for fun. Fancy
dress. The artist who perceived and relished this change more than any
other was the young Picasso. In the paintings he did in Barcelona at the
turn of the century, like *Woman in Blue* (Ill. 57), Picasso seems to be sweep-
ing his eye over the centuries he was leaving behind and giving us a wicked
pastiche of all those overblown costume portraits that high society had
taken so seriously. He is mocking the absurdity of it all; he is mocking
the grandiloquent skills so laboriously acquired by artists flattering dress-
makers flattering husbands flattering their ladies flattering themselves as
Olympians of the *salons* – the entire chain of fantasticated sycophancy in
which women had been the golden link. Maybe Picasso is mocking the
very mockery of women, too, for she has a wild look in her eye, and the

118

mouth of a blooded piranha, as though she would gobble in an instant any man who would make a status symbol out of her.

And yet, how richly painted, how sumptuously enjoyed are those very skills he parodies – enjoyed just as much as Goya who had to paint this sort of thing to order as official painter to the Spanish court, and still managed to do so with such dash and with such perception of the frail or fearsome ladies cocooned within. Picasso's painting is a homage to his Spanish forebear just as much as it is any pastiche. It is Picasso dawdling out his youth for a while among the attics of the past, and playing with its dolls before going out to tackle the twentieth century.

Picasso never returned to painting dolls, but a number of his con-temporaries continued to do so all their lives. Now that clothes no longer hung a social label on to paintings of women, artists of the early twentieth century felt free to dress their subjects to suit themselves. Kokoschka even made himself a real doll, which he used to take with him to the theatre in Vienna as some sort of gesture of defiance for having been spurned by his mistress Alma Mahler. But that is beside the point. The real doll-painters were those who employed this new freedom from the demands of fashion-able portraiture to decorate images of women with costumes of their own fancy – generally erotic fancy. Vienna, because of the mine of fantasy opened up by *art nouveau* designers, and perhaps because of the presence of Sigmund Freud whose *Interpretation of Dreams* had been published in 1899, produced the most self-indulgent of these painters in Gustav Klimt. And none of his images of women is more self-indulgent in its decorative excesses than the portrait he painted in 1907 of a languid young beauty called Adele Bloch-Bauer (Ill. 58).

Klimt was to paint her several times, but never again quite like this. The inspiration is Byzantium. She is wrapped in gold like an icon. Gold, the most precious of man's materials, traditionally encased the most pre-cious woman in man's faith, the Virgin Mary. So Klimt is setting his devo-tion high: the doll has become an object of worship. All the artist's skills which in the eighteenth century would have been spent on effects of lace and silks have been lavished on this extraordinary golden mosaic far more elaborate than the casing of any icon; it is as if she is gazing down at us in majesty from the cupola of Santa Sophia.

This exalted status she owes to her role as a kind of artist's super-doll. Had she been an eighteenth-century clothes-peg all this gold would have honoured some other man – the man who had bought her and bound her with these rich spoils from the earth that he had successfully plundered. But Klimt's portrait does not feel like this. If there was a Herr Bloch-Bauer, and presumably there was somewhere, we are not made aware of him. He is irrelevant to the picture. And the reason is simple enough: this is not about fashion, it is about fancy-dress. She never wore such a costume, nor did she ever inhabit such a room. Klimt has supplied it all, not an

119

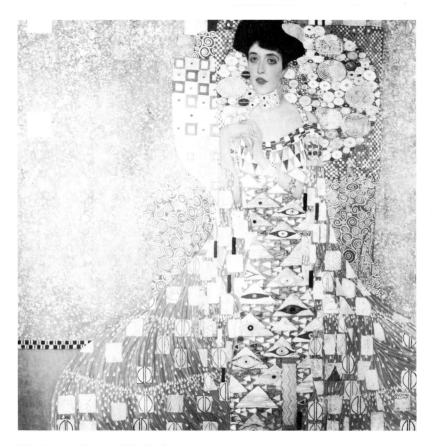

58 GUSTAV KLIMT, *Adele Bloch-Bauer*

absent lover or husband. The gold is his, the worship is his, the picture is his, and by extension she is his because he has created her. She is his work of art. He is her Pygmalion in reverse: he has turned her back into art so that he may love her.

In this way the painter's art becomes the vehicle for flattering, not a patron, but the painter himself. By treating her as a doll – passive, mute, portable, dressed and undressed at will – the artist has complete control over her. He can make her exactly what he wishes her to be. As a clothes-peg she at least enjoyed the identity of being another man's real woman: now she has no identity at all beyond that of embodying the artist's sexual fancy. It is interesting to apply the Berger test to Adele Bloch-Bauer and let the eye turn her into a man: instantly the sexual frisson evaporates and he becomes a ridiculous decorative ornament. This is even more strongly so with the costume pictures Henri Matisse painted between the

120

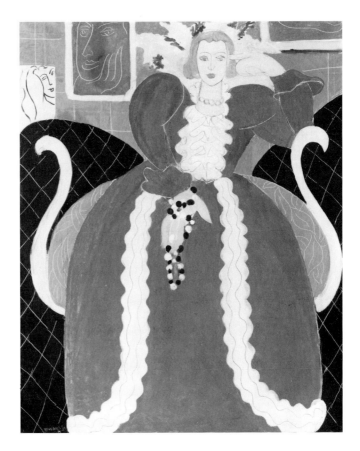

59 HENRI
MATISSE, *Lady in
Blue* (collection of
Mrs John
Wintersteen,
Philadelphia)

wars. Now they even look like dolls. *Lady in Blue* (Ill. 59), of 1937, is a
vibrant pattern of coloured shapes in which the sofa and the dress with
pale frills form luscious arabesques swooping around her like the necks
of swans – but where is the lady? She is somewhere hidden within and
behind all those arabesques. She points to her head as if to say 'Here I
am!' She does not even figure in the title of the picture. The painting is
about her clothes, not about her. A doll is nothing, except what it wears.

I admire Matisse, and I enjoy him. There are paintings by him – though
not this one particularly – which I would dearly love to have around me
where I live and where I work, and which leave an afterglow in the mind's
eye from the public galleries where they hang. To encounter Matisse is
to encounter a very familiar and unruffled world transformed into a kind
of carpet. It is a world interpreted as colour-patterns and rhythms. The
eye follows one pattern, which is echoed by another. Start again with a

121

third pattern and the picture changes: different colours come forward, others recede.

But the world of Matisse is also a world of women. He was as obsessed by them as Renoir was. For Renoir women had been pretty ornaments in the sun: for Matisse they were pretty shapes in the carpet. It is a revealing fact that the two painters of the last hundred years whose work is most closely associated in our minds with the theme of women should both of them have been artists fascinated by life's surfaces, not its substance. It would seem that women as decorative objects – as dolls to dress and arrange and play with as man pleases – fit so much more comfortably into the creative process than women as human beings. It is also true that Matisse, as much as Picasso, has been the modern master who has exerted the most profound influence on the art of our time. In his exploration of colour he awakened a fresh perception of what the painted surface could be. And yet in his treatment of his favourite theme – women – he looked not forward but back, far back, to all that heritage of painted rag-dolls men have loved to display, to possess, and not really have to think about very much.

No wonder the art of our day has had nothing to say about women. It has been left – significantly – to commercial artists to dictate the way we see them. Having formerly dressed to advertise a man, women now dress (or undress) to advertise a product.

Clothes-peg or doll, woman depicted in this way is made to inhabit a kind of nursery world. The picture frame is her play-pen. She has been infantilised. Her status in art reflects her status in life. 'She was created,' wrote Mary Wollstonecraft in 1792, 'to be the toy of man, his rattle, and it must jingle in his ears whenever, dismissing reason, he chooses to be amused.'

The toy of man has often been a sexual toy, and clothes have been a favoured means by which painters have endowed images of women with particular kinds of erotic status. The sixteenth-century German artist, Lucas Cranach the Elder, was pre-eminently an image-maker of this sort. He was official painter to the Electors of Saxony, and he amused the courtiers of Wittenberg with quantities of such toys, of which *Cupid complaining to Venus* (Ill. 60) is a pretty example. The picture purports to illustrate a third-century BC Greek poem by Theocritus called 'The Honeycomb Stealer', in which Cupid is attacked by bees and seeks help from Venus; and this trivial incident is given some pretence at ballast in the form of an inscription that Cranach has added – 'So in like manner the brief and fleeting pleasure which we seek injures us with sad pain.' Ho! Ho! It seems most unlikely that anyone at the court of Wittenberg was taken in by such gnomic solemnity. We can virtually ignore the honeycomb story, as well as Cupid having his little tantrum; and we can certainly ignore any moral significance the painting pretends to. Here is a very precise sexual statement, inviting an equally precise set of male responses.

122

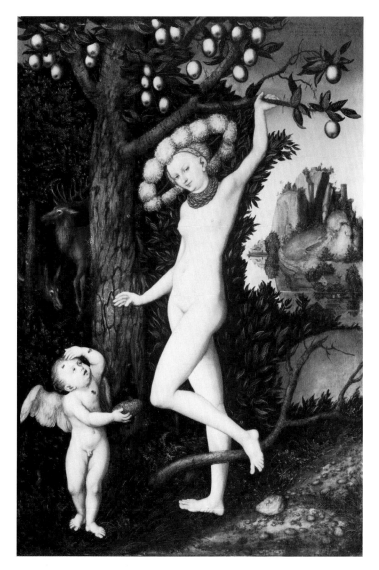

60 Lucas Cranach the Elder, *Cupid complaining to Venus*

Venus stands at the edge of a forest, naked except for a necklace and
a prodigious hat, with one leg crooked against a bough and one hand clasp-
ing a branch above her head. Everything about her is designed to allure,
and to do so in a particular way. If she were simply a nude she would
be appealing but no more so than any other pretty girl, and presumably
Elector Johan Frederick the Magnanimous had access to as many pretty
girls as he wished. So, rather like the tortoise in *Brideshead Revisited* which

123

was transformed into a precious trinket by having diamonds studded to its shell, Cranach has called her Venus, the Goddess of Love herself, which elevates her to a status flattering even to the ruler of Saxony. Cranach has then brought the goddess down from Olympus and given her this amazing hat to suggest that Venus was actually an ultra-fashionable lady of the Wittenberg court, even more flattering to Cranach's patrons because now she becomes accessible. But not only is Venus a fashionable court lady; she is also a temptress. The tree she grasps is laden with apples. No art patron in Saxony would have failed to spot her similarity to those Gothic representations of Eve in the act of bringing about man's downfall. So, to her erotic status as Venus are added delicious implications of sin. Cranach has cunningly manipulated a variety of contradictory associations in the mind of the spectator in order to flatter, tease, excite, and entertain him all at the same time. She is a toy designed never to grow stale: she will jingle in man's ears whatever mood grips him.

Different patrons expected different toys, relative to the tastes and fashions of the particular era. Cranach's hybrid of Eve, Venus, and society lady was a quirk peculiar to the court of Wittenberg. A more universal sexual fantasy among wealthy art patrons was the eighteenth-century shepherdess. She personifies the French taste in amorous painting during those dancing years before the Revolution, and being French taste it was copied by most of the other royal courts of Europe.

Now the adult nursery world is nature itself, or at least a cleaned-up version of it – to every good Frenchman real nature was of course dismissed as *le désert*. The young Marie-Antoinette could free herself from the straitjacket of court life by playing milkmaids at her little farm in the grounds of Versailles. Similarly, the patrons of Lancret, Boucher, Pater, and Fragonard could escape the privileged tedium of their town lives into a fake rusticity of baa-lambs and rosy-cheeked maidens.

Dressing women up as shepherdesses carried a number of advantages and painters exploited these advantages with charm, skill, and an unwavering disregard for veracity. Indeed, the whole point of pictures such as Lancret's *The Bird Cage* (Ill. 61) was to avoid any possible invasion of truth. The shepherdess was quite outside the social milieu of the French ruling classes, so she could be safely played with. She was inferior, without power or status, and in this guise a woman could be represented as entirely servile and compliant, while performing useful menial tasks that conveniently denied her any brain or individuality. She only needed to be pretty. What was more, she lived close to nature and was therefore by implication more natural, more sweet, and more wholesome than other women. As every advertising agency knows, if you want to make a product appear clean and good for you, set it in nature among fresh flowers and dimpling streams. How many Versailles courtiers, saddled with their titled termagants and lumpy duchesses, must have longed to be Lancret's young gallant with

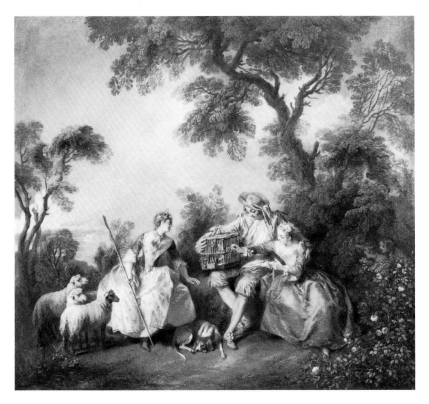

61 Nicolas Lancret, *The Bird Cage*

two innocent little dolls to play with. He has a bird-cage on his knee, and
the two birds symbolise the girls' purity. Both girls are reaching out to
set the creatures free; they are vying with each other to give themselves
to him. Here is the pre-Revolutionary male dream – to be free of life's
burdens to dally among pretty maids who will never expect more than
to guard sheep and be led like sheep.

Nature's child! Extending far beyond the dallyings of eighteenth-century
courtiers, how her appeal ripples through western art. Flowers in her hair,
fruit in her arms, she is that other aspect of woman in harmony with
natural forces. In her first aspect she was deadly, a man-eater, harnessing
nature in order to destroy man: she was Artemis, Circe, Medea, the Sirens,
Medusa, and the witch who copulated with the devil. She embodied all
man's sexual fears, and she gave him the pretext to subdue her, control
her, rape her, burn her. But in the aspect of nature's child she is harmless,
man's delight, his dream of innocent perfection. She wears nature because
she is part of it. She is Flora, Perdita, Ophelia: the nymph glimpsed naked
in the forest or dancing barefoot on the shore, always out of reach because

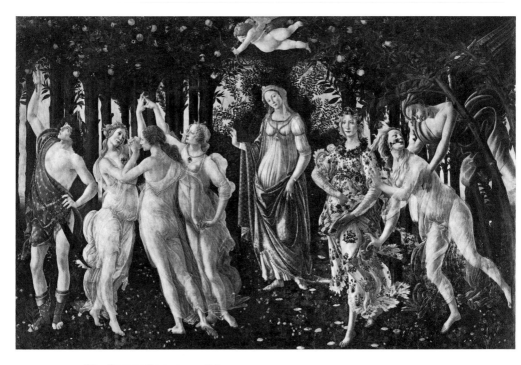

62 SANDRO BOTTICELLI, *Primavera*

she belongs to nature, not to man. That is why he longs for her. To possess her would be to possess nature's secrets. She is all the seasons except winter – spring because she is young, summer because she is warm, autumn because she is fruitful.

She steps towards us most memorably as Flora in Botticelli's *Primavera* (Ill. 62). Garlanded in flowers, dressed in flowers, and strewing flowers about her, she walks on flowers too. She is not Love, for Venus herself stands behind her rather quizzically, and Cupid flying overhead is shooting his arrow quite the other way. No, Flora is not Love, but something much more unattainable, which is nature's perfection and fecundity. Love we can have – at a price, for Venus is dangerous. But this perfection of nature we cannot have because it is too pure for us.

I offer this not out of any art-historical certainty but because it is how the painting speaks to me. I believe this is what is so magically appealing about it. On a narrative level she actually illustrates a poem by Ovid which explains the origins of the annual spring festival of flowers, known as the Floralia. Zephyr, the West Wind, is chasing the nymph Chloris – shown on the right – and on being grasped by him, Chloris is transformed into the figure of Flora. And so the West Wind, harbinger of spring, marries the mistress of flowers, and she becomes goddess of the spring.

126

It is a delightful myth, and Botticelli has illustrated it with tenderness and with that extra perception of meaning which only a great painter – a great dreamer – can extract. Flora steps out of Ovid's myth as she steps towards us. And yet she is not for us. She is not man's clothes-peg; she is nature's. She wears flowers, not fashions. Flora's successors in painting are not those eighteenth-century shepherdesses and milkmaids giggling in the sexual playschool that man liked to call nature. They are those figments of male longing who, like Flora, are forever casting flowers of hope at men's feet, and who became worshipped by the Romantics as embodying that ultimate human experience – unattainable love.

7 *Beloved Lepers*

And so to love. To woman as the loved one.

Since most pictures have been painted by men about women, and the central human relationship has been the one between man and woman, here we might reasonably assume must lie the very heart of painting. Whatever moral code we adhere to, whatever philosophy we follow, it must seem right to expect such a dynamic passion as love to occupy the centre of that great mirror of our feelings which we call art.

But look around. Where are they, these painters of love? A few stand out – indeed, stand out because they are so few. Rembrandt, obviously; Watteau, certainly; Goya, sometimes – three painters I want to treat separately at the end of this book. Then, Rubens once in a while amid the muscular rough-and-tumble. Renoir occasionally as a young man. And then? A great many artists we rather vaguely associate with love on the grounds that they painted beautiful women, or people being reflective and sad, or naked, or in a helpless plight, but who are not really painters of love: Memling, Titian, Cranach, Vermeer, Gainsborough, Fragonard, Manet, Matisse, Modigliani, and a great many others.

In fact, compared to the vast body of pictures men have painted which depict women as sinners, women as virgins, or women as possessions, there are very few paintings indeed that treat women as lovers. The phrase 'love painter' does not even exist, though we readily describe an artist as a landscape painter, a still-life painter, a religious painter, a genre painter, even a sporting painter.

There are, of course, painters of the nude by the thousand, but a nude may have little or nothing to do with love: love is a passion, and a nude neither expresses or invites passion. She is there to be assessed, not loved, even if she is called Venus. The fact is, where passions are expressed in paintings of the female nude they are generally sadistic: they relate to scenes of seduction, rape, or martyrdom, and there are infinitely more of these than there are paintings about love. Then there are an inordinate number of paintings concerned with love-games – the conceits of love, its frills and frolics – but these are not about love either, they are about amorousness, which is different again.

Yet man has this enormous capacity to love. Nothing else about people

matters so much. The most significant thing about the human race is that people copulate, and that unlike the rest of the animal kingdom they do so not just to procreate but as an expression of love.

So, where is the art of love? Why is it so rare? In defence of art it may be said that until very recent times no code of decorum has permitted the frank display of love-making; and that in any case there are quantities of lubricious drawings and paintings circulating surreptitiously between the *cabinets de dessins* of horny collectors where they rightly belong. But this has little to do with it: the art of love does not have to be an illustrated manual on the techniques of sex. Literature is rich in love poetry, little of which offers descriptions of copulation. And what about music? It is not necessary to be Shakespeare's Count Orsino to experience that music can be the food of love: yet even music which sets out to be overtly descriptive – like Debussy's *La Mer* or Tchaikovsky's '1812' Overture – cannot describe their subject precisely, in the way painting can. Music can only allude, evoke, stimulate a mood, offer an equivalent experience.

Maybe the answer lies here. Music, unless accompanied by the human voice, has to be an abstraction of human experience; it is unencumbered by direct references to life as it is lived. Free of these references, music by-passes the moral and social inhibitions which organised society sets up to govern the relations between men and women. Poetry communicates experience more literally than music, but still obliquely through the symbolism of words: life is re-cast in terms of language and the abundant metaphors language offers. For instance, 'Shall I compare thee to a summer's day?' is a statement about love. But a picture of a summer's day cannot be unless it includes the image of the person loved. Only painting insists that human experience is evoked by an actual physical imitation of life itself. Painting is naked in a sense that neither music nor literature are naked; hence it reflects more nakedly the reality of man's response to woman in the world we actually live in. Music alludes; literature compares; but art confronts.

Seen in this light, the scarcity of love paintings alongside the profusion of paintings about nudes and rapes and martyrdoms is obviously much more than a question of decorum. It is to do with the level of reality at which painting strikes. Freud expressed the view that the artist taps man's human neuroses and thereby makes it possible for the spectator with no such gifts to derive pleasure from his own unconscious. If Freud is right, then this scarcity of paintings which are unequivocally about love tells us a revealing amount about man's inner fears and fantasies of women.

There is a picture in the National Gallery, London, which on the surface has nothing whatever to do with sex. It is an early painting by Titian, and it describes the first appearance of Christ after the Crucifixion – to Mary Magdalene (Ill. 63). It illustrates the moment described in St John's Gospel when Mary, having first taken him to be the gardener, recognises Jesus

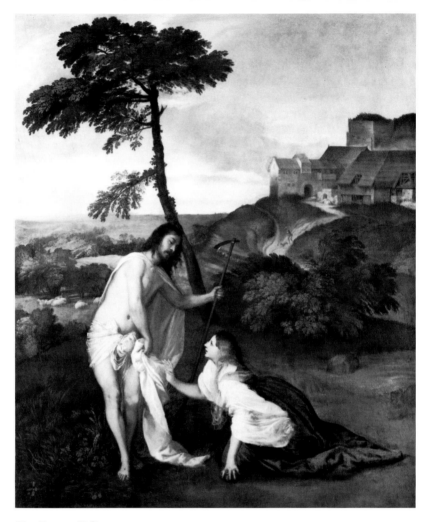

63 TITIAN, *Noli me tangere*

and reaches out for him, only to be rebuked with the words 'Noli me tangere' – 'Touch me not, for I am not yet ascended to my Father'.

Titian, with a touch of well-intentioned absurdity, has put a hoe in Christ's left hand, there being nothing else about this almost naked figure that could possibly have led Mary to assume he was the gardener. Certainly, Titian did not want Jesus to look like a gardener: he wanted him nude, or as nearly nude as Christ could be decently allowed to be. Most obviously this was because the Bible states that his linen clothes were still lying in the empty sepulchre; but from the way the two figures relate in the picture it was also clearly important to Titian that the physical beauty of Christ

130

should act as a kind of magnet for the Magdalene. On her knees she stretches forward with a surge of emotion to touch him. He in turn arches his body away from her and pulls his cloak in front of his loins.

We cannot know what was in Titian's mind when he chose to compose these two figures in this way. He would certainly not have wished to invite a charge of blasphemy by admitting even the hint of a sexual relationship between Christ and Mary. Yet at some level of consciousness this is exactly what he did. And if this sounds absurd or offensive, try looking at the painting for what it physically is – a description of two figures confronting one another in a landscape – and then arrive at the most likely interpretation of what is really going on. Looked at in this way, here is a picture about a woman making an impassioned physical approach to a naked man who is engaged in hastily covering his genitals and keeping his distance.

Our Christian ethic derives from the example of an earthly Saviour who shunned all physical relationships with women, and whose mother conceived him as a virgin. Titian was one of the most intelligent artists who ever lived, as well as one of the most sensual: it is impossible to imagine that a man of such shrewdness could have failed to grasp the psychological implications of this precedent – that horror or fear of sexual contact is built into the moral code of Christianity. *Noli me tangere*, besides being among the most beautiful pictures Titian ever painted, is also a profound statement about male sexual untouchability; and the enormous force of this statement comes from the fact that he has made it about the Son of God. And as if to underline this inner meaning, Titian chose as a setting precisely the same formation of landscape and farm-buildings as he had used in another picture some five years earlier. This was not a biblical painting at all – far from it: it was Giorgione's *Sleeping Venus* (Pl. VI) which, according to the diary of Marcantonio Michiel, Titian had completed. Why the identical setting? We do not know: Titian would hardly have been willing to let on. All we do know is what we see: the landscape in which the Goddess of Love reclines in one picture becomes the landscape of Mary Magdalene's love for Christ in another. The pagan promise and the Christian rejection. It is hard to believe Titian made this conjunction by accident.

It is also hard to believe that Titian had not read his St John's Gospel, and noted the discrepancy between Christ's physical rejection of Mary and his invitation to Doubting Thomas, ten verses and eight days later, to touch his wounds with his hand – a discrepancy that the Church has never satisfactorily explained, though it has worried over it at great length. Christ's own explanation, as John gives it, seems more like an excuse – 'for I am not yet ascended to my Father'. But he had still not ascended when he spoke to Thomas, so why 'Yes' to Thomas and 'No' to Mary Magdalene?

All in all, it is not surprising that the physical recoil of Christ before Mary should look like male retreat from a voracious sexual female. The moment of *Noli me tangere*, as Titian has described it, has taken on the significance

of a corrective to that other confrontation in the Bible in which woman reached out to touch man – when Eve offered Adam the apple, and Adam did not recoil but took it. The picture even looks like a re-enaction of the Temptation, this time with man refusing to be tempted and so regaining his power, his authority, his control over women, which in the Garden of Eden he lost.

The notion of Christ as the redeemer of man's sexual authority is not likely to win me a host of admirers in the College of Cardinals. And in strictly theological terms the notion of course is entirely meaningless. But pictures, even when they directly serve the Church, are not theological illustrations, though the Church might wish they were. They are interpretations of a legendary world in terms of the known world; and it is in this process of translation from legend to a kind of living reality where paintings sometimes expose unexpected meanings and unexpected truths. One of the primary functions of art is to do just this. The biblical account of Bathsheba, as I have shown, acquires a quite new significance when interpreted by Renaissance and Baroque artists. So does the Greek myth of Danaë. And so, inevitably, does the story of the Fall of Man and the story of Christ's appearance to Mary Magdalene.

Suddenly these last two images seem to lie side by side in the mind like the twin panels of a diptych set up for man to contemplate and learn from. Art has created two immensely powerful archetypes of the right and wrong relationship between man and woman. In the Genesis story man concedes to woman out of love, enjoys what she offers, and is punished by being cast out of paradise. In order to win back his place in heaven, as the New Testament makes clear, he must reject woman even if he loves her as Christ loved Mary Magdalene; and it is Jesus, man's own saviour, who shows him how.

Here lies a formidable dilemma. Man also loves. Man is a sexual animal. For a painter to represent woman loved involves a violent clash of values because to be truly loved she has to be morally respected as well as sexually desirable; yet man's strongest passion is the very thing his God says he should deny. The only resolution which will placate God and satisfy man is to keep his sexuality towards woman apart – to create a physical or psychological barrier between himself and the object of his desire. So, in painting love finds its most natural expression at a distance, and the fullest display of male passion for a woman is from the safety of separation.

At its most extreme this separateness finds expression in some of the passionate art offered in worship of the Virgin Mary. It would be hard to retreat further from a loved one than by choosing to equate the perfect woman with a long-dead virgin and then adoring her from within a cocoon of priestly celibacy. It can be no coincidence that the mediaeval cult of the Virgin Mary expanded in parallel to the romantic cult of Courtly Love

132

64 Tapestry detail:
*The Offering of the
Heart* (copyright
SDPMN/DACS 1984)

– the Bible and the thirteenth-century *Roman de la Rose* are said to have
been the two most popular books of the late Middle Ages. The divine ideal
of woman and the earthly ideal of woman had much in common: one was
kept at a safe distance by dogma, the other by chivalry. Both ideals
precluded sexual consummation; both invited male adoration for a woman
who was required to be physically unavailable.

Courtly Love found its most handsome expression in the courtly art of
tapestry; and it is in a tapestry like *The Offering of the Heart* (Ill. 64), woven
in Flanders during the early years of the fifteenth century, that the ideal
of chivalric love is clearly shown to be an elaborate convention for keeping
lovers as far apart as possible. Look at it: two lovers are supposed to be
meeting in a forest. He is stepping forward to offer the lady his heart –
his undying love – rather as though he had just plucked it from one of
the trees. He holds it out to her with one hand while making some sort
of beckoning gesture with the other.

But far from being moved, or impressed, the lady takes no notice what-
ever. She is making an offering too – nothing so poetical as her heart, just
a tit-bit for her dog. None the less it occupies her attention entirely, and
if she is to be distracted at all it is likely to be by the falcon perched on

133

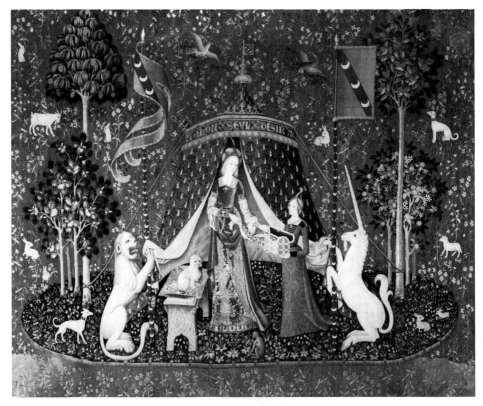

65 'A Mon Seul Désir', from *The Lady with the Unicorn* series of tapestries (copyright CNMH/DACS 1984)

her other hand, certainly not by her suitor. She is a huntress, a mediaeval Diana whose virginity is impregnable and whose pleasures are solely with nature. His cause is hopeless, and of course he knows it or he would never be making such an extravagant offer. If she were to raise her head and reach out to take the heart, or fly into his arms, the whole convention would collapse and his chivalric conceit be put to flight. It is a pretty story and a silly story, and it is woven to embellish with appropriate love sentiments the chasm that separates the man from the lady whom he pretends has enslaved him.

These amorous courtly sentiments come into their own when the separateness of the lovers is openly acknowledged. Then the most delicious self-indulgent passions can flow. A more famous tapestry of the sixteenth century is from the series in Paris known as *The Lady with the Unicorn* (Ill. 65), probably commissioned as a wedding gift. The bridegroom or male lover only acknowledges his presence with heraldic devices and in the form of a protestation of love. 'A Mon Seul Desir', inscribed across the tent where the much-desired lady stands. Removed from the scene, he can shower

134

66 NICHOLAS HILLIARD, miniature:
Young Man Among Roses

her with the trappings of love without having to make any ludicrous
gestures from the wings. She is gorgeously dressed, she takes his gifts of
fine jewels from a casket, all nature pays her court, and the trees laden
with ripe fruits proclaim his longing for her. But she is a virgin – the tamed
unicorn kneeling at the sight of her tells us that. She is a glittering showcase
of virtue, and the garden of love where she stands is like an island beyond
his reach. From afar he can safely regard his paradise and adore the fair
maiden who presides over it.

It is easy to imagine him to be the *Young Man among Roses* (Ill. 66) in
another work from the sixteenth century – Nicholas Hilliard's miniature
in the Victoria and Albert Museum, London. Here is exactly the sort of
young exquisite with his hand on his heart who might be gazing in agonies
of pleasure at his 'Seul Desir' over there on her island of virginity. For the
Elizabethans, too, were obsessed by the conventions of Courtly Love; and
whoever he may be – the Earl of Essex or some languid courtier who loves

135

being in love – he is the perfect match for her. He, too, is decorated with the trappings of love – the fine clothes and fine legs to impress her, the curls, the gestures, the cloak casually cast off one shoulder, the roses that grow apparently all over him as if he is held up by love alone, and of course the thorns so very prominent to tell us of the pain which is love's hand-maiden and his destiny.

> Yet what is love, I pray thee sain?
> It is a sunshine mixed with rain.
> It is a tooth-ache, or like pain;
> It is a game where none doth gain;
> The lass saith No, and would full fain:
> And this is love, as I hear sain.

Sir Walter Raleigh's sentiments fit him as snugly as his clothes. Like the Lady with the Unicorn, he too is separated. What separates him is his own demand that she remain virtuous; and in order to remain virtuous she has to say No. It is he who insists on it, while pretending it is she. *Noli me tangere.* So, the game of Courtly Love is played to his fullest satisfaction. His God, who says he should deny women, is placated, while his own strongest passions are freed from guilt to fly out to her across the abyss.

The High Renaissance, and above all the Venetian High Renaissance, brought very different conventions to bear on the theme of human love; and in particular there was the classical convention of the female nude. Venus, the Goddess of Love, was commonly represented in Renaissance painting as nude, and so in various mythological guises were a variety of beautiful ladies offered to us by artists without coyness or prudery as Love Objects. But there was no equivalent convention for men. The male nude in Italian Renaissance art might be offered in a spirit of narcissism, or of pederasty, but certainly not for the sexual delight of women. Male painters, working for male patrons, were not at all favourable to exposing their own sex in the way they relished with the opposite sex. (The modern cinema follows exactly the same double standard, and presumably for exactly the same reasons.) Male lovers by and large were, and are, expected to be decently clothed, at least around the loins.

It is only when these two conventions come together in a single painting, like Giorgione's *Concert Champêtre* (Ill. 67), that the double standard begins to look like another manifestation of *Noli me tangere* – that protective barrier set up by men between themselves and the women they desire.

I have often stood in front of Giorgione's painting in the Louvre and felt physically warmed by this vision of a world at peace, a world in which the most gentle pleasures of the senses fill people's hours and are echoed by a gentle landscape in the evening sun. The painting is generally interpreted as an Arcadian vision of perfect harmony such as Renaissance poets loved to wax lyrical about: and, having said that, historians have got down

136

to the usual business of art scholarship which is to decide how much Titian may or may not have added, what X-rays reveal, the origin of this or that pose, the possible relevance of a drawing in the British Museum which may or may not be a copy of a lost Giorgione original, and so on.

But what is immediately striking about the picture is that the two men are clothed while both women are naked. Furthermore, the men are entirely absorbed in one another. The two women are in attendance on them: we – the spectators – are more aware of them than the two men are. The effect is not in fact one of harmony but of separateness. The men are at peace because they are separated. Their clothes set them at a physical distance from their women, and hence at a psychic distance. The women, by being naked, offer availability and intimacy: the men offer neither, preferring to inhabit a private and untouchable stockade of maleness.

The picture brings me back again to Titian's *Noli me tangere* (Ill. 63), painted only a few year later. Here the sexes are reversed – Mary Magdalene is clothed, and Christ naked. But look at the difference. The two women in Giorgione's painting are made to look at ease and confident without

67 GIORGIONE, *Concert Champêtre* (copyright SDPMN/DACS 1984)

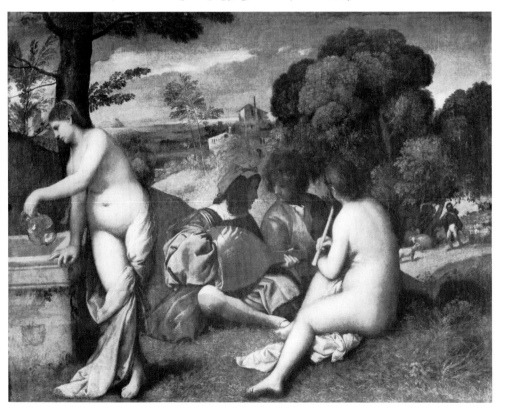

clothes: the artist even displays the vagina of one of them, full-frontal and fully lit. The naked figure of Christ, on the other hand, is made to look coy and threatened: a cloth not unlike the one the women have unconsciously let fall is hastily tugged across his loins which in any case are tightly bound already. The two men in the Giorgione are emotionally distanced by clothes; but Mary Magdalene's clothing is no emotional barrier at all – she reaches out towards Christ with an impassioned surge of her body. The pictures compliment one another and tell the same story: it is woman who advances and man who recoils.

But supposing man does not recoil. What happens if he gives in to his passions and rushes headlong to the lady he loves? This is, after all, the glamorous thing he is supposed to do. Yet history, religion, myth, literature, and of course painting, provide overwhelming evidence of exactly the opposite: that, far from longing to be unrestrained in his love for woman, he fears that he will be punished for it, even destroyed by it. It is love as disaster, not as bliss, that has most deeply caught the artistic imagination. It is no accident that many of the most abiding love stories we have are tragedies – Hero and Leander, Orpheus and Eurydice, Tristan and Isolde, Romeo and Juliet, Antony and Cleopatra, Héloïse and Abelard, Dante and Beatrice. Paintings illustrating the theme of Love Satisfied, if gathered together, would occupy a tiny area of wall-space compared to the acreage filled by accounts of passionate doom.

Among the most eloquent illustrations of how male love of woman can be divided into the safe and the unsafe are the paintings of Rubens. Not even Titian loved painting women more than Rubens. No other Baroque painter of the seventeenth century made the figure of woman so crucial to almost everything the artist had to say about life. She is the emotional focus of Rubens' imagination, and the theme of man's love of woman often haunts even those paintings where love is not obviously relevant. Not for Rubens the calm, almost drugged vision of Giorgione and the young Titian, in which the ideal condition of love is a reflective and interior state, cool as a cell. Rubens is forever making public statements about what love is, what it looks like in action, and what it does to people; and it is because his art is a public stage that his actors declaim their roles so clearly.

Rubens treats the theme of love in a variety of ways. As the most tender state of conjugal happiness (the self-portrait with his first wife in a honeysuckle bower (Ill. 101)). As female sexuality offered to be enjoyed (Venus as Helena Fourment, the artist's second wife). As the preoccupation of elegant company at a garden party (*The Garden of Love*). As a beauty parade (the numerous versions of the Judgment of Paris (Ills. 46, 47)). As a pastoral frolic (*Venus and Adonis*). As temptation for a king (*Bathsheba*). And as rape (*Leda*, the *Rape of the Daughters of Leucippus* (Ill. 34), and the *Effects of War*). Each of these experiences of love is presented as deeply pleasurable to a man. No threat, no fear, no danger is implied in any of them. Here is a

138

range of love relationships that are entirely within the rules of a society controlled by men, and therefore safe for men. There is the institution of marriage in which the woman is man's legal property. There is the mistress who is his sexual property. There is the dress parade in which she is the clothes-peg showing off his wealth and success. There is the beauty contest he is invited to judge. And there is the sexual meat he is invited to devour. In all of them the woman is subservient. She has no power over him. It is never required of his love that he sacrifice control or expose himself to vulnerability. All vulnerability is on the woman's side.

But in a very few paintings Rubens does treat male love for a woman as a passion that cracks this armour of male authority. And suddenly the mood is very different indeed: instead of love being an experience pleasurable to man, it is an invitation to chaos. Either that chaos is implied in a story we know well (*Adam and Eve in Paradise*), or it is vividly described (*Hero and Leander* (Ill. 68)). In either case the lesson is extremely clear: man has disobeyed the laws of male society, he has allowed passion for a woman to rule him, and the gods have punished him.

Both pictures were painted by Rubens as a young man, before his glittering career took off, and it seems significant that we never see man presented so vulnerably again once the honours of every court in Europe began to shower upon the artist. Thereafter Rubens' men, like his own fortunes, swagger in confidence through the world. In these two paintings, though, man stumbles into disaster for the love of woman. Adam, handsome and

68 PETER PAUL RUBENS, *Hero and Leander* (Yale University Art Gallery)

built like an athlete though he is, is obsessed by Eve – at her mercy. She is beautiful, commanding, and disdainful. It is the very moment of the Temptation: she has him, like the apple, in the palm of her hand. And he is doomed.

Leander, too, fell because of a woman. According to the Greek poet Musaeus, Leander used to swim the Hellespont by night to meet the lady he loved. She was Hero, a priestess of Venus, who would guide him across the water with a lighted torch. But one night a storm blew out the light and Leander was drowned, whereupon Hero threw herself into the sea and shared his fate.

What Rubens gives us is a storm of cataclysmic proportions – a glare of lightning, cascades of spume, gigantic waves sucking the helpless lover into a trough of black water from which he has not the minutest chance of survival. His death is presented to us not as a terrible accident: it is a judgment. Like the storm in Shakespeare's *King Lear* (written, incidentally, at much the same time) this rage of the elements is a divine curse on him as well as an echo of the emotional storm within him. And, like Lear, Leander is a noble creature: Rubens lays him on the water like a fallen god. His great battered torso is superb in death – he is loved by sea-nymphs who tug at him in helpless pity. What he has done is magnificent because he has given all for love. At the same time he has met the fate he deserved.

Is Leander, then, heroic or a fool? Rubens backs off from dealing with searching questions by telling his story through the medium of melodrama, hiding behind the artificiality of theatrical effects so that in the end we are not troubled by having to take the painting too seriously. Full-blooded passion was something Rubens never felt comfortable with. He lightens his story even further by infusing it with playful banality. The nereids who pull at Leander's body also frolic in the waves that have drowned him, and by implication they invite the male spectator to frolic with them. We can almost forget that Leander is supposed to have drowned for love, and that the lady he loved is hurling herself to join him in death far over on the right of the painting. So, the cutting edge of male anguish is blunted, and the thought we take with us in the end is not the disturbing one of man destroyed, but the comforting one of man resuscitated – Leander need not have been so foolish as to abandon himself to love; he could have lain back and had any nymph he wanted.

From here there was a choice of two directions for the male lover to go – towards love as pleasure or towards love as pain. He could hold back from Hero and frolic with the sea-nymphs, or he could be Leander and meet his doom. The first aspect of Rubens' painting looks directly towards the eighteenth-century court of Versailles and to Boucher's flotilla of little mistresses ((Ill. 45) with their bottoms in the air splashing around the libido of Louis XV.

The other aspect, more serious, looks further forward to the darker

waters of Romanticism and the turbulent passions of unrequited love. That storm that swept Leander to his death is the storm of the nineteenth century brewing.

Earlier I posed the rhetorical question 'Where is the art of love?' Surely, you may say, it is here. Romanticism and love are synonymous; and if it is not about love then what on earth is it about?

So, with Keats in my head and Chopin in my ears I thumb through books on Romantic art in search of love. And what do I encounter? I am massacred by armies, blinded by sunsets, shipwrecked, eaten by sharks, toppled by avalanches; I man barricades, attend funerals, commiserate with widows, commit suicide over and over again, gaze at a thousand Gothic churches by moonlight, attend numerous amateur productions of Shakespeare, visit almost as many convents, am visited by ghosts, dog the footsteps of Hannibal, Dante, Napoleon, and Byron, and travel in overcrowded carriages in a top-hat to desolate beaches at low tide. Exhausted, I pause to admire sheep, bird's-nests, pebbles, small children, and smaller flowers. Finally I search for oblivion, then drink the waters of Lethe, and have horrible dreams.

Recollecting these experiences I realise that they have been very little to do with women. I may have suffered a good deal on account of them in the course of these journeys, and they on account of me; none the less women have not been much in evidence. It has been a man's world I have whizzed through.

No, I do not think Romantic art is greatly about men's love of women. Self-love, yes! Most of all it is about extreme states of emotion. The fire that burns within these extreme states is sometimes passion for a woman, it is true, but at an enormous distance from the object of that passion. Such intensity of feeling needs space around it to breathe, needs isolation to feed on, unfulfilment to raise its pitch. 'Heard melodies are sweet, but those unheard / Are sweeter . . .' Keats speaks for most Romantic artists. The focus of Romantic Love is no longer Woman Owned: man cannot own her now; love for her owns him, holds him 'in thrall'. So he scales peaks in her name, crosses perilous seas for her, liberates nations, rescues the downtrodden, dedicates all nature to her, even dies for her. But all this he does alone. Romantic Love has elevated the male lover to a new pinnacle of untouchability.

One might expect Romantic art to be the expression of anguished vulnerability to women, but this is not what it feels like. All this exploitation of extreme states of emotion feels much more like a bid to regain confidence in maleness – a re-assertion of male control over the realms of passion which somehow, somewhere, had got lost. The art of Renaissance Europe showed man supremely self-confident at the centre of his expanding universe: he knew who he was, where he was going in this world and

the next, and his admiration for women was on the perfect understanding that they were there firstly to flatter him and secondly to breed him an heir. They would cause him no pain, offer no threat to his mastery of all he surveyed.

But by the beginning of the nineteenth century that male serenity had become deeply furrowed. Renaissance self-confidence had stumbled into doubt. The monarchies of Europe were being shaken or overturned; revolutions were upsetting traditional structures of male authority. The world was no longer the same secure place for man to command. It was women, after all, who knitted at the foot of the guillotine. In England, Germany, France, Spain, art developed nightmares – Fuseli, Martin, Blake, Friedrich, Girodet, Goya.

Inevitably these social tremors shook the way men regarded women, for without the confidence of controlling the world, confidence in manliness was undermined too. What Romantic art documents is how male self-confidence becomes re-asserted by transforming psychic frailties into positive virtues. Loneliness becomes a state of heightened spiritual awareness, self-pity an orgy of self-regard, self-destruction a heroic stance. It is better to be unhappy than happy. Love unsatisfied is finer than love satisfied; and the apotheosis of love is not blissful unity with the loved one but death through pining for her. Again it is Keats who speaks for the Romantic artist: 'For many a time / I have been half in love with easeful Death', and 'Now more than ever seems it rich to die, / To cease upon the midnight with no pain'.

Of all the extreme states beloved to the Romantics, death was the most extreme and the best-loved. Romantic painters gazed upon it in fascination rather as artists of the Counter-Reformation gazed upon miracles, and eighteenth-century artists upon sea-nymphs. And yet, when you look at Romantic painting, all this exquisite contemplation of death is in reality a contemplation of the effects of death on others. It is not about dying, it is about power: the Romantic cult of death is very like the posture of the child who announces 'I'll kill myself and then they'll be sorry'.

In the context of love the savouring of death becomes an expression of cruelty towards the loved one: it is the ultimate withdrawal, the final refusal to offer fulfilment and happiness; it is a determination that the woman loved will suffer helplessly and enduringly and with any luck will herself die. Francis Danby's painting in the Victoria and Albert Museum, *Disappointed Love* (Ill. 69), embodies all these aggressive sentiments, sugaring them with sentimentality to make the picture feel as though it is about love. She is dressed in virginal white, her hair falls loose, nature surrounds her with flowers in full bloom; she is a sexual woman spurned like a leper. The painting is a celebration of male rejection. So is Millais' more famous *Death of Ophelia* in the Tate Gallery. Again she is cradled by nature: the wild rose of love grows abundantly on the river-bank, while the flowers

142

69 FRANCIS DANBY, *Disappointed Love*

she has herself picked – pansies, daffodils, a red rose – float with her to her death.

In Romantic painting women are the victims of a resurgent male hostility elaborately dressed as love. Death, the ultimate self-indulgence, is also the ultimate revenge on the loved one. The archetypal revenge painted in Romantic art is Delacroix's *Death of Sardanapalus* (Ill. 70) in the Louvre, painted in the 1820s. This was during the flood-tide of Byronism, just a few years after the poet's death at Missolonghi, and like a number of Delacroix's themes at this time the *Death of Sardanapalus* was inspired by one of Byron's verse tragedies. This particular turgid drama, dedicated to Goethe, concerns a king of Nineveh who is overattentive to his pleasures and is defeated in battle by his rebellious subjects. As alarums sound closer and closer, Sardanapalus mounts a pyre built high around his throne and commands his favourite slave-girl to light it, so that he may be 'purified by death from some / Of the gross stains of too material being'. She – presumably one of those gross stains of which he is being purified – none

143

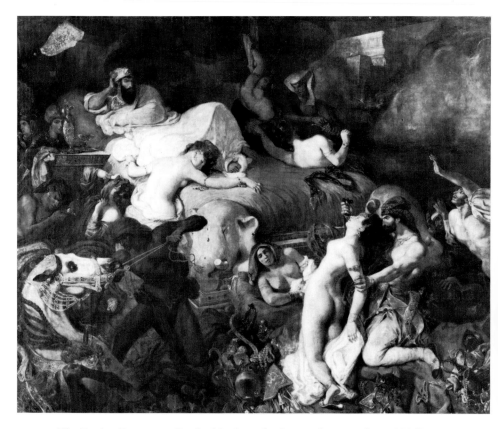

70 EUGÈNE DELACROIX, *Death of Sardanapalus* (copyright SDPMN/DACS 1984)

the less plunges a torch into the pyre and throws herself on to it to join him in ritual suicide, crying ' 'Tis fired! I come' (Curtain).

All this was meat and drink to an artist of Delacroix's spirit, and it is illuminating to see what he made of Byron's piece of posturing nonsense. Sardanapalus' throne is no longer a throne but a gigantic bed filling virtually half the painting. The picture is clearly going to be about sex, not kingship. And upon the bed the bearded king reclines in apparent comfort, while he surveys a scene of carnage all around him. In Byron's play Sardanapalus and his Greek mistress are the only two to die: the king has already ordered the occupants of his palace to flee to safety, taking the regal treasure with them, and all slaves to be freed so that they too may 'Fly! and be happy!' This, too, did not suit Delacroix's purpose at all. He wanted a massacre to match his *Massacres at Scios* which had won him so much public fame at the Paris Salon four years earlier. Most of all he wanted the massacre of women – one woman was not enough, it had to be a multiracial harem. They had to be naked, and they had to be put to death by men while the

king, and we the spectators, watch. Numerous naked women writhe in the voluptuous throes of death around the royal bed. One sprawls face downwards across the bed itself in an attitude of crucifixion. Another appears to be hanging by her arms. The most prominent one at the foot of the bed has been seized from behind by a soldier so that her breasts are thrust towards the king as the soldier's right hand plunges a dagger into her throat. Four other women, clothed, presumably await their turn. Art books delight in reproducing details of the *Death of Sardanapalus* to demonstrate how excitingly, sparkingly modern it is, with what masterful employment of Baroque diagonals, and how profoundly indebted to Rubens. It is all these things, and a revolting picture to boot. Delacroix has transformed Byron's absurd account of a suicide pact into a cold orgy of sadism. It would be hard to find a more unguarded display of the Romantic hatred of women.

The Romantic quest for new manly roles was bound to arrive at solutions less drivellingly self-pitying than all this. The male ethic required action too – action of a spectacular and courageous kind that did not pander to death but, instead, rescued weaker mortals from it.

So, along with the extreme state of suffering came the extreme state of valour: the Romantic hero rediscovered his active manhood as a mediaeval knight born again into the era of frock-coats and malacca canes. And in order to be a true knight in shining armour it was necessary to find a damsel in distress: without her there could be no point to it, no fun in it. Painters did not have to look very far. Western art and Byzantine art were rich in heroes who rescued ladies from perilous situations, and in particular there were three legends which required only to be updated. There was the legend of St George and the Dragon, originating in the Eastern Church; there was the classical Greek myth of Perseus and Andromeda; and the Italian Renaissance epic of Ruggiero and Angelica. All three appealed strongly to painters of the Romantic era, especially the last two, perhaps because they lacked the rather prissy Christian overtones of the first.

Christian or pagan, they are effectively the same story as far as painting is concerned – knight saves beautiful lady from dragon. In mediaeval painting, and in Byzantine icons, this story was treated as a simple parable of good and evil: the knight is Christian goodness in action, the lady is the Church, the dragon the devil. It became a favourite theme of Italian Renaissance painting from Uccello to Raphael. The straightforward parable interpretation was retained, though with the advance of Renaissance naturalism the combat between knight and dragon grew more lifelike and the lady's predicament began to contain a hint of sexuality. From being an impersonal symbol of the Church, she became more specifically an image of the Virgin. Paintings of the Virgin of the Immaculate Conception even include the figure of a dragon beneath her feet – lust symbolically trampled

under foot. The dragon was acquiring the added meaning of the serpent in the Garden of Eden, Eve's tempter. Already in about 1460 Uccello's *St George and the Dragon* (Pl. XIV) is electric with erotic meanings that run through the mediaeval pageantry like messages we are left to de-code: Uccello has the dragon open-jawed before a yawning cavern and bleeding from the thrust of St George's lance, while the lady stands gazing impassively at her rescuer and holding the beast by a cord fastened from its neck to her girdle.

Much more overtly erotic is Piero di Cosimo's *Perseus freeing Andromeda* (Pl. XV), painted about half a century later, also in Florence. Instead of the picture being just an allegory of good and evil, now the lady's predicament is personal and the threat to her specifically sexual. She is bound and naked to the waist; the beast's tusks thrust towards her as he advances. She turns her head in despair while her body invites the very assault from which she recoils. The artist has added a deeply ambiguous note to the story by making the lady not merely vulnerable but a temptress. In other words, the damsel in distress has become a sexual woman, therefore a bad woman, who needs to be rescued not simply from external evil but from the evil within her. Henceforward distressed ladies in European painting protest their virtue with a wink that is ever more exaggerated. Titian's Andromeda, in London's Wallace Collection, dances most fetchingly in her chains while the battle for her purity rages in the background. Rubens in his more mundane way (in the Berlin Gallery) has her lowering her gaze from her saviour as he wrestles with her bonds while busy little cupids lend a hand or take turns to ride Pegasus.

Here then in Renaissance and Baroque painting was all the armour the Romantic hero needed to re-equip his manhood. The distressed damsel, bound, naked and at his mercy, was the ideal focus of Romantic Love. For Uccello, Raphael, even for Piero di Cosimo, the lady to be rescued had been a subservient figure, lingering on the verges of a male combat and quietly awaiting the outcome. By the nineteenth century she is stripped and thrust at us like a victim. But a victim of what?

Look at Delacroix again (Pl. XVII). Here is Andromeda chained naked by her wrists to a rock so that she may only stand or kneel. The sea-monster is approaching, and plunging down from the sky brandishing shield and dagger is Perseus to the rescue. But the relative inconspicuousness of monster and rescuer throws all our attention on to the naked girl – quite the reverse of Renaissance accounts of damsels rescued, in which the maiden is a modest onlooker in the background. This is a picture about torture – mildly stated, it is true, and glossed over with soft sentiments and rather anaemic sensuality, but torture none the less. The narrative is paper-thin, the parable of good and evil even thinner; peel these layers away and there is only one meaning that the painting could hold for the nineteenth-century art collector or for us today – here is an elaborate overture to rape.

146

And yet the Romantic treatment of damsels in distress is more complicated than this. Invariably rape is implied but is never actually committed. The Romantic hero is meant to be a lover, a latter-day knight of chivalry: he is her saviour and the protector of her virtue, not her rapist, not even her lover at all in the physical sense. His manic energy and phallic weapons are directed not against her but against the monster about to devour her – a monster which itself represents lust.

This psychological complexity is even more striking in the paintings of Delacroix's great contemporary, Ingres. In art-historical terms Ingres is regarded as the classical counterpart to Delacroix, not Romantic at all; and stylistically this is true. Yet his paintings share many of the same nineteenth-century preoccupations with manliness and male authority, and he was an artist whose imagination was far more deeply engaged by women and by sexuality than was that of Delacroix, who cared little for women. The several versions Ingres painted on the theme of damsels in distress remain the most eloquent demonstrations we have of the Romantic hero in action.

The version of the story Ingres chose (Pl. XVI) was from Ariosto's epic poem *Orlando Furioso*. Angelica, a princess at the time of Charlemagne, is chained to a rock by a jealous lover so that she may be devoured by a sea-monster; but a pagan champion, Ruggiero, rides to the scene on a hippogriff (shades of the *Star Wars* saga!) and dazzles the monster with his shield – except that for Ingres a shield is too passive a weapon and he substitutes a more manly twenty-foot lance which he thrusts into the monster's throat in the manner of Uccello's St George.

How superficial the term 'Romantic' is when applied to paintings like these. On the most trivial level only can Ingres' *Ruggiero and Angelica* be regarded as Romantic at all. It might be possible, by switching the mind off almost completely, to regard such a painting as an illustration of courageous manhood dashing to the rescue of endangered womanhood, the man thereby proving his own honour and his love for her, and so earning her gratitude and undying devotion. Maybe this is what nineteenth-century connoisseurs told their wives these pictures were about in order to justify purchasing them. In this light Ruggiero becomes a boy scout *avant la lettre*, and Ingres is Lord Baden-Powell with balls.

On the pictorial level – what we most obviously see – it is another overture to rape. He is entirely clothed, she entirely naked. He bears an enormous weapon; she is bound. The jewels in her hair award her sexual status – she is a princess; his ardour and the size of his lance award him sexual status – he is a real man. He is the fantasy of the soft-porn magazine and the Victorian erotic photograph: a vision of sexuality for men of declining powers and ripening hang-ups.

But there is still more to it. Her nakedness, and the posture that she holds, suggest her sexual awakening. It is a sensation she is powerless to

resist; hence her chains. Her hair – invariably in art an indicator of a woman's sexual role – is long and free; she is abandoned to her emotions. He on the other hand is clothed, armed, protected; he is the master of his emotions. His passions and his lance, what is more, are directed against the dragon: they pass her by. The dragon is the embodiment of lust. This is what he is killing – her sexuality but also his. The love he has to offer is of the spirit, not the body. His act is therefore symbolically both a murder and a suicide: he is killing her sexual existence and his own. Though not quite. The weapon with which he destroys lust is itself a sexual one, and the mouth it penetrates suggests that traditional object of male terrors – the toothed vagina. So, out of fear of her lust he punishes her in kind, by brutal rape. The only sexuality apart from voyeurism which Ingres can contemplate is punitive, violent, sadistic. Had he lived in an era less starched in its language perhaps he would have been heard to remark on occasions of sexual discomfort – 'What that girl deserves is a damned good fuck!' Hiding behind the massive respectability of art, this is what the fantasies of Ingres announce. What sets out to be Romantic Love turns out to be Romantic Hate.

Through Ingres, the cult of the distressed damsel passed into the tepid bloodstream of the High Victorians – even more respectable than Ingres and utterly devoted to him as the standard-bearer of what they believed to be the great tradition of the classical nude. So Lord Leighton, President of the Royal Academy, has his Andromeda in the Liverpool Walker Art Gallery cowering beneath the dragon's wing as if it were a large black umbrella; and Sir Edward Burne-Jones, in the Southampton Art Gallery, has her mincing by the sea-shore while her boy scout gets thoroughly knotted up in the coils of his lust – an appropriate image. From nineteenth-century England the distressed damsel found a new home in the Victorian-ism of the early Hollywood cinema: now, instead of Perseus and St George, she found herself rescued by Rudolph Valentino and Johnny Weissmuller. From Hollywood she passed into popular strip-cartoons; thence she made a surprising reappearance in 'fine art' as late as the 1960s through that jester of modernism, Roy Lichtenstein. His *Drowning Girl* (Pl. XVIII) hangs in the New York Museum of Modern Art crying sweetly in tune with all her predecessors who had likewise believed that a big strong male meant a big strong love.

Looking back, nineteenth-century Romanticism feels like a violent storm generated by passions that came too close to one another and had to fight it out. All the major painters of the Romantic era were men, as they were in every preceding era; consequently the threat which passions so clearly posed were threats felt by men. The female view has passed unrecorded. The very few women who made any kind of mark in their profession during the nineteenth century justify no more than a few pages in Germaine

148

Greer's study of women painters, *The Obstacle Race*: their names are no more familiar than those of nineteenth-century women jockeys, and their paintings are all to obviously mere echoes of what male artists were painting at the time. In art there were no Jane Austens, Charlotte Brontës, George Eliots, Elizabeth Gaskells and Elizabeth Barrett Brownings, no George Sands or Mary Shelleys, to tell us how women really saw the world they lived in, or saw the men who ruled their lives and their beds.

After the suicides and the tears, Manet's *Déjeuner sur l'herbe* (Ill. 71), painted in the 1860s, looks like a peace settlement. The sexes have settled down to enjoying picnics in the forest. The fact that the picture created a famous scandal, and the ridiculous Emperor Napoleon III called it 'indecent', are irrelevant as well as being laughable in view of the Romantic savagery that had been served up as art before an uncomplaining public for the previous fifty years.

Manet's masterpiece was altogether too truthful for mid-nineteenth-century taste. It was not the kind of truthfulness which suggested, as was

71 EDOUARD MANET, *Déjeuner sur l'herbe*

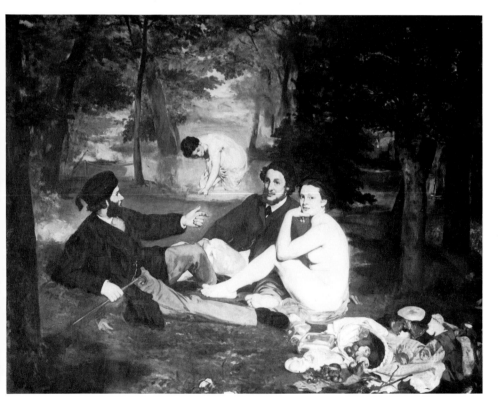

widely feared at the time, that fashionable Paris bohemians were in the habit of stripping their lady-friends in the woods while they drank wine, ate cherries, and did God knows what else. Manet was offering a truthful observation about the way – beneath the skin of good manners – that men have always looked at the women they desire, and about the way they have expected those women to look at them. The men are clothed and protected, the women naked and exposed. It is a deeply honest painting about what relationships between the sexes are really about, and Manet presents it in as natural a manner as possible in order to minimise the gulf between fantasy and reality, between art and life, which the nineteenth century had so preposterously enlarged. With Manet the two become inextricably mixed. The woods are those Manet knew around Paris, and the figures are the artist's favourite model, Victorine Meurend, plus his brother and a friend. But his other references are those of art. The composition is from Raphael's *Judgment of Paris*, which he knew from engravings, while the juxtaposition of nude and clothed figures in an Arcadian landscape is from Giorgione's *Concert Champêtre* (Ill. 67) familiar to Manet in the Louvre.

The *Déjeuner sur l'herbe* fascinates me the longer I gaze at it. No other painting I know casts so sharp a light on how art defines the nature of men's love for women, or comes so close to explaining the conundrum with which I began this chapter – why it is that women have been the abiding obsession of European artists, and yet there are so very few paintings which have treated women as lovers.

The *Déjeuner* is a piece of artifice made to look natural. It is a picture in which the language of art pretends to be the language of life. Conversely it is a picture of life represented as art, in a way which suggests that in our daily lives this may actually be what we do all the time – reshape the world around us in our mind's eye in order that it fits what we feel about it, just as in speech we choose the words that fit what we feel about it.

Manet's *Déjeuner* presses home the fact that European art has evolved a set of conventions – mainly through classical Greece and the Italian Renaissance – which have enabled artists to express more truthfully what men feel about women. And what those conventions tell us is that men have felt most at ease with women when able to perceive them as works of art, as objects to be owned, admired, desired, dreamed about, longed for, always from a self-protective distance. Hence art becomes an analogue of life itself: the artist creates a picture of the woman he loves because this is how he really sees her. And the distance at which he perceives her in life is analogous to that of the painter re-creating reality on a canvas set up between himself and the object of his love.

Picasso saw this. His fascination for the theme of the painter and his model was a fascination for this interplay between life and art. The artist creates an image of himself creating an image of a woman who is separated

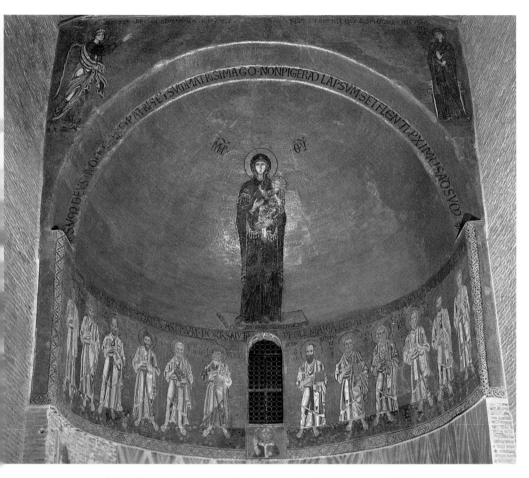

XIII Torcello Cathedral, Venice: mosaic of Madonna and Child

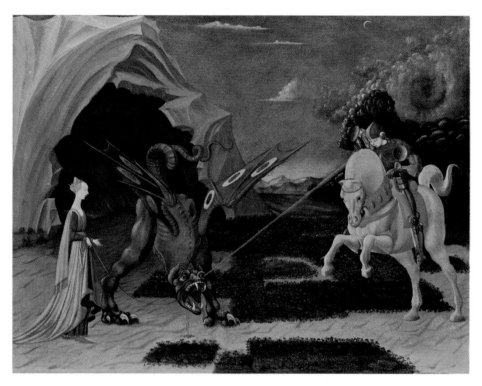

XIV PAOLO UCCELLO, *St George and the Dragon*

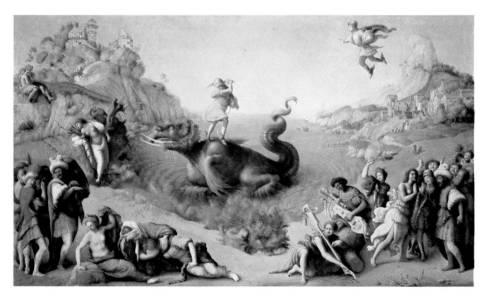

XV PIERO DI COSIMO, *Perseus freeing Andromeda*

XVI JEAN-AUGUSTE INGRES,
Ruggiero and Angelica

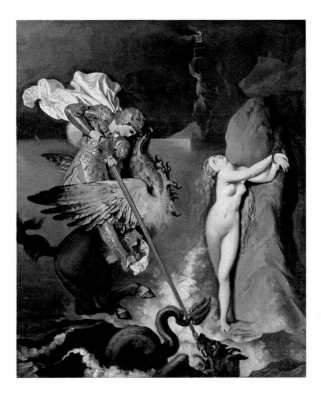

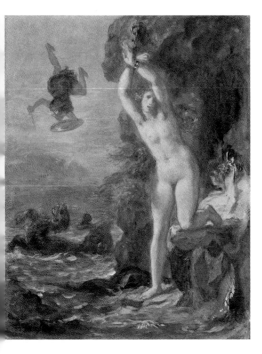

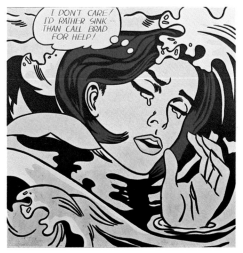

XVIII ROY LICHTENSTEIN, *Drowning Girl*, 1963

XVII EUGÈNE DELACROIX,
Ruggiero and Angelica

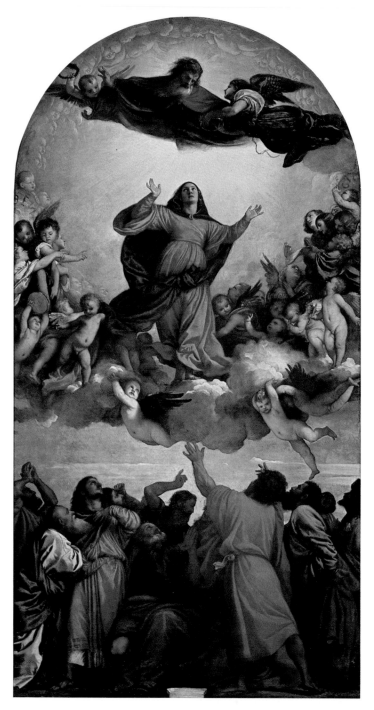

XIX TITIAN, *Assumption of the Virgin*

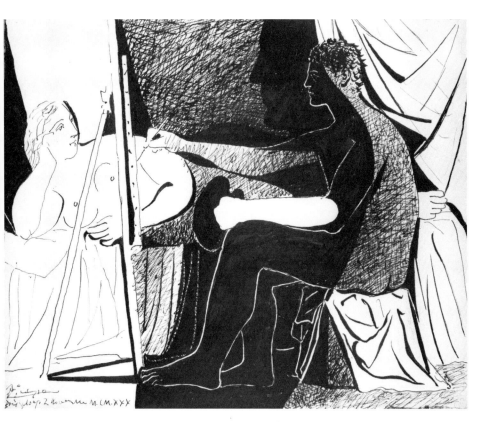

72　Pablo Picasso, *Painter and his model* (copyright DACS 1984)

from him by a canvas which his emotions vault. Haunting the many paint-
ings, drawings, and engravings which Picasso made on this theme (Ill. 72)
is Manet's *Déjeuner*. Over and over again Picasso drew the figure of an artist
at work with his arm extended towards his canvas in exactly the gesture
used by the figure on the right of Manet's painting. It is as if he perceived
this to be its hidden meaning, and the space separating Manet's clothed
male from the naked model to be divided by a canvas we cannot see.

Maybe the perceptions of Manet and Picasso supply a reason why there
have been so very few paintings about love. It is that artists have been
less interested in conveying the experience of love than in creating images
of love for their own private delectation. And if the artist is the one who
can express what other men feel but cannot express, then this must be
what we do. *Noli me tangere*!

8 *Mothers and Heroines*

Art galleries are stacked with mothers, and most of them are virgins.

If I offered this information to someone who knew nothing of art or of Christianity I should expect a bewildered look and some rather uneasy questions. It would be hard to give a reasonable explanation. I could take a defensive side-step by pointing out that not only Christianity has attached spiritual significance to the Immaculate Conception. It was certainly a belief shared by classical Greece: it was held, for example, that Plato had such an origin. All the same I should have to admit that, were the Second Coming to take place, Christ himself might be astonished by the enormity of the cult grown up around his mother since the Middle Ages, and by the weight of dogma attached to the principle of his own virgin birth and that of his mother.

Books have been written about the Immaculate Conception, which I have managed not to read, and in recent years almost as many about the Virgin Mary. Her appeal to the feminist movement is understandable. Mary is the archetypal woman who did not need a man; though with a god for a lover, a god for a son, an exclusively male priesthood to honour her, and no status of her own whatever outside these male connections, she is anything but the archetypal liberated woman. But I have no desire to add to this debate: I want to make a number of comments on how the mother of Christ has been represented in painting, and on the extent to which images of Mary as Christ's mother have become our prescription for motherhood generally.

To begin with – an apparently trivial instance. There is an Italian magazine published in Brescia for the last twenty years entitled *Mamma*. It bears the sub-title 'a tutte le mamme del mondo', though I doubt if it actually reaches quite that number of mothers. However, it is available for the modest price of 500 lire (about 20p) in a good many Italian churches; and it was in one of these, in Venice, that I recently purchased a copy, attracted by the picture it bore on the cover.

The picture is in pastel – a nice soft medium appropriate to nice soft sentiments – and it represents a very pretty girl who looks about eighteen. Her lips are pursed, her eyes downcast, her hair swept back, and about her head floats a white veil. Around it a delicate line of chalk offers the hint

of a halo. Superimposed upon this image of purity is a photograph of a pink rose of the kind sometimes pinned to the dresses of little girls attending their first communion; and the inscription beneath reads 'Una rosa per te mamma . . .' It is a picture aimed at the mind of a child – at least I imagine it is. What it is telling the child is that its own mother is like the Virgin Mary and should be loved as such. Her beauty is a reflection of her beautiful thoughts, her youthfulness is a guarantee of her innocence, and her virtue is enshrined by her white veil. Being the child's mother she cannot literally be virginal – not even the Catholic Church would pretend that – yet spiritually she is to be regarded as such. Her sexuality is entirely removed from the perception the child has of her: she is to be seen as immaculate, as Mary was.

Slick, trite, and saccharined, *Mamma* is no great shakes as art. Yet, just as pop songs are sometimes lifted from Bach chorales and Beethoven symphonies, she is instantly recognisable as a type we have all seen a thousand times before, treated with wonder and gravity in esteemed altarpieces. She would never be adorning the cover of a Catholic magazine at all were it not for the Madonnas of Bellini, Leonardo, and Raphael. She advertises the principle that all art, given a chance, degenerates into slush. At the same time she advertises another principle, which is that art is immensely powerful. In the same Venetian church, San Zaccaria, I put 100 lire in a machine which illuminated one of the noblest of *Mamma*'s ancestors, Giovanni Bellini's *Sacra Conversazione*. Bellini's Madonna in the centre of this painting has the same pursed lips, downcast eyes, fragile beauty, and the same white veil. In terms of quality here is the difference between champagne and sugar-water; yet they are variations on an identical archetype. She is the ideal mother.

Art is responsible for creating Mary's face and form; the Church is responsible for enshrining her. Together they have stamped her image on the vision of western man. As the model mother she stands powerfully before man's eyes; she controls the threshold of his encounters with the world; she is his standard of womanhood and the guardian of his morality. She is the one he is most free to love; indeed, if art is the true witness of his feelings, she is the only woman for whom he feels no hate, no fear, no cruelty, no need to be master.

Look at Mary. It is impossible not to: she is everywhere. Her life story is recounted in art over and over again. She is born, presented to the Temple, educated, married, visited by the angel of the Annunciation; she nurses her son, flees with him to Egypt, presents him to the Temple, witnesses his crucifixion, laments over his body, sees him again after the Resurrection, herself dies amid a gathering of mourners, and is received and crowned in heaven. She is the pomegranate, the white rose, the lily; she is the olive, the flawless mirror, the star. She is Queen of Heaven, she is Mater Dolorosa.

She is the Virgin of Mercy, Virgin of the Rosary, Virgin of the Rose Garden, the Virgin with the Unicorn, Virgin of the Seven Sorrows, and she is the Virgin with numerous donors and innumerable saints who attend her. One of these, St Bernard, even believed her – improbably – to be pre-figured in the Old Testament as the bride in the Song of Solomon – 'a garden inclosed . . . a fountain sealed . . . a well of living waters, and streams from Lebanon . . . fair as the moon, clear as the sun'. Many of the greatest cathedrals are dedicated to her. St Luke was even believed to have painted portraits of her. So heady did the Marian cult grow by the twelfth and thirteenth centuries that the Church's historic antipathy to women could not stem the tide of worship. Works of art are among the most sumptuous legacies of the cult, and over some of the most exalted creations of man's genius she reigns. Art has indulged Mary, and artists have stretched their imaginations to express the extravagance of man's love for her.

She enters art in Byzantine and early mediaeval Europe not in her role as archetypal mother but as Queen of Heaven, and here she remains for many centuries, changing but only as styles change. Invariably she is a hieratic figure, of majestic impersonality, who holds her son in her arms as though he were an appendage, a sort of badge. And of course he is – her badge of rank. It is only through him that she is Queen of Heaven. There is nothing motherly about her. Congregations who gazed at her in the dark, huddled churches of Byzantium would certainly not have seen in her any prescription for motherhood: her power lay in her regality. Relationship between mother and son is a formal one only. She displays him as the young Saviour, and is herself displayed in a golden heaven.

This is how the early Venetians represented her after they created their first city on the island of Torcello. They dedicated the cathedral they built to her, expanding it from the seventh century as their wealth and power expanded until by the beginning of the eleventh the great gaunt basilica we know today was completed. A hundred years later they began to enrich the place with mosaics; and into the curved vault of the apse behind the high altar they placed an enormous image of Mary, Mother of Christ (Pl. XIII); an impassive figure in blue set amid a vastness of gold. The qualities for which she stands here are not human ones, they are symbolic. What she offers to us is her presence and her power, not her humanity. She is far larger than all other figures decorating the basilica; with her child in her arms she is isolated so that there can be no possible rival to her imperious authority; and the most expensive material then known to man evokes the heaven she inhabits – gold. She is not so much a mother as Mother Church.

Then, a hundred years later she begins to become both. When Giotto painted her early in the fourteenth century for the church of the Ognissanti in Florence (Ill. 73), he brought to her a little – but only a little – of that naturalism with which he had already breathed life into the Bible story

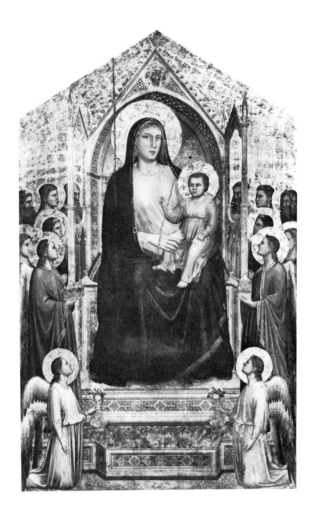

73 GIOTTO, *The Madonna in Majesty*

in the Scrovegni Chapel at Padua. There, in his Padua frescoes, Giotto had been recounting an actual narrative, and his sense of dramatic action was set free. Here, for his altarpiece in Florence, he had to produce an object of veneration, an icon, and it cramped him. She had to be Queen of Heaven; so here is the golden throne, the golden heaven, and the stiff rank upon rank of angels and saints attending her.

And yet she is not quite the regal, impersonal figure of Byzantium. She looks, not at the world in general, but at us. By doing so she compels us to regard her as a woman, and therefore the child she holds as *her* child. Giotto's altarpiece now hangs in the Uffizi Gallery, Florence, and when I stand in front of it I feel I am gazing at two pictures: one is an icon, the other is a portrait. The first is I suspect what Giotto felt he ought to paint; the second what he could not help but paint. Here is the first Queen of

Heaven who finds herself living on earth. A gigantic step has been taken towards representing Mary as a mother.

Like all the steps taken by Giotto towards naturalising religious painting, this one had no followers for a further hundred years. The International Gothic style swept a new wave of mysticism through Church art until eventually, early in the fifteenth century, the world of mankind again began to assert itself over the world of fantasy. Then Masaccio in Italy and Van Eyck in the Low Countries set painting on parallel courses that – to put it at its simplest – were to lead to the Southern and Northern Renaissance. Henceforth it was never possible again to depict the Virgin Mary as a hieratic symbol of regality entirely removed from our associations with an earthly mother.

Van Eyck's most moving representation of her is his *Madonna and Child in a Church* (Ill. 74), painted in the 1420s, originally the left-hand panel of a diptych, and now in the Berlin Gallery. It is a diminutive painting – under six inches across – but it feels huge. It seems to grow as tall as the Gothic arches of the church into which the picture opens like a door. And in the centre of the nave stands the Madonna, majestically crowned, robed in cerise and the deepest indigo – virtually the only colours in the painting. She is slender and beautiful, her eyes and smile are turned wistfully from us. In her arms she very tenderly holds the infant Jesus who is laughingly playing with her necklace just as any child will. And half hidden behind the rood-screen stands a distant huddle of figures with their heads turned her way. We peer close to see if they are priests.

Again I find myself looking at two pictures. Van Eyck's naturalism is so sharp, so compelling, that the eye takes in a real setting – art books even solemnly tell us that scholars have made attempts to identify the building, unsuccessfully. Sunlight pours through the clerestory windows, throwing dappled shadows on the vaulting and pools of white on the floor-tiles. There are noticeable cracks in the plaster-work above; even cobwebs. It is bewitchingly real. And how natural it feels that this gracious figure in red and blue should be standing here, while a service of some kind is in progress up there towards the high altar.

Then I look again, and this reality begins to fade. We are exactly at Mary's eye-level, and this is level with the point of the arches flanking the nave. If the scene is naturalistic, then she has to be at least twenty feet high – quite as tall as the Madonna who gazes down on us from her golden heaven in the cathedral at Torcello. And the light: there is something strange here too. We are looking up the church towards the altar; therefore east. Yet the light pours in from the left – from the north! Furthermore, those distant figures: they are not priests busying themselves with Mass. One of them has wings.

This is not just a church, it is *the* Church. As for the light, Van Eyck can hardly have been ignorant of where the sun rises and sets; he therefore

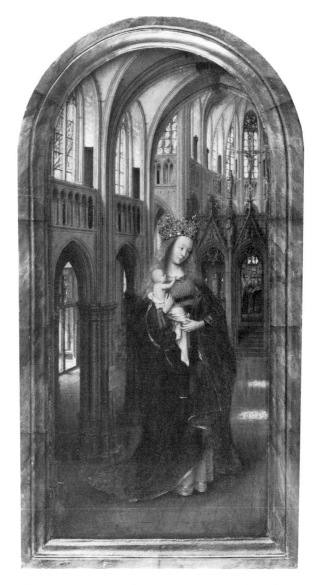

74 Van Eyck,
*Madonna and Child
in a Church*

must have got it wrong deliberately. Again, his purpose seems to have been to dispel naturalism, to suggest that this was not the sun's light, but God's. And Mary herself he magnified out of all proportion in order to elevate her from the natural world, to emphasise that spiritually she is above us all. So, even when apparently on earth, Mary is still Queen of Heaven. In Van Eyck this is still her first role, not that of a mother.

The big change takes place later in the fifteenth century. Hitherto the child has been an accessory, Mary's badge of rank. It is by his existence

157

that she is queen. Once Mary, Queen of Heaven, ceases to inhabit that golden and symbolic world and becomes a figure of womanhood on earth, then her child has to do likewise; and once he becomes a recognisable baby son all the usual reactions we have to babies with their mothers inevitably take over. Except, of course, that there are vital differences: he is not just a baby, he is our Saviour; she is no ordinary mother, she is virginal and perfect. She is also a mother who, by divine appointment, exists for her son's sake and nothing else, and whose sole duty it is to nourish him until he is old enough to be delivered up into man's world, which she does symbolically when she offers him to the Temple. Her job is then done, until she is left with her grief at his death and her ultimate reward in heaven. So it is that, by coming down to earth and cradling a real child in her arms, Mary ceases to be a regal figure and becomes instead a propaganda figure, a prescription for ideal maternalism. This shift in emotional focus has therefore transformed the role of Mary. She no longer wields the authority of a queen, but occupies the humble and comforting status of a nurse.

75 FORD MADOX BROWN, *The Pretty Baa-Lambs* (Ashmolean Museum, Oxford)

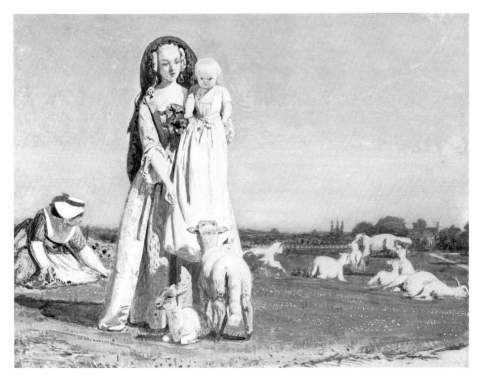

158

What art shows is how this self-abnegation, entirely proper for the mother of Christ, becomes the most essential ingredient of good motherhood generally – long after the demand for church paintings of the Virgin and Child virtually ceased. Nineteenth-century artists simply transferred the Christian model to images of domestic motherhood, varying it according to personal predilections. Ford Madox Brown's *The Pretty Baa-Lambs* (Ill. 75) sets the ideal amid a Pre-Raphaelite idyll of spring pastures: the mother embraces the child who extends its arms to embrace the lamb. Here is a sweet Victorian echo of Leonardo's *Virgin and Child with St Anne and the Lamb* (Ill. 76), St Anne having receded into the background and become the kneeling figure plucking wild flowers. Renoir's *Maternité* (Ill. 77), some

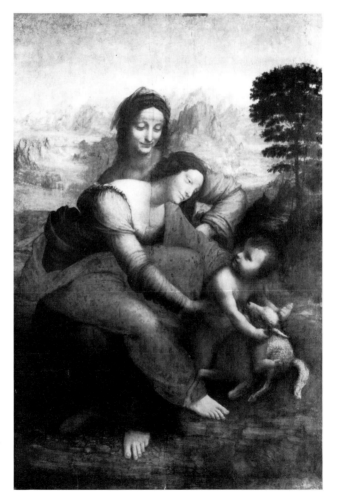

76 Leonardo da Vinci, *Virgin and Child with St Anne and the Lamb* (copyright sdpmn/dacs 1984)

159

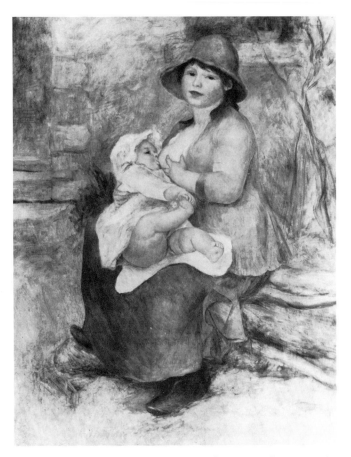

77 PIERRE-AUGUSTE RENOIR, *Maternité* (photo – Bernheim-Jeune)

thirty years later, has no such obvious religious overtones; it appears to be simply an affectionate portrait of the artist's large wife breast-feeding their son. And yet Renoir's gentle idealisation of domestic motherhood is rooted in the iconography of Mary and the infant Jesus. She might be Leonardo's *Litta Madonna*, out of doors with a sun-hat and a smile. Even Picasso, whose moments of sentimentalising women were scarce, to say the least, still found himself sugaring the mood of a Raphael Virgin and Child when he wanted to paint his wife Olga with their son Paulo (Ill. 78) in the 1920s.

As a model for domestic motherhood the Renaissance Mother and Child has proved irresistibly powerful, and at the same time invariably anaemic. Shorn of the drama and pathos of its original Christian meaning, it becomes a prescription for bovine passivity. Self-abnegation, so necessary in the image of the Madonna, is retained in secular painting as a virtue in itself

160

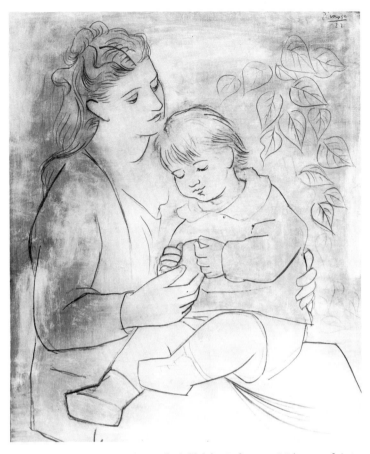

78 PABLO PICASSO, *Mother and Child* (The Baltimore Museum of Art;
the Cone Collection, formed by Dr Claribel Cone and Miss Etta Cone of
Baltimore, Maryland (BMA 1950. 279))

– a pillar of what is perceived to be the ideal state of maternal mindlessness,
called Mother Love.

By contrast, look at some of those fifteenth-century Madonnas and notice
how poignant and how moving the same ideal of passive, nurturing
motherhood can be within the context of Christianity. Mantegna's *Virgin
and Sleeping Child* (Ill. 79) is a small canvas from the third quarter of the
fifteenth century, now in the Berlin Gallery. It is thinly painted in egg
tempera, monochrome, in sombre browns against a background almost
black. The figures of the mother and child look carved out of the very dark-
ness: a cold light picks out the solemn and impassive face of Mary, and
picks out her arms and gown that enwrap the child sleeping in its
swaddling-clothes against the mother's breast. One hand supports the

161

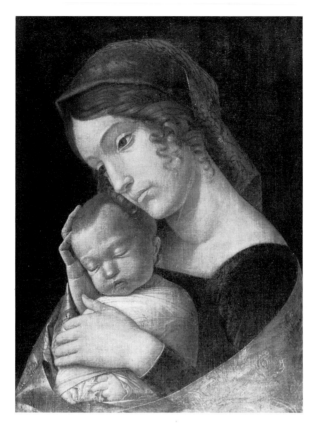

79 ANDREA MANTEGNA, *Virgin and Sleeping Child*

child's head, the other protects its body. This can only be a real mother
with her baby: Mantegna cannot possibly have invented it. What he has
done is to infuse a domestic scene which is touching but quite ordinary
with an almost unbearable pathos. Because the mother is Mary and the
child is Jesus we know exactly what this relationship means in terms of
our history, and we know what is going to happen to the child. He is being
cradled in sleep as he will be in death: her dark eyes seem to gaze into
the outer darkness of her own destiny. The painting becomes a sublime
statement about a mother's love as well as a tragic statement about a
mother's pain.

It is this perception of Mary as a tragic heroine which has left us the
most moving pictures of motherhood ever painted. Unlike nearly all the
female stereotypes I have been dealing with in this book, here is one that
awards a woman truly heroic status. Instead of being the feckless plaything
of man, incapable of serious thought or serious feelings, dressed and undres-
sed like a doll, here is an image of woman capable of selfless love, and

162

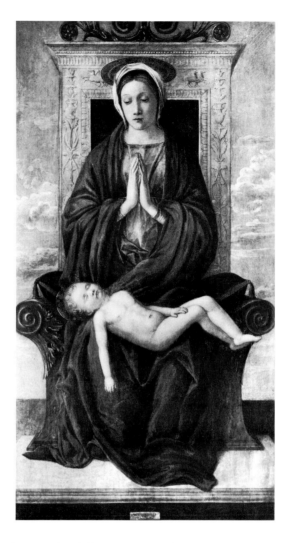

80 GIOVANNI BELLINI,
*Madonna adoring the
Sleeping Child*

of enormous courage and strength of character – qualities generally the
preserve of man. In Mantegna's Venetian contemporary, Giovanni Bellini,
we can witness the extraordinary transition from a limited perception of
Mary as an impersonal figurehead, to a vision of heart-rending tragedy;
and there are two paintings in the Venice Accademia which show how
one becomes the other. *Madonna adoring the Sleeping Child* (Ill. 80) was pain-
ted by Bellini in about 1473. She is enthroned, the child asleep across her
knee, her hands clasped in prayer, her face impassive under a halo, her
throne ambiguously set between earth and sky. She is still very much Queen
of Heaven come to reside among men, and she has no feelings beyond those
of duty.

163

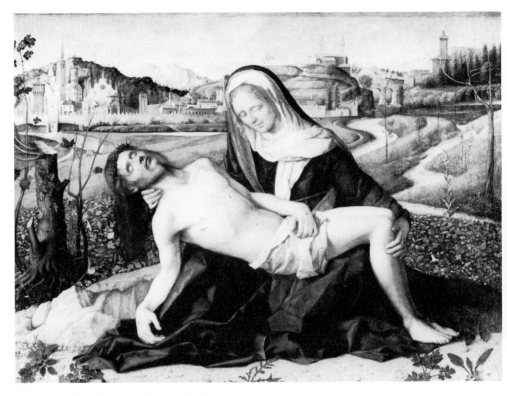

81 GIOVANNI BELLINI, *Pietà*

Yet the sleeping child on her lap is so naturally, so vulnerably, of this earth – his head fallen back, eyes tight closed, legs crossed, one hand resting on his thigh, the other dangling. Look at this exposed, unconscious figure – and now look at the dead Christ in Bellini's *Pietà* (Ill. 81) painted some thirty years later. They are all but the same, yet the transformation is a shock. The head slumped back is exhausted with pain, the torso is blooded, the hands that were pudgy are now pierced, the eyes that were closed in sleep are now closed in death.

It is disconcerting, almost surreal, this transition of a single reclining form from sleep to sleep, all life between left out, the Christian story implied but not told. And the identical form of these two figures of Christ throws the maximum dramatic impact upon the change in Mary. With her young child she was an ethereal figure of devotion and calm: with the dead Christ she is still devoted, still calm, and she even wears the same white head-covering and brown dress; but now her face is aged and worn; grief has drawn a mask across her features and laid upon her mouth the ghost of a smile. Christ is brought low – mocked, scourged, despised, awarded the

164

ultimate degradation of a criminal's death; and yet her smile and her embrace are of a mother who cradles her beloved son again.

From this same vein of tragedy the *Pietàs* of Michelangelo in Florence and Rome were carved, and in the 1570s Titian's *Pietà* which the artist intended for his own tomb – that final sepulcral masterpiece in which the aged St Jerome leans forward as if still hoping for a flicker of life in the figure of Christ slumped across Mary's knee, while the Magdalene turns away and shrieks in horror to the world.

Such richness of passion bestowed upon woman as mother is rarely to be found awarded in western painting to any wife or lover. It is as if, in the image of the *Pietà*, the profoundest longings of man towards woman find their most natural expression – a need deeper than conjugal love, deeper even than sexual desire. Perhaps an answer, then, to why there are so few love paintings is because the richest expressions of man's love have been directed towards the perfect mother. And she of course is one woman in a man's life with whom a sexual relationship is absolutely taboo.

From the moment when the Virgin came down from heaven and took on the role of an earthly mother, how artists have depicted the various aspects of her opens avenues of understanding of what it is men have valued in the figure of motherhood. Looking at those deeply moving *Pietàs* I grow aware of how reassuring they are: even in death man will be loved, cherished, held. Even if the world destroys him, she will be there.

But she is reassuring in life, too. Alongside the tragic Mary is the presiding one, the figure whose authority offers safety, permission, forgiveness. She guards, she watches, she passively controls, she knows what is right and wrong. She is wise.

The most enduring image I know of her in this role is in the small town of Borgo Sansepolcro in central Italy. Piero della Francesca was born here, and in the mid-fifteenth century a religious body in the town offered their little-known local painter a commission for an altarpiece which has come down to us as the *Madonna della Misericordia* (Ill. 82). In fact it has come down to us only in bits, the tattered survivor of fire and desecration, much of it deadeningly overpainted, much of it the work of hack assistants in the first place. None the less it has just about survived, pieced together again, and in the centre of the jigsaw stands the dominant figure of the Madonna of Mercy, with her arms outstretched like wings to enfold her brood of little mortals. There is nothing of the tyrant about her; she is a mysterious figure, serene, generous, with an expression of understanding rather than command. Because she is a mother, and more particularly because she is the Mother of God, she exerts a natural authority, and because that authority is not a sexual one it offers no threat. Man can submit to it, be comforted by it, feel safe.

Like the cradling gesture of a *Pietà*, this spread of her arms is deeply

82 PIERO DELLA FRANCESCA,
Madonna della Misericordia

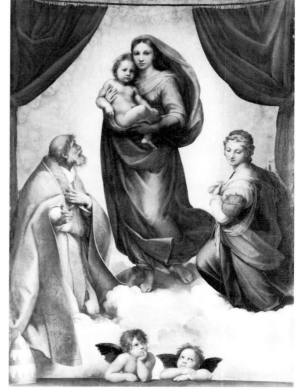

83 RAPHAEL, Sistine *Madonna*

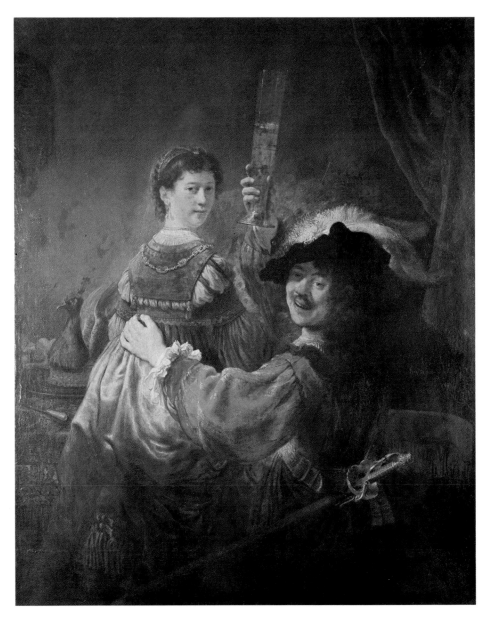

XX REMBRANDT VAN RIJN, *Rembrandt and Saskia*

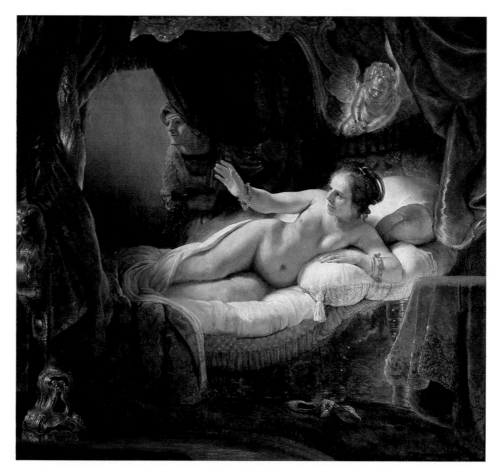

XXI REMBRANDT VAN RIJN, *Danaë*; Hermitage Museum, Leningrad; photo, L. Bogdanov

XXII FRANCISCO GOYA, *The Countess of Chinchón*

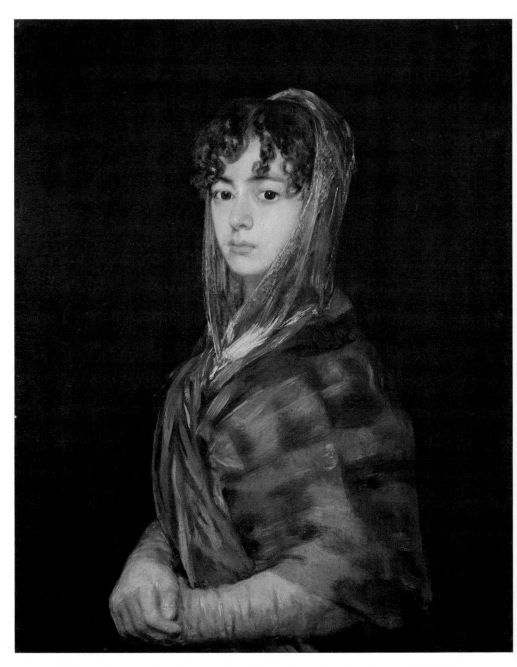

XXIII Francisco Goya, *Señora Sabasa García*; National Gallery of Art, Washington;
Andrew W. Mellon Collection, 1937

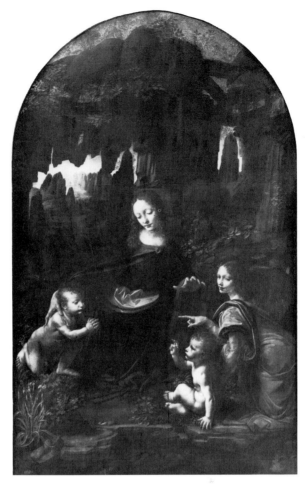

reassuring. Furthermore it dictates the very structure of the painting – like
a tent opened for us to see, the figure of the Madonna acting as the central
support, her gown hung upon her arms as a canopy. This is a composition
that recurs over and over again in Renaissance paintings of the Virgin
Mother in her presiding, protective role. The triangular arrangement of
figures practised by Raphael half a century after Piero, much lauded in
art history as representing a perfection of classical unity, is a development
of the same protective gesture. In the Sistine *Madonna* (Ill. 83), now in
Dresden, the Virgin and Child form the apex of the triangle, and the two
attendant saints, Barbara and Sixtus, the base. Instead of Piero's gown the
same umbrella effect is achieved by the golden light of heaven blazing down
on either side of the Madonna and framed by twin curtains drawn dia-
gonally aside to the left and right.

An identical triangle defines the figures in the two versions of Leonardo
da Vinci's *Madonna of the Rocks* (in London and (Ill. 84) Paris). Now the
arms of the Virgin are extended almost in the manner of the Piero – one

167

embracing the infant St John the Baptist on the left, the other raised above the child Jesus who is being supported by the angel kneeling on the right. Then, further intensifying the effect of a canopy, the whole scene is roofed with dark rocks, so extending the shielding role of the Madonna to include nature itself and its associations with the cave of the Nativity, even – by a stretch of the imagination – with the mother's womb itself.

Leonardo's canopy is also a canopy of light. In the *Madonna of the Rocks* it falls on the Virgin full face, and from here it seems to flow downwards and outwards – to her outstretched hands, to her robe, and to the three figures at the base of the triangle. So often how an artist sees light is how he sees the world, and how he paints light is how he explains to us his vision of that world. With Leonardo, as with Piero and Raphael, light emphasises this sense of sanctuary offered by the protective mother by creating a cocoon of brightness around her; and within this area of brightness her love is concentrated and mankind is warmed.

Some one hundred and fifty years after Leonardo an even more intense effect of maternal love symbolised by light was achieved by that great painter from Lorraine, Georges de la Tour, in what is probably his best-loved work, the picture entitled *The Newborn Child* (Ill. 85) in the museum at Rennes, Brittany. By now, in the seventeenth century, it is impossible to be certain whether the mother holding her swaddled child with such concentration of love within that brilliant pool of light is in fact the Madonna or simply a mother – a member of the artist's own family, or a friend. She could be either. The Christian model of the Mother of God has become universal and secular. Her small sleeping bundle, a few hours old, limbs bound, is the image of utter helplessness. Whether that bundle is Christ, or just a baby, we do not know. But again the Christian model of the child Jesus removes any intimations of threat from the mother's total authority over it, because in that model the infant, however vulnerable, has the ultimate authority. He is God.

The overwhelming precedent of the Virgin and Child in European painting endows all paintings of motherhood with a kind of sanctity. The mother is special: the child is special. They occupy an ideal world which we, the spectators, enter when we regard them; and in doing so we suspend many of the precepts we are accustomed to hold. Within this sanctity the mother is awarded qualities generally denied to women in painting. She is allowed authority without danger of depriving the male of his: she is allowed to be responsible and courageous; she is allowed – at last – to be loved. The same sanctity enshrines our vision of the child. Wordsworth's 'Heaven lies about us in our infancy' is the sentiment expressed in just about every picture of a baby in its mother's arms from the fifteenth century to the present day. The precedent of the Christ Child has endowed our perception of childhood generally with such an aura of innocence and absolute goodness that it is virtually second nature to assume it. Freud's observations

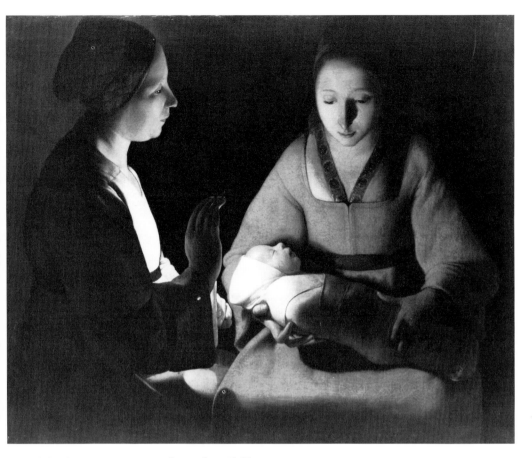

85 Georges de la Tour, *The Newborn Child*

about a child's sexual fantasies directed towards its mother are still – eighty years later – probably the least generally acceptable of all his psychological pronouncements.

Paintings show us that as a mother a woman may be adored, admired, loved, submitted to. She is courageous, self-sacrificing, and enormously powerful. Only one step further and her maternal role becomes a universal one, and we find her going into action as a heroine. She not only stands for all the virtues, she raises her banner and fights for them.

Her classical antecedent in this militant role is the Greek goddess Minerva, born fully armed from the head of Zeus and therefore the nearest thing to a male immaculate conception. The significance of Minerva's birth must lie in the conviction the Greeks shared with most early societies that a woman's womb was contaminated – hence the importance they attached to puberty rites enabling boys approaching adolescence to be freed from the mother and given a symbolic 're-birth' from the father. Minerva, being

free of that contamination in the first place, was in consequence the arche-
typal man's woman able to be entrusted with the role of safeguarding the
values he held most dear. She became the goddess of wisdom, and as a
war-goddess the champion of liberty and of justice.

She is everywhere, Minerva. She holds the scales of Justice above every
court of law. She is the Statue of Liberty raising her torch 150 feet above
the entrance to New York Harbor. She is the Soviet Union's 270-foot statue
of the Motherland in Volgograd. She safeguards the French revolutionary
ideals of Liberté, Egalité, Fraternité. She rules the waves as Britannia. She
is even the guardian of our currencies: she is on all British banknotes;
she lends her torch to the United States dime; she sows seeds of justice
and the good life on the French coinage, and stands helmeted grasping
an olive-branch on the Italian. It is through her benign power that the
great forces for good are generally regarded as female and motherly:
countries (except Germany) are motherlands, Westminster is the Mother
of Parliaments, Greece is the cradle of democracy, the very world we inhabit
is Mother Earth. Even ships, aircraft, cars, are female. The first man on
the moon, though he took a 'giant step for mankind', stepped out of one
female on to another.

The cocoon that wraps De la Tour's new-born child also wraps the
universe of the grown man.

The image of woman as heroine championing man's most sacred
endeavours is to some extent a flower of the nineteenth-century Romantic
imagination, and of the revolutionary idealism which accompanied it.
Amid the gunsmoke of Europe the Mother Heroine bares her breasts on
barricades, suckles brave new republics and outstares tyrants. She is Boadi-
cea and Joan of Arc reborn in shining bronze in city squares where martyrs
have been slain or empires celebrated. The nineteenth century would look
emptier without her, and its armies lack the most stirring of its generals.

The Romantic painter who captured the spirit of her most vividly was
Delacroix. Three years after having massacred every woman in sight in
his *Death of Sardanapalus* (Ill. 70), when he came to represent the Paris
uprising of 1830 (which he actually witnessed at close quarters), Delacroix
turned the tables: *Liberty leading the People* (Ill. 86) is strewn with the
slaughtered and dying figures of men, while above them on the barricades
stands an Amazon queen of a woman, tricolour raised aloft in one hand,
a musket grasped in the other. Historians have suggested that Delacroix
only introduced the allegorical figure of Liberty as a pretext for including
a semi-naked woman in an otherwise male picture; but this misses the
point. She is bare-breasted because Liberty has to be seen to be the mother
of the people. She stands for the human rights of all those brave men fight-
ing around her precisely because she wields this tremendous maternal
authority. She nourishes their manhood, their courage, their ideals, sup-
porting them in their cause as the Virgin supported Christ. She has to be

170

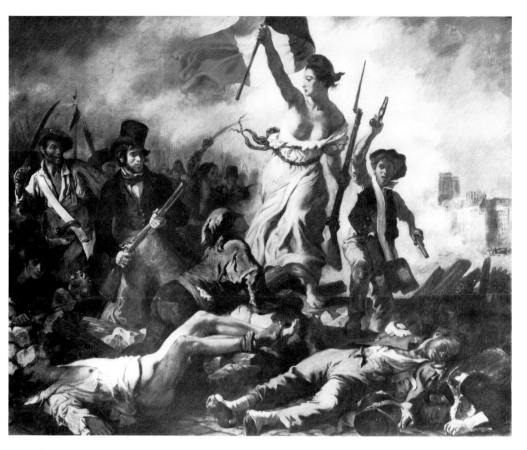

86 Eugène Delacroix, *Liberty leading the People* (copyright SDPMN/DACS 1984)

the universal mother to inspire this kind of trust. Daumier came to the point much more literally eighteen years later with his entry in a government competition for a figure to represent the young (and short-lived) Republic: what he painted was an enormous and proud woman seated with a tricolour in her hand and two infants clamped to her breasts. She is Mother Nurse, Mother Courage, Mother Champion.

In terms of European painting we can see where she comes from, this formidable lady armed with breasts and virtue. To all French Romantic artists the exemplar of the Mother Champion had been on display in Paris since 1625 when Rubens' twenty-one gigantic canvases on the 'heroic deeds' of the Queen Mother, Marie de' Medici, had been hung in the Luxembourg Palace, today in the Louvre. What in many respects are among the silliest pictures Rubens was ever called upon to paint – sycophantic bombast

171

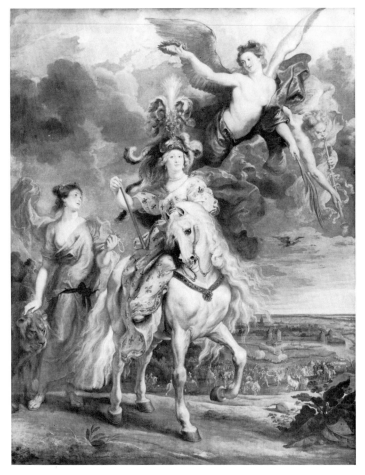

87 PETER PAUL RUBENS, *The Capture of Jülich* (copyright SDPMN/DACS 1984)

– are none the less an important historical link between the militant heroine of the nineteenth century and her Renaissance and classical forebears. Rubens clearly wanted to represent Marie as a latter-day Minerva. There is a separate portrait of her – bare-breasted – in the actual guise of the Greek goddess; and in the thirteen-foot nonsense of Marie (Ill. 87) riding triumphantly to capture the Rhineland city of Jülich (which in reality she never did), it is as a pantomime Minerva that she advances – with her double chin and her carnival headdress, flanked by the figure of Strength fondling a lion, with Victory and Fame fluttering among the Baroque storm-clouds.

But it is another of Rubens' paintings in this series that hints at a more serious origin of the Mother Champion. The equally enormous canvas entitled *The Education of Marie de' Medici* (Ill. 88) shows her not as Minerva herself but as a young woman kneeling to receive instruction at the god-

172

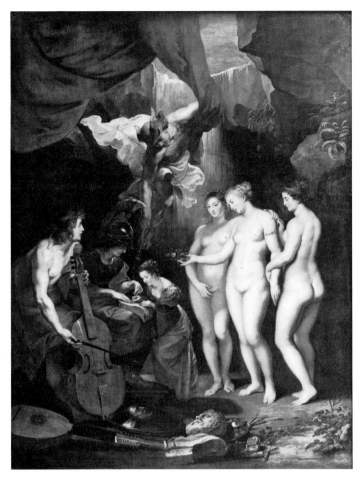

88 PETER PAUL RUBENS, *The Education of Marie de' Medici* (copyright
SDPMN/DACS 1984)

dess's knee. The painting is a hotch-potch of various classical allusions of
the kind that the sophisticated French court would have appreciated. A
waterfall in the background is supposed to represent the Castilian Spring:
this was sacred to the god Apollo, who is shown seated next to Minerva
playing a viol, and to the three Muses who are present too, though they
also suggest carbon copies of the three goddesses in Rubens' *Judgment of
Paris*; while swooping down on the scene clutching a curtain in mid-air
flies Mercury, messenger of the gods, bringing with him the blessing of
Olympus.

But the core of the picture – which shows how very clever Rubens could
be – also makes a quite different reference which the French court would
have understood just as easily as they understood the classical references.
Half close the eyes so that Minerva's Roman-looking fireman's helmet blurs,
and the young Florentine princess's jewellery melts into the hair, and the

173

two figures become the familiar biblical theme of the young Virgin receiving instruction from her mother St Anne. Rubens probably conceived the idea as an elegant piece of flattery for his royal patroness, the link between the two figures being supplied by their common name – Mary. At the same time it is more than an intellectual conceit. Rubens found a tactful way of drawing a comparison between the most commanding woman in contemporary Europe and the most revered woman in Christian history.

In brief, the Virgin Mary in her humble, nurturing role becomes the prescription for domestic motherhood culminating in the soppy front cover of *Mamma*. And the Virgin in her role of moral champion becomes the model for universal motherhood culminating in the figure of Britannia on our coinage and the 270-foot statue of Motherland in Volgograd.

Not always, however. Throughout this chapter I have been conscious that some of the greatest works of art elude categories and cannot easily be accommodated within arguments. One painting has been haunting me without my being able to do anything about it. The picture is Titian's *Assunta* – the Assumption of the Virgin (Pl. XIX). The artist painted it as the altarpiece of the Frari Church in Venice where fifty-seven years later he was to be buried. And it still hangs there – gloriously! It is one of those masterpieces that reaches out beyond the frame of the story it tells and touches our eyes with a truth about ourselves, as if we had been blind until that moment. It is a painting I can imagine might change a person's life. Quite possibly it has changed mine. At least I doubt if this book could have been written without it.

The *Assunta* is the ultimate expression of man's glorification of woman. It presents us with the overwhelming image of a woman ecstatic at being received into heaven by God, and the spectacle of man's joy at witnessing it. The picture is colossal, considerably over twenty feet high, and it dominates a colossal church. Because the painting is raised well above the level of the nave, everything is designed to be seen from below. The entire action moves upwards. In the foreground stands a throng of apostles, and in the seconds before the moment we are witnessing their attention has been aroused by what they see above them, and they have spontaneously raised their faces and their arms in expressions of joy and astonishment.

Their gestures and their eyes are directed towards the figure of the Virgin Mary, her blazing red and rich blue robes swirling about her; and she in turn, with another impulsive gesture of hands raised, gazes up into a golden heaven to where at the very top of the painting God the Father floats like some gigantic bird hovering to receive her. Everything about the *Assunta* proclaims a happy ending; and it is this sense of elation that sweeps across the huge church of the Frari like a cry of triumph.

Titian has not simply offered us the happy ending of the story of Mary; the appeal and the implied meaning of the picture is much broader than

174

that. He offers us a joyful resolution to the dark story of woman as Christianity has painted it. This began with a comparable moment of joy – the creation of Eve in Paradise from Adam's rib. Eve was innocent, without knowledge of evil, without knowledge of sexuality. Then came the catastrophe of the Fall, which was judged to be Eve's fault. Through her man found himself banished from Paradise, and woman thereafter became tainted in his eyes, her carnality dangerous, her morality flawed, her role reduced to that of chattel and breeding-stock.

Chapter Two of the story illustrates how man could be redeemed only through an earthly god who was born of a virgin and who thereafter denied himself any contaminating contact with woman. Again it is Titian who offers us the most poignant image. His interpretation of *Noli me tangere* (Ill. 63), which I discussed in the previous chapter, emphasises this physical recoil from the touch of a woman, the two figures arranged in such a way as to suggest that Christ's rejection of the Magdalene has the added significance of a corrective to Eve's original temptation of Adam.

What Titian has done in the *Assunta* is to give us the third, triumphant chapter of this same story: he shows us woman welcomed back into the light of man's love and God's favour. It is a painting about reconciliation. How Titian has pulled it off is by disregarding all the stereotypes; or, rather, she has become a composite of them all. She is a virgin by virtue of being Mary, yet she is no image of cold piety. She is a mother, since Christ was her son, yet she is not presented to us in a maternal role. She is a heroine through her elevated position above mankind, without having to don armour and mount barricades to prove it. And she is a woman who can clearly arouse physical passions in man, without carrying any stain of sin as a result. She is not a temptress, not a sinner, not a man-eater; she is neither tragic, self-abnegating, nor coy. She answers to none of the usual prescriptions of virtue or of vice. Yet she is Virtue itself. And woman herself. She manages to be all things to man and all things to God.

What Titian has given us is a painting not only of reconciliation, but of liberation. The chains stereotyping women have fallen away. Here is a woman who, however you care to regard her, can be openly loved. Hence the jubilation of mankind below; hence too that exultant gesture of welcome, warmth, and fulfilment which Mary extends to the world and to heaven.

The *Assunta* catches a spirit of human joy as eloquently as any painting I know. Looking at it is like seeing enacted one of those golden moments when everything in life feels possible.

9 *All Passion Spent*

'Love and marriage, love and marriage . . . go together like a horse and carriage' – when Sinatra crooned these words there were no perceptible gasps of horror and disbelief. They felt true, and I suspect that no argument the Women's Movement has come up with since then has even slightly dented the universal belief that they *are* true. Marriage is where it is all supposed to lead, what it has all been waiting for.

In art one might expect a confirmation of such a widely held faith. In the preceding chapters art has been witness to Olympian seductions, mythological subterfuges, damsels rescued in distress, and nudes stretched fetchingly across landscapes and perfumed couches; it has been witness to much agonised worship of virginity and martyrdom, much guilt, fear, pain, lust, longing, and loneliness. Where, then, could so many extravagant passions have been striving to go if not towards some triumphant union of the sexes – a reconciliation of differences, a celebration of human love that would surmount all constraints and set the spirit at peace?

But what does art actually show us of the state of marriage? A relationship of quite a different kind. Of the hundreds of thousands of images in western painting which have mirrored men's feelings for the female sex, no category of picture reveals such a dearth of passions of any sort than pictures of the married state. To such an overwhelming extent is this so that it is hard to believe marriage to be anything other than the very opposite of where all those passionate overtures were leading. One long look at pictures of married couples, no matter when they were painted or where, is enough to make anyone opt for sin or celibacy.

Perhaps that is exactly it. Sin and celibacy, after all, are both presented in art as enormously attractive from the man's viewpoint. And they are presented as complementary: celibacy is temptation resisted, sin is temptation succumbed to. Both are delicious in their hyper-awareness of women's sexuality; and both set women at a safe distance – either as too virtuous to be touched or too evil to be loved. In neither case does she have to be lived with. Man is free of her.

In marriage, on the other hand, he is trapped. He is required by society to take a wife in order that she fulfil a social role in his life, and breed him an heir. She becomes part of his property, as well as the means of

176

keeping that property in the family after his death. Marriage is a contract. And in the terms of the contract she of course is trapped too. In return for the benefits of material comfort, protection, status, and motherhood, she submits to being owned by him, enjoys (until quite recently) negligible rights in law, and has no identity except as his wife and the mother of his children. She does not really exist. That is the price she pays. Everything about portraits of the woman in marriage paintings speaks of control. Her body is locked within clothes, her hair tightly bound, her expression buttoned. She is kept, and kept under constraint. The containing device is marriage. It is a contract that binds her entirely: what the man does outside that contract is his affair. He lends himself to the marriage portrait; she belongs there.

True, paintings of married couples are not by and large meant to be an account of personal relationships, any more than are wedding photographs. They present the public face of marriage, how it seems fit that the married state be displayed to the world – at least to a man's world. It would be absurd to conclude from po-faced marriage pictures that none of these couples enjoyed making love, and it would be equally absurd to expect a marriage painting to show them doing so.

Nonetheless, if this is the public face of marriage, it is inviting to ask why it is. The public is not some tyrannical outside agency that presents individuals with demands: all the couples within these paintings *are* that public, just as we are who gaze at them. The public is western society, and if one of its sacred institutions is enshrined in this bleak fashion it must be because this is how we have wanted marriage to look, and how we believe ideally it should be. And what art tells us it should be is a state of dutiful penance. No acknowledged emotions. Certainly no acknowledged sexuality. Everything subordinate to social responsibility and to God's laws. For women a form of enslavement, for men a form of institutionalised misogyny. The refrain in my ears when I leave an art gallery is not Sinatra, but St Paul – Better marry than burn.

If paintings were concerned only with the public face of marriage they would be very dull indeed – as dull as wedding photographs, which are capable of recording only that public face. Paintings obviously do a great more than this. The artist is not simply a recording instrument; he brings to bear on what he sees a host of thoughts and perceptions which generate a sensation of inner life even where the subject might appear to have no life at all.

This is why a theme as wooden as *The Arnolfini Marriage* (Ill. 89) becomes, under the eye of Jan van Eyck, one of the masterpieces of fifteenth-century art and probably the most celebrated marriage picture ever painted. It is executed with such apparent naturalism that I have heard people standing in front of it in the London National Gallery exclaim that it looks as if a

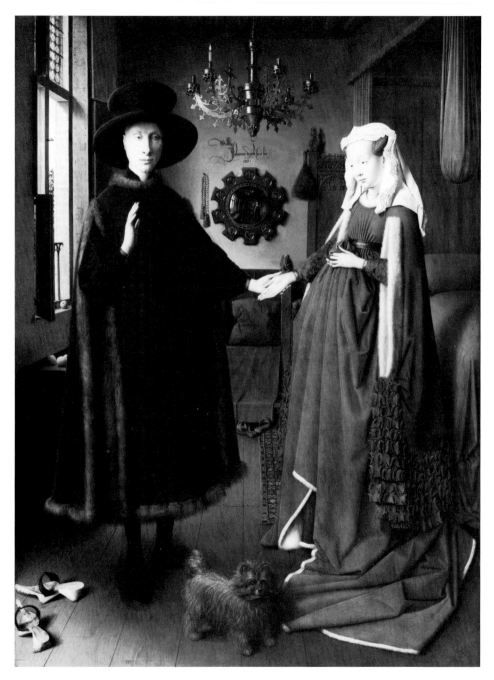

89 JAN VAN EYCK, *The Arnolfini Marriage*

camera had done it: yet if a camera had done it, it would have been terribly boring. What Van Eyck has achieved with a seemingly life-like record of a marriage ceremony is a demonstration of the magic which we call art.

He passes no comment; he observes every detail, picking out each one as if it were a pearl; but in presenting us this silent jewel-box of a room he manages to convey the precise reason why everything is where it is, what lies in the minds of husband and wife, even what it feels like to be the two witnesses to the marriage ceremony who are minutely reflected in the far mirror – one of whom is presumably the artist himself since he has inscribed his name on the wall: 'Jan van Eyck was here'.

It is these thoughts and psychological perceptions, silently conveyed through Van Eyck's observation of detail, that illuminate the relationship of the young couple as they stand here in front of us for the oath of marriage. What the artist's vision of them emphasises is that the bond into which they are entering, whatever benefits it may be bringing them, is an emotional straitjacket. Look at them as they face us. They touch, but without a touch of love, barely of tenderness. Their hands are limp, pious. His other hand is raised as if to give, rather than receive, the blessing, like a priest. His face is a blank. He does not look at her, and it feels hard to believe that should he do so those small dead eyes could kindle much fire. She, however, does look at him – with a distant quizzical gaze that is matched by the tight mouth, the tightly bound hair, and by the barricade of a gown drawn up like a second line of defence before her, giving her (ironically) the appearance of being pregnant, which soon of course will be her regular function. A space yawns between them – a space filled not by their feelings for one another but by a chandelier on which a single light burns like an altar candle, and by a mirror decorated with scenes from Christ's Passion and in which the marriage witnesses are reflected. In other words, the couple stand divided by symbols of their duty to God and their duty to society – symbols of precisely what are supposed to unite them.

The early-twentieth-century American artist, Grant Wood, produced what has often struck me as a sardonic updating of *The Arnolfini Marriage* when he painted *American Gothic* (Ill. 90) – a study of a grim middle-aged couple which manages to be about the best-known and quite the nastiest picture in the Art Institute of Chicago; and I only include it in this chapter because with a heavy-handed realism it presents a caricature of so many pictures of married couples. It is as though the mirror behind the Arnolfini couple offered them in this painting a reflection of themselves in later life, transported to the American Bible Belt. Their faces have changed little: they have never smiled: their lives have narrowed into a mean simplicity of daily toil under the shadow of their God. His blessing on their state is symbolised by the church window that divides them, and by the three-pronged (trinity-pronged) pitchfork thrust towards us to proclaim the virtue of their hard life and hard faith. At her throat sits a cameo of a girl who

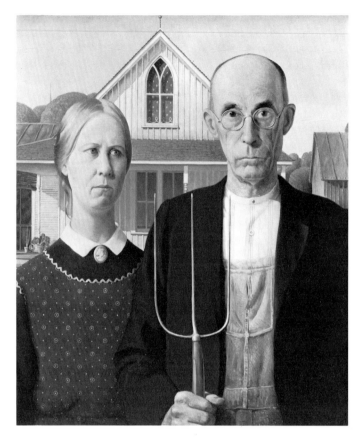

90 GRANT WOOD, *American Gothic* (The Collection of the Art Institute of Chicago)

once had long free hair: at his throat is his concession to ornament, a brass collar-stud.

The marital straitjacket is not usually shown to be quite so homespun as this, nor so charmless. Art has evolved all manner of conventions for disguising the garment as comfortable, even attractive. To include the son and heir is a natural softener of tension in paintings of married couples: our attention is turned from the gulf between husband and wife to their collective role as parents. One of my favourite family portraits, in the Munich Gallery, is a painting by no one in particular of a Ferrara nobleman of the late fifteenth century (Ill. 91). He is holding a falcon, symbolising his nobility, and is posing with his wife and small son. In a curious contrived setting the theme of fruit is heavily emphasised everywhere we look, presumably to make clear that the straitjacket of marriage has been worth wearing and the union productive.

As with the Arnolfini picture, reference books and gallery guides stress the quiet dignity of the figures, their restraint, the air of peacefulness and

180

91 FERRARESE MASTER, *Family Portrait*

so on, never the glaring absence of contact between them. In this way
we are lulled by the expert into assuming that hearts beat warmly under
these straitjackets and but for some kind of admirable decorum the couples
would be flying into one another's arms. The author of a semi-official guide
to the Munich Gallery goes so far as to comment, of the Ferrara nobleman,
that he 'has his hand on his wife's shoulder in a quiet gesture of conjugal
love more touching than any open display of emotion'. What he omits to
add is that the nobleman's face is set as impassively as if he were gazing
at a muffin, and that he is not even looking at her but staring out into
the open landscape where he will soon be able to feel the blood course
in his veins by flying the falcon perched on his hand. It is this hand, gloved
for sport, that is much more eloquent of the man than the other hand rest-
ing limply on his wife's shoulder. She meanwhile, expensively jewelled –
virtually chained by jewels – has retreated behind an uxorious set of the
mouth, casting her eyes downwards with the self-abnegating humility of
the good mother and resting her hands on the shoulders of her son.

Like Van Eyck, though in a more stiff and primitive manner, the unknown artist from Ferrara has picked out significant details to convey – quite uncritically – a few truths about the institution of marriage. What the picture is laying bare is nothing to do with the touching nature of conjugal love: it is showing us an inert relationship in which the preoccupations of the husband have drifted elsewhere and those of the wife have become focused on her child.

In Dutch and Flemish painting of the seventeenth century the marital gulf tends to be filled with action rather than sanctity. There is no nonsense in Dutch and Flemish portraits of couples: the artist sets out to show what rank of man he is, and what rank of woman she is, and then places them side by side at a suitable distance, both looking squarely at us.

Hence Gerard Honthorst's huge double portrait of Prince Frederick of Orange and his wife Princess Amalia (Ill. 92) now in the Mauritshuis, The Hague. What is on display is not their marriage but their role as rulers of the Netherlands. It is a study of power and wealth. He is a commander-in-chief, and dressed as such in full armour; she is a gracious lady with beautiful hands and enough pearls to pay for his army, I should imagine. As a painting of two public figures there is no fuss about any kind of inner relationship the two of them may have: it is how they strike the world that counts. And since the central issue of their marriage – as we are invited to view it – is not their feelings, these can conveniently be set aside. In this their age helps: the fact that they are middle-aged places them at a distance from whatever sentiments may have brought them together in the first place. The impersonality of their marriage frees the artist to paint both of them as impersonal symbols – something he could not possibly have done had they been young lovers because their feelings (or lack of) would have got in the way. A newly wedded young man dressed up in this manner in full armour would have looked as if he had stepped straight into the marital straitjacket. As it is, with Prince Frederick it feels perfectly natural. The portrait of the two of them looks easy and relaxed precisely because it is not a marriage picture at all: the issues of love and sexuality are therefore irrelevant.

Action, status, rank, authority (for the husband); grace, passivity, obedience, maternalism (for the wife): it is attributes, not emotions, that stand up to be counted in paintings of married couples. And so characteristic are they of portraits of husbands with their wives that it is easy to overlook how they serve to camouflage a lack of human contact between them.

As art has changed, so has the style of camouflage. Early Italian Renaissance portraits are normally impersonal profiles anyway; so portraits of a husband and wife merely become twin profiles side by side – independent as postage stamps. Artistic convention supplies its own camouflage. The greater naturalism of Northern Renaissance painting brings to group

92 GERARD HONTHORST, *Prince Frederick Hendrick of Orange and Princess Amalia*

portraits such as Van Eyck's *Arnolfini Marriage* a believable unity of space; at the same time it separates the figures by imposing upon them an air of frozen sanctity. The bravura style of Baroque painting disguises the impersonality of relationships in a new way, by introducing a theatrical swagger to the figures, exemplified by the Honthorst double portrait and more dramatically by those of Van Dyck and Rubens. A rich example of camouflage by theatricality is the portrait by one of Rubens' pupils, Jacob Jordaens, of the Flemish government official Govaert van Surpele and his wife (Ill. 93), in the National Gallery, London. Like the Honthorst picture here is another middle-aged couple: intimate passions need not therefore be expected. But look how Jordaens has decorated the emotional emptiness that lies between them. He struts in his expensive lace and velvet; she swells

183

93 JACOB JORDAENS, *Govaert van Surpele and his Wife*

like a comfortable balloon under hers. They are blown up and blown apart by worldly success, and into the space between them the husband has struck the boards with his staff of high office – to which the wife's hand gestures, too, making it doubly clear that this is what the relationship is all about: power. The staff is like a standard to which their marriage is pinned, and upon which it is dependent.

In the eighteenth century strutting heroics give way to elegance, to manners. Manners are by definition a form of camouflage, so the smoothness and grace of eighteenth-century marriage portraits make them appear just as natural in their own way as Baroque portraits look natural through being about action. The English painter Thomas Gainsborough was a mas-

184

ter at this kind of concocted ease, and the National Gallery in London possesses two glorious marriage portraits – the first painted when the artist was a young man, the second near the end of his life. Seen in contrast the two paintings demonstrate Gainsborough's advance in sophisticated skills; but they also demonstrate how social elegance and fine manners come to create the illusion of communication between two people simply by covering up the gap.

For instance, in the earlier of the two Gainsboroughs, *Mr and Mrs Andrews* (Ill. 94), the lack of contact between the newly married couple is quite embarrassing. The gentleman-farmer trying to look casual with his gun and dog, his coat buttons undone and his hat a bit askew, would obviously feel more comfortable if his wife were not there at all. She, primly out of place in the open air, turns away from him and regards us with slit-eyed suspicion. Neither acknowledges the presence of the other; his legs are crossed away from her, and hers away from him; their hands are kept safely apart. Only the dog displays some small affection. To be here looks like an endurance test for both of them, and it is easy to imagine that when the ghastly sitting is over they might depart silently and in opposite directions to get on with their separate lives. The great charm of the picture lies in the way this pair of unnatural dolls are made to occupy so natural and vivid a landscape: all the affection withheld from one another is poured into their farm, so beautifully kept, such an advertisement for good husbandry that the couple themselves have been set to one side the better to show it off. But the painting would have been psychologically more truthful had they posed at opposite ends of the picture and shown off the farm in the middle.

94 THOMAS GAINSBOROUGH, *Mr and Mrs Andrews*

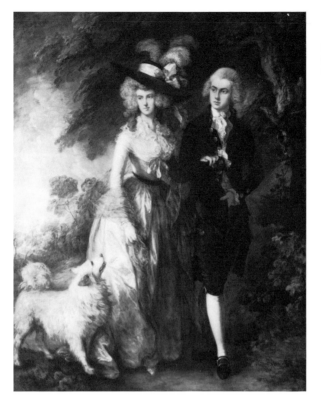

Some thirty-seven years later Gainsborough, by now up to his eyes in fashionable portraiture, painted the picture known as *The Morning Walk* (Ill. 95). Here too is a pair of newly-weds – William and Elizabeth Hallett. Again they are out of doors, and again decidedly overdressed for the occasion. Here apparent similarities end. The two of them look perfectly united. She has a hand through his arm as they walk; they stroll in step; their eyes turn to the same point of interest, whatever it is. They advertise a good society marriage. But now look more closely. The only actual contact between them is that limp hand given as a gesture of etiquette, just as any lady would be required to do to her escort into dinner or out in the park. They do not look at one another; neither face displays the slightest feeling or awareness of the other. As with the Andrews portrait this is left to the dog. There is no more emotional electricity between them than there was between Mr and Mrs Andrews. Their separateness is merely camouflaged by good manners and high fashion, and in the intervening years Gainsborough has grown expert at painting camouflage to look real.

The public face of marriage wore a sterner look in the nineteenth century. It became less of a fashion parade and more of an institution – a piece of social architecture as elaborate and as monolithic as Victorian institutional building, aspiring ever upwards and heavily buttressed by virtue.

Never was the straitjacket straiter, or the camouflage more impenetrable. Under the surface the Romantic era promoted bohemian escapades and passionate elopements, and no age ever supported such a population of whores: none the less the indestructible Gothic museum of marriage remains the most prominent landmark in nineteenth-century painting, as in nineteenth-century novels. No more swagger, no more theatricality, no more foppish languor: husbands and wives are now twin pillars of rectitude holding up the moral edifice of civilisation.

My favourite image of this kind of nineteenth-century marriage is not one of those lamplit studies of a Victorian family gathered for chamber music or Bible reading, but an enchantingly fresh open-air scene on the banks of the River Seine painted by Georges Seurat in the then revolutionary style of *pointillisme*. The painting is *A Sunday Afternoon on the Island of La Grande Jatte* (Ill. 96), shown in the eighth and last Impressionist exhibition of 1886 and now in the Art Institute of Chicago.

The world is at ease on a summer afternoon. People fish, sail, row, play music, play ball, pick flowers, or watch the rest of the world go by. Surveying all this are a couple on the right as stiff and upright as the trees that seem to parody them in the background. His hat, cane, and cigar, her corsetted and bustled figure, their tight-lipped attention to what is before them and none at all to one another: these attributes seem to say everything about the public face of nineteenth-century marriage. The picture shows – as we may assume – society's most respectable institution taking itself for a walk.

96 GEORGES SEURAT, *A Sunday Afternoon on the Island of La Grande Jatte* (The Collection of the Art Institute of Chicago)

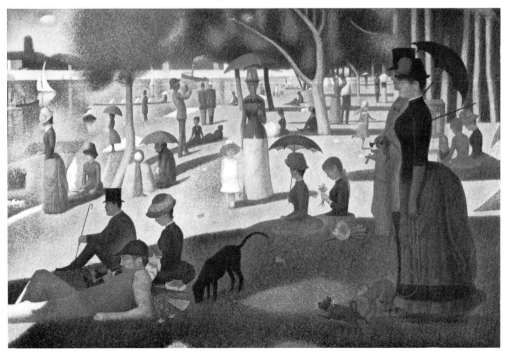

But – not at all! Seurat, with scarcely a flicker of a smile, has been enjoying some fun. The lady dangles a lead in her left hand, and on the end of the lead is a monkey. Seurat knew his art history and was perfectly well aware of what that meant: a monkey is a symbol of human lust. This pillar of rectitude is in fact a prostitute; the gentleman in the top hat is her keeper, her lover. So, what we actually have here are sex and sin dressed in the straitjacket of wedlock! Instead of a portrait of nineteenth-century marriage, Seurat has given us a portrait of nineteenth-century hypocrisy. It is as if he has seen all the guises by which art over the centuries had camouflaged the frigidity of the married state, and has produced a camouflage which achieves something quite different – lust disguised as bourgeois respectability.

What Seurat has managed to illuminate is that all – or virtually all – images of marriage are a hypocrisy of one sort of another; that art has always sought to display the closest relationship between man and woman as something that belongs to the world outside, an outward-turning relationship rather than an inward-turning one. Artists, and those who commission artists, have consistently chosen to represent marriage as a social convention, not as a union of two people. Therefore style – both life style and art style – are of supreme importance in marriage pictures. It is no accident that one of the most successful marriage paintings of the twentieth century, David Hockney's *Mr and Mrs Clark and Percy* (Ill. 97), in London's Tate Gallery, is in every respect an exercise in style. Hockney himself is profoundly style-conscious both in his life and in his work: many of his paintings are simply about ways of painting. And his subjects here, Ossie and Celia Clark, are themselves preoccupied with style, he as a fashion designer, she as a designer of textiles. Hockney's double portrait of them at home with their cat is an exercise in how to present two people whose lives are a form of self-presentation. We know absolutely nothing about them as a private couple, nor are we meant to. They are as separate as Arnolfini and his wife, the Ferrara nobleman and his wife, as Mr and Mrs Hallett, as the couple parading on the island of La Grande Jatte.

What can it be about marriage – a state incandescent with every passion known to the human race – that it seeks to wear such a cool mask?

I am no sociologist, and no psychologist; but looking at pictures causes me to wonder if the prevailing male fantasy, which art converts into the appearance of reality, is that the state of marriage is quite the opposite of incandescence; that it is the condition of spent passions. The control of all that is natural. A prison. A kind of necessary death.

It is interesting, for instance, how many marriage pictures contain pet animals. Now obviously people enjoy pets and like having them around, and what could be more natural than wanting to include them in a painting of oneself and one's partner? On the other hand it would seem most

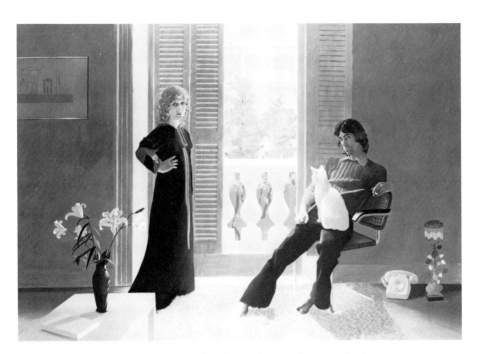

97 DAVID HOCKNEY, *Mr and Mrs Clark and Percy* (Tate Gallery, London)

unnatural, downright weird, to include a pet animal in any kind of painting
where passions rule – Jupiter seducing Io, Perseus rescuing Andromeda,
or the Assumption of the Virgin. A pet is hardly an accompaniment to
heroic action, or adoration, or desire; but a marriage portrait can comfort-
ably include a fluffy dog precisely because passions do not rule. It fits
because it is tame. It matches. It is an emblem of what is felt to be the
married state, or at least what is felt to be so by the men who have commis-
sioned these pictures and the men who have painted them. The pet, so
endearingly prominent, so lovingly portrayed, is rather like the women
these men have married. They too are nature confined, tamed, controlled,
on a lead, with their hair and their bodies tightly bound and their absolute
attentiveness to the man's career, the man's rank, the man's children. They
are not the wild beasts he may fear or lust for in his dreams – the man-
eaters, the sinners, the mistresses, the bad woman he goes to when he
feels like being bad. They are the virtuous ones he feels safe with – and
perhaps bored with. Like pets!

Can this be the ideal – this dull state? And if so, why should it be so
prosaic and earth-bound when the ideal of motherhood is so spiritual? The
answer would seem to be that the model mother is the Virgin Mary, hence
throughout the story of western painting motherhood has persistently been
treated as something divine. In the role of mother, woman has been shown

to be someone worshipped, adored, bathed in an extravagance of love; as man's protector and comforter, raised to heroic status as champion of all he holds most dear; the perfect woman, the pearl of great price. But in the role of wife she enjoys no such divine status; she is a mere chattel, and the only pearls to be seen are those her husband has hung round her neck to make her look more worthy to be his spouse. One is an idealised relationship: the other could not be more humdrum. Art has treated the two female roles as if they were entirely separate, even though a mother is likely to be someone's wife, and a wife someone's mother.

This idealisation of Mother is made psychologically possible because invariably she is represented as *our* mother, rather than as the mother of *our* children. Accordingly she is a woman to whom man can relate asexually, and in consequence she can be as perfect in his eyes as the Madonna. A wife cannot be this: she is a sexual partner, however weakly the fires may be lit. Here is the one sexual relationship sanctioned by Christian morality: therefore the wife is depicted as virtuous and dutiful, not dangerous and exciting. She is not a figure of fantasy to be passionately loved at a distance; she is not a beloved leper too dangerous to allow close. The wife has to be close, day by day, for better or for worse, till death do us part. Under these circumstances she absolutely must not be threatening: she must be utterly safe, utterly submissive, and probably utterly dull. Neither virgin, nor heroine, nor symbol of all things man acknowledges to be greater than himself, she is left with nothing to offer beyond being his social companion and the breeder of his children. So says art.

You might expect that Mary would be the prescription for a perfect wife too, since she was the bride of God. What better model, male vanity being what it is? But here theology ties itself in painful knots because Mary was also married to Joseph. The Bible says so. Presumably for this reason, the marriage of Mary and Joseph was not a favourite theme of church painting, though it did produce at least one masterpiece – Raphael's *Marriage of the Virgin* (Ill. 98), commissioned as an altarpiece and now in the Brera Gallery, Milan. Here is a masterpiece, what is more, that succeeds in achieving something most rare in art, which is to represent marriage as the outward celebration of an inner state.

Strictly speaking, of course, it cannot be. The painting illustrates not the Bible story but an absurd tale recounted in the mediaeval *Golden Legend* of how suitors for Mary's hand presented rods to the High Priest of the Temple who then awarded her hand to the one whose rod blossomed. So there cannot have been much inner state, nor much outward celebration. And yet Raphael has risen far above the silly romance of the tale. Two figures are rapt by the moment of marriage – the placing of the ring on Mary's finger. Neither seems aware of anything else; we are invited to share a private experience. Raphael has made both figures physically beautiful, not in appearance so much as in the way they move and the way those

190

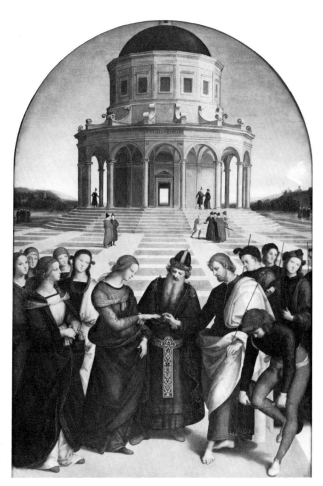

98 RAPHAEL, *Marriage of the Virgin*

movements bring the two figures together. It is this emphasis on physical grace which gives the occasion an ethereal quality that is present in few pictures of marriage actually witnessed – and a tremor of sexuality that is even rarer.

Artists generally have given marriage a bad press. Instead of being free to employ a model upon whom to project his fantasies, the painter is now compelled to face the real, down-to-earth thing – the married state. It is seen as a relationship set in a very low emotional key. The woman who is married is portrayed as a stereotype of a particularly boring kind. She is not exciting enough to be a mistress; she is not dangerous enough to be a man-eater; and she is not pathetic enough to be the object of romantic love. The husband's role is represented as not quite so yawningly dull as

191

this, but equally wooden. He is neither lover nor hero nor tragic victim: he is like the senior partner in a rather inert company called Family and whose real pleasures are enjoyed outside office hours. Within the marriage relationship both participants are mere pieces in a game: they are players who act out roles in a play that has been written for them, and which they are fated to perform as long as they live.

Look at Ingres. I realise that I have been looking at Ingres rather often in this book; but he is an artist whose attitudes to women are so clear-cut that I find it hard not to. He is at once the great professional and the great naive. Women are so many contradictory things to him that I imagine his daily life to have been a psychological battleground of warring factions – united only by a common worship of the great Ingres. He is particularly illuminating on the theme of marriage because he has such a diamond-sharp perception of what marriage is, and of how totally different it needs to be from any other male-female relationship.

When Ingres looks at marriage it is necessary to wash from the mind all record of how he regards women in any other connection – in particular to wash from the mind the women of his fantasies, those damsels in distress, those nymphs supine with adoration of the mighty male, those somnolent harem girls forever waiting to be of service. Ingres' studies of marriage are nearly all of them drawings, and they are some of the loveliest drawings we have. But they are all somewhat the same: not the people depicted, each of these is scrupulously individual, but the *ensemble*, the reality and feel of the group, what Ingres is conveying about them being together.

The Family of Alexandre Lethière (Ill. 99), in the Boston Museum, is among the sharpest of them: and it is easy to understand from gazing at it why generations of art professors have leaned over their students' efforts and muttered 'You can't draw!' – meaning 'You can't draw like Ingres!' Nobody ever could draw quite like Ingres: there is a precision and a sensitivity about this use of a mere lead pencil which is quite uncanny. Everything seems to be here – features, physique, character, expression, a dozen different textures from skin and hair to lace and velvet; even the little kicking gesture of the child's right foot. Breathtaking! At the same time, what is Ingres showing us? He is demonstrating a stereotype as perfect as his drawing of it. The husband is above the wife, and at a decent distance. The wife is seated below him, hair tightly bound, expression a little more vacant than her husband's, and cradling their year-old child. The infant, unlike its parents, smiles, enjoys itself. Lethière had in fact been a dashing young naval officer taken prisoner in the Napoleonic Wars, and she a Roman beauty swept off her feet after his release and after the sudden death of his first wife. A romantic pair – yet there is not one hint in the drawing of what husband and wife may feel for one another, no suggestion of contact between them beyond an amiable domestic rapport indicated by the

192

99 JEAN-AUGUSTE INGRES, *The Guillon-Lethière Family* (French, 1780–1867; graphite; H.: 26·5 cm. W.: 20·25 cm; 26·45, Purchase, Maria Antoinette Evans Fund; courtesy, Museum of Fine Arts, Boston)

hand resting on his sleeve. Marriage has taken over. It is a masterly portrait of a social institution.

There is a strong feeling about the drawing that all is as it should be. With Ingres, responses to women have to be pigeon-holed; the labels must not get mixed up or chaos might ensue. Emotions appropriate towards a wife are entirely different from emotions towards a woman conjured out of fantasy, or towards a mistress. Compare the Lethière drawing with a painting of which Ingres completed no fewer than five versions, *Raphael and La Fornarina* (Ill. 100). Ingres admired Raphael above all other artists, so it is safe to assume there was a strong self-identification in his portrayal of the Renaissance master. The woman known as La Fornarina was Raphael's model and mistress: by the nineteenth century she had become elevated to the status of legend – the ideal muse/mistress for the ideal pain-

ter. And this is what Ingres tries to paint. It is a love relationship just like Lethière's with his beautiful Roman wife; but what a difference! Now she is above him – she is his world, his inspiration, his lover. She is half naked seated on his knee, her arms wrapped round him. Notice that his arm around her still holds the stylus with which he has been drawing her. So, his genius and his passions are intertwined: each nourishes the other.

All this is as it should be, too, because La Fornarina is pigeon-holed Muse/ Mistress. The requirements of a wife are entirely different: she belongs in quite another pigeon-hole, and therefore invites quite another set of responses.

What is virtually a commandment in the eyes of Ingres has to varying degrees been the practice of artists in general. Marriage is perceived to be an institution in which people are symbols of a pre-ordained relationship; and this relationship is one that cancels out feelings. But every so often – very rarely – the opposite takes place, and instead of the institution of marriage over-riding human feelings, it is the feelings of two people which over-ride that institution. And when this happens it is invariably a painting of a couple the artist knows well. The stereotypes break down and he

100 JEAN-AUGUSTE INGRES, *Raphael and La Fornarina*

194

presents them as people – as two people who love one another and in consequence happen to be married.

No painter threw off marriage stereotypes more vigorously than Rembrandt, and significantly some of his most joyful pictures relate to his own marriage (Pl. XX) to Saskia (but I want to step round Rembrandt for the moment and come back to his treatment of women in the final chapter). More unexpectedly, so did Rubens: the artist who committed so many unfeeling barbarisms with female stereotypes in his pursuit of a triumphant career also gave us one of the most touching of marriage pictures when he looked into his own heart and painted himself and his first wife – *Rubens and Isabella Brandt in a Honeysuckle Bower* (Ill. 101), now in the Munich Gallery. What he shows us has none of the unlaced exuberance of Rembrandt, to be sure: Rubens keeps rather formally to the public face of marriage, anxious to show off their breeding and their worldly state. But through all this they are showing us their happiness too. She is offering a glimmer of a smile towards the man painting her who is also, of course, the man seated casually next to her in whose hand she lays hers. She is gazing at Rubens who is gazing at himself holding the hand of the woman

101 PETER PAUL
RUBENS, *Rubens and
Isabella Brandt in a
Honeysuckle Bower*

195

he loves – a neat triangle round which a warm current of feeling flows. Love is there, but it has to be read – in those smiling eyes, those hands touching, in the lover's bower where they sit, in the sweet honeysuckle draped around it.

Some ten years later Rubens' Dutch contemporary, Frans Hals, painted another of those rare marriage portraits not to creak with institutional formality – his *Portrait of a Man and a Woman*, in the Rijksmuseum, Amsterdam (Ill. 102). We have no idea who they may be. Claims that the man may be Hals himself or his brother Dirck are now pooh-poohed, and yet the fact that they have been considered seriously without any supporting evidence says something very important about the picture. It is perfectly obvious from looking at Hals' portrait of this jolly middle-aged couple that they were people the artist knew well, and liked well. Whether or not he was commissioned to paint their portraits, he still painted them out of his liking for them, not as symbols of a marital relationship. The husband is well-dressed and obviously successful, but this is not thrust at us as a camouflage: he leans back in a jocular fashion, and in the next second he might reach for a flagon of ale or plant a kiss on his wife's mouth – we cannot be sure which. Perhaps both, one after the other. And she – less beautiful than most of the ladies in the more formal marriage portraits I have been looking at, yet she has a freshness and a warmth about her that they lack, and she flirts with the painter in a way that tells us much about the person she is and how naturally and physically she relates to the man she is with. Even Hals' concessions to fashionable symbolism seem light-hearted and unimportant next to the reality of their relationship – the Roman landscape to suggest their cultural sophistication, the vine tendril hinting at her character, the thistle hinting at his. In formal portraits such symbols were meant to be taken most seriously: here they seem more like a joke that the couple will share with the artist afterwards when they look at their picture.

A third painting clamours to be included in the small company of marriage portraits that are about people's feelings for one another rather than about a social institution. This is Renoir's picture – now in Cologne – of the young Alfred Sisley and his wife (Ill. 103), painted two and a half centuries after the Rubens and the Hals, and yet it possesses something of the elegance of the first and the joviality of the second. Again it is a portrait of friends – Renoir's fellow-Impressionist and closest painting-companion at the time (1868), and the lady he had recently married. What is so delightful about the picture is that it acknowledges the public face of marriage – he with his top-hat and black bow-tie, she swathed in crinoline – and then takes no notice of it. They lean forward to touch one another. She is lost in listening to what he is saying. It feels like almost too private a moment to be watching.

A marriage picture? This is a painting about love: one of too few.

102 FRANS HALS, *Portrait of a Man and a Woman*

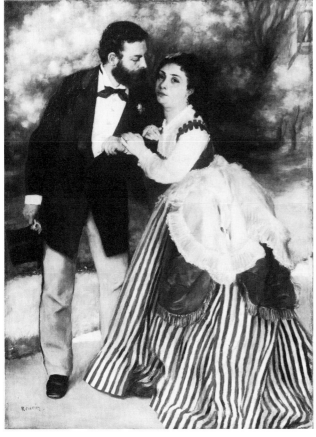

103 PIERRE-AUGUSTE RENOIR, *Alfred Sisley and his Wife* (Wallraf-Richartz-Museum, Cologne)

10 *In Love and Laughter*

There are gaps in the tale which I must now fill in – painters who have looked me in the eye as I have looked at them, and have said 'Not guilty'.

As I have told it so far, much of the story of women in painting has been something of a protracted melodrama acted out by creatures in masks, like a classical chorus. We have known what the creatures stand for by the masks they are given to wear – the mask of innocence and purity, of carnality, of vanity, loyalty, domesticity, submission, helplessness, beauty – the mask of wife, mother, mistress, virgin, heroine, temptress. And so on. What I have been looking at by and large have been stereotypes; how men, turning women into art, have chosen to typecast them – often in apparent homage, it is true, yet invariably for male convenience and entirely in accordance with male rules. And because art has been a man's game, only one has been invited to play.

All stereotyping contains within it a strong dose of hostility: we often label what we fear, and by labelling it we tame it. The evidence of western art is that this is exactly what has happened to women. The compliments art has paid to them are double-edged: it has been the most sumptuous accolade man has ever offered to woman, and a powerful instrument in his control of her. Man, through art, has announced – This is Woman, and this is how she ought and ought not to be.

There are, however, artists who have not made such judgments about women, and I want to end this book by looking at four of them: Rembrandt, Watteau, Goya, and Toulouse-Lautrec. These four selected themselves – or, rather, they exempted themselves whenever I came to consider the stereotypes into which women have generally been cast. There were others who exempted themselves too, of course, but these four stand out. They are painters I particularly love: perhaps only now do I begin to known why.

So, I have to admit that the selection is to some extent personal and subjective, criteria which art scholars are often encouraged to shun, as though objective evaluations of daubs of colour were quite enough and the power of art to make the blood and the brain race were an embarrassment to the scholarly mind. Sometimes I feel that art historians are the gardeners of art's estate, trained to keep the paths swept clean for the rest of us to walk along. Of the truly outstanding scholar this is, of course, never

true: his perceptions and his knowledge invariably work together. Let me, then, pay tribute where it is due and lead into Rembrandt with an observation by Sir Ernst Gombrich – which I take as both an invitation and a warning. 'To talk cleverly about art is not very difficult, because the words critics use have been employed in so many different contexts that they have lost all precision. But to look at a picture with fresh eyes and to venture on a voyage of discovery into it is a far more difficult but also a much more rewarding task. There is no telling what one might bring home from such a journey.'

Rembrandt's women. They could so very easily have been stereotypes, and in the eyes of many painters almost certainly they would have been. Rembrandt's subjects are not in themselves particularly original. There are portraits of his wife in fancy costumes that in other hands might have added to the store of Women as Clothes-Pegs. There are women bathing who could have been voluptuous sea-nymphs. There are women trying on earrings and admiring themselves in a mirror who might have been symbols of Vanity. There is Danaë receiving Zeus in the form of a shower of gold – by Rembrandt's day she had already undergone her transformation from innocent to temptress. And various women out of the Old Testament including Susanna and Bathsheba, both of them by the seventeenth century treated as little more than eyefuls of coy flesh splashing about in the water in full view; and Potiphar's wife, an archetypal man-eater if ever there was one. And among New Testament themes, the woman taken in adultery – an archetypal sinner – and (as potential models for motherhood) a number of Holy Families with or without angels in attendance.

And yet when you look at these paintings one thing becomes immediately clear: Rembrandt did not set out to typecast or to judge women. There are no goodies or baddies in his vision of things, only human beings caught in an electric circuit of relationships. Rembrandt is at his finest as a painter of human affairs: even when he is painting single portraits, or studies of people alone, he still enables us to perceive in their faces and gestures how they relate to their own world and what they feel about themselves in that world. One of the strengths of Rembrandt is that he finds everybody interesting. His brush is at its most passionate when digging out of a person's features those private sentiments which in our own lives we all imagine we can mask: it is this of course that makes his self-portraits the most illuminating chapters of pictorial autobiography we have, and it is this too that gives Rembrandt such a depth of empathy towards others, men and women alike.

Consider an extreme case. Few women in the Bible are as unredeemably mendacious as Potiphar's wife Phraxanor. The account of her in the Book of Genesis is brief and to the point. She lusted after her husband's trusted servant Joseph, tried to persuade him to sleep with her while Potiphar was away, and was rejected by Joseph on the reasonable grounds of not wishing

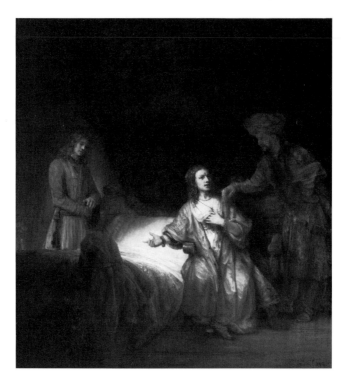

104 REMBRANDT VAN RIJN, *Potiphar's Wife accusing Joseph* (National Gallery of Art, Washington; Arnold W. Mellon Collection 1937)

to betray his master's trust. In revenge she then used the coat he had left behind in his haste as evidence of his attempted seduction of her. Joseph had to flee the house in disgrace. The most generous-spirited artist could be expected to paint her as a viper.

But now look at Rembrandt's account of her – *Potiphar's Wife accusing Joseph* (Ill. 104), now in the National Gallery in Washington (another version hangs in the Berlin Gallery). A full glare of light falls on this impassioned figure. One hand is across her breast, the other extended towards the man she accuses, and she leans back in her chair in the full flow of her words. Her face is one of ravaged beauty; under a thunderous frown her hooded eyes blaze into the dark as if searching for some object worthy to be melted by them. She is a woman caged and desperate. She is magnificent: her passions are worth twenty of the feeble heartbeats of the two men on either side of her – her husband dragged into all this and gravely listening in the half-darkness, and the downcast and sanctimonious figure of Joseph. Rembrandt has seen her as a tragic heroine as much sinned against as sinning, a woman whose great unused wealth of sexuality has finally burst into destructiveness. He neither accuses nor exonerates her; he looks beneath her perfidy and tries to comprehend what kind of person might be driven to commit it.

200

Nothing separates Rembrandt's view of women from that of other painters more sharply than his treatment of sexual sin. To Rembrandt there is really no such thing. He would have known Flemish art well, and was certainly familiar with Italian and Spanish painting; he would have been aware that in the tradition of religious painting all over Europe sex and sin were usually synonymous, and that of the legions of sinners marched naked to hell the most culpable were invariably women. Living in a country newly converted to Puritanism, where there was no call for altarpieces, Rembrandt enjoyed the freedom of not having to paint religious subjects for a celibate Church that hated both sex and women: in fact, had Rembrandt lived in a Catholic country it seems doubtful that he would have painted religious subjects at all. As it is he was able to turn to the Bible much as he turned to classical mythology – as a source of dramatic narrative illustrating the passions of mankind.

It is typical of Rembrandt that when he paints the *Woman taken in Adultery* (Ill. 105: London, National Gallery) he shows us a beautiful woman dressed all in white like a bride. She is not a sinner, but a woman who knows love, and Rembrandt surrounds her with men who know only hate. Even more suffocatingly than with Potiphar's wife he shows us a

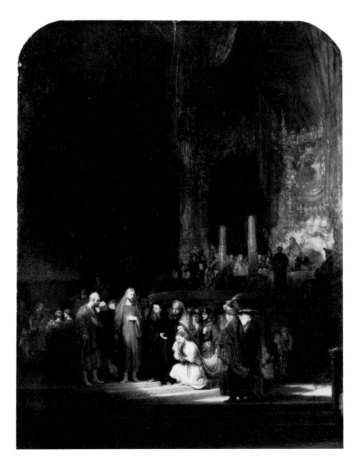

105 REMBRANDT,
The Woman taken in Adultery

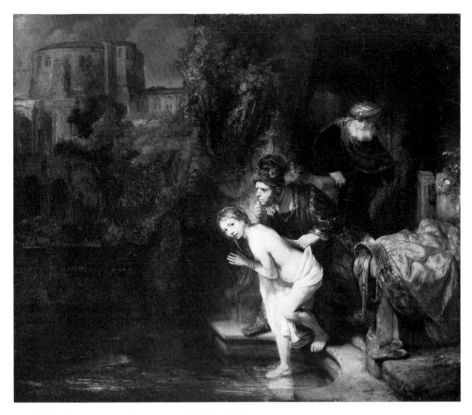

106 REMBRANDT, *Susanna and the Two Elders*

woman caged by a world of men: Christ's words 'He that is without sin among you, let him first cast a stone at her' seem directed with force at this ugly crowd of oglers whose moral tyranny is echoed by the monstrous gilded architecture towering above them.

And the temptresses painters loved so much – Susanna, Bathsheba, Danaë. Here were women with bit-parts in the Bible and in Greek myth, creatures of no consequence whom chance shoved unawares into the path of history for a moment as they slept or bathed. By the seventeenth century those fleeting entrances in the nude had earned them promotion to leading ladies, at the price of being transformed from victims to seductresses.

Rembrandt paints them too. His Susanna (Ill. 106), in the Berlin Gallery, even wears that look of shock on her face of one who is suddenly and quite unexpectedly exposed to the public eye. Rembrandt's light, full on her, is like a torch turned on to a crime. It is exactly the moment when the two lechers – looking very like the old men standing in judgment round the woman taken in adultery – have leaped from their hiding-place and are blackmailing her into making love or else standing accused of infidelity to her husband. All this is in her face and in her gesture: shock, embarrassment, terror, bewilderment. It is a brilliant dramatic stroke of Rembrandt's

202

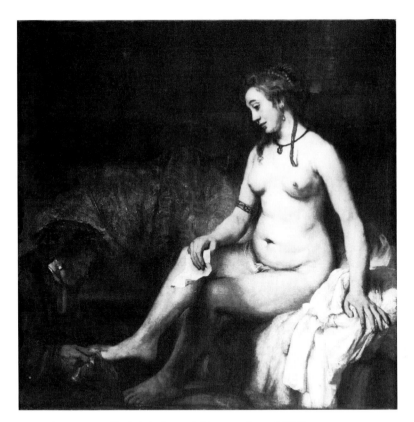

107 REMBRANDT, *Bathsheba* (copyright SDPMN/DACS 1984)

to use that beam of light to make her turn towards us, because as she does so her look implicates us in the crime and at the same time appeals to us for help. We cannot stand outside her predicament – we cannot ogle her – we cannot blame her for being such a tempting sight. We have to receive the full impact of her fear, her anger, and her plea, as well as the full impact of her beauty and her nakedness. Her shock is also our shock, her confusion our confusion. Rembrandt allows no possible emotional distance between ourselves and her, and therefore allows us no comfort in being able to separate our perception of her sexuality from our perception of her plight.

Bathsheba, in the Louvre (Ill. 107), makes no such direct involvement of us. She is totally unaware of our existence – aware only of her own thoughts. But in that lost, wistful look all her thoughts are there to be read – as clearly as she herself has read the letter in her hand summoning her to be King David's mistress. Here is no flirtatious little hussy as art so often shows her to be: Bathsheba is another of Rembrandt's sexual women caged in a world of men – a weak, vain woman this time, but in Rembrandt's eyes the more tragic for being so. Her head is full of dreams of pearls and palaces, but her smile is also a smile of sadness. Fatalism

hovers over her features – a hopeless acceptance of her own frailty, of being a mere pawn in the game of history, of the certainty that she will betray her husband and herself, even a foreknowledge that the cost of her own acquiescence will be her husband's death. Bathsheba is one of Rembrandt's few nudes – and it is vital that she should be nude since it is her body that she is giving to her king, her body which is both the flame and the victim of his lust. Rembrandt shows her still beautiful but already ageing, thickening, as if he wants to stress the vulnerability of this woman flattered at finding herself still beautiful enough for a monarch. 'Frailty, thy name is woman' could have been Rembrandt's caption. But still he will not judge her. She is no whore and no temptress, only a human being of no special valour who finds herself caught in a web of events far more powerful than she.

Danaë too is a pawn in the game of history – or, more accurately, a toy in the sport of the gods. According to prophesy the King of Argos will be killed by his daughter's son. Accordingly Danaë, the daughter, is locked away high in a tower to keep suitors away. But Zeus, his appetite as usual whetted by challenge, visits her disguised as a shower of golden rain; as a result she gives birth to Perseus who eventually kills his grandfather by accident with a discus. The legend of Danaë, like those of Susanna and Bathsheba, is about male lust: in Chapter 4, I described how artists progressively turned these legends into demonstrations of female lust. Between the sixteenth and the twentieth centuries Danaë undergoes a systematic transformation from symbol of chastity to flirt, temptress, whore, and – finally – masturbator.

Rembrandt's masterly account of her (Pl. XXI), now at the Hermitage in Leningrad, ignores this decline into voyeurism entirely. It is a deeply erotic picture, among the most erotic Rembrandt ever painted – this spread of bejewelled flesh on white sheets cocooned in velvet and gold curtains. Yet the sexual electricity flickering across the painting is generated entirely by Danaë's predicament as Rembrandt has perceived it. What he shows us is a woman imprisoned from the outside world, alone except for an elderly servant who is also her jailer. All thoughts and passions are locked into this suffocating cubicle with no outlet for them but in the dreams and hopes that come to her through that little glimpse of sky. The bronze cupid weeps for her: the old servant has a stunted, withered arm. Suddenly something has appeared to her in that patch of window; Rembrandt does not even show us clearly what it is because the focus must be on her. It does not matter that it is Zeus on the razzle. This is not a seduction, it is *her* awakening. She is a woman about to receive her first lover. The picture is a celebration of love.

Indeed, all Rembrandt's love paintings are celebrations. When he paints his first wife Saskia he dresses her up in slightly absurd shepherdess outfits or festooned with flowers as the goddess Flora: no pompous display of jewels

204

and high fashion – she is never represented as a clothes-peg on which to hang finery to enhance her value as his possession. On the contrary, Saskia's bewildered face always seems to be trying to resist catching her husband's laughter as he paints her – because he too has dressed up for the occasion, as he shows when he puts himself in the picture as a young cavalier, raising a toast to their happiness in that most joyous of marriage paintings, *Rembrandt and Saskia*, in the Dresden Gallery (Pl. XX).

Think of those portraits of wooden married couples rigidly maintaining appearances and impersonal distances from one another, and then look at this. Here is Rembrandt celebrating the laughter of happiness – grinning at himself in the mirror while he paints the back view (why the back view?) of his bride squatting heavily on his knee. He is faking it of course because he has no hand free to paint; none the less he has assembled it so convincingly, even to her frown of slight disapproval at the high-jinks, and the peacock on the dinner-table dressed as flamboyantly as he. It is a portrait of a happy relationship, not of a public institution.

With Rembrandt everything always comes back to human relationships. He gives us such a range of them. That other great marriage portrait traditionally known as *The Jewish Bride* (in the Rijksmuseum, Amsterdam: Ill. 108) is as quiet as the self-portrait with Saskia is boisterous. The man's hand rests very lightly on the girl's breast, hers even more lightly against his hand. They lean together without looking at one another or needing to, because each face is filled with thoughts of the other: it is a moment of silence between things said, and in this silence all is said.

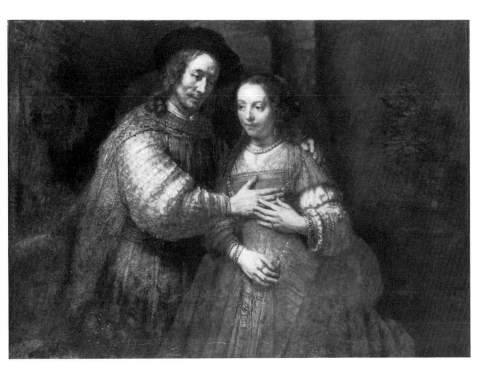

There has never been a painter who so magically gave flesh to private thoughts and feelings, made the invisible so visible, so tangible, tactile even. Rembrandt is a painter who acknowledges quite naturally the flow of passions between two people, setting up no barriers, and imposing no rules. Women's sexuality – and his own – he takes in his stride, never trivialising sex or depersonalising it, but accepting it quite simply as a bond two people share. And it is in this understanding of the equality of relationships that he avoids the common stereotypes and awards dignity to women and to men's love of them.

It is a trick of style that some painters insist we regard them as serious when by and large they are not, while others invite us not to take them seriously at all when they fundamentally are. A perfect case of the first is Rubens, and of the second Watteau.

Watteau looks such a slight painter, a miniaturist compared to Rubens. Place the two artists on a set of scales and Watteau would fly upwards. The sheer material substance of Rubens' output gives it a heavyweight feel: Watteau's work by comparison is small in size, small in number, featherweight. Here is matter weighed against spirit. Yet Watteau owes much to the example of Rubens, and both are above everything else painters of women – Rubens in early-seventeenth-century Flanders, Watteau in early-eighteenth-century France.

The difference between their treatment of women is not in the end one of weight so much as of outlook. To Rubens women are generally flesh – to be handled, viewed, valued, desired, or abused by men. They are the passive objects of male attentions. Watteau's women are equally objects of male attentions, yet they are anything but passive. They have hearts that must be won; they have tastes that ask to be respected; they are mistresses of themselves and not of the men around them. Exquisitely pretty they may be, dainty and butterfly-like, but it is not their bodies that Watteau tries to capture in paint; it is their feelings. Watteau is above all a painter of sentiments. And the sentiments he touches are rather like the shimmering dresses he adores to paint – they are the infinitely varied surfaces of a gemstone that he turns before our eyes; and that gemstone is love.

To Watteau there are as many colours of love as there are colours of an opal: its true identity is elusive, yet we know it to be precious. Watteau looks at love – like the gemstone – from every angle and shows us what lights it catches at each moment: love can be sparkling and brilliant, sombre and sad, a trick, a game, a flirtation, a frolic; bewitching, numbing, painful, flamboyant, ridiculous. All are faces of love, and Watteau enjoys them all. Behind all the faces lies an ideal which his characters are always seeking – they never do anything else – and they pass their days trying to find which key it is that will lead them there. This ideal is never conquest, possession, romantic capture, adoration from afar – none of the male sexual

206

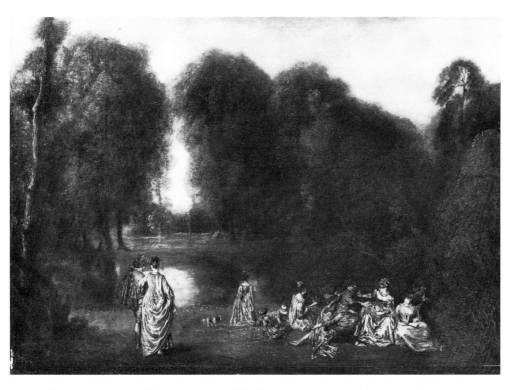

109 JEAN-ANTOINE WATTEAU, *Assemblée dans un parc* (copyright SDPMN/DACS 1984)

pursuits that create the customary stereotypes of women: it is of a union bonded by mutual love of such perfection that it can only be touched, never grasped.

This haunting obsession with the unobtainable is the keynote of Watteau – the persistent chord of great intimacy and great loneliness. A tiny painting in the Louvre, *Assemblée dans un parc* (Ill. 109), is a miniature account of Watteau's world. Here is an autumn evening by a lake among trees. Watteau's people have gathered in search of love, as usual. The main group of them is spread about on the grass, and Watteau has painted their costumes in silvery strokes of bronze and red and green which echo the more sombre tints of nature around them – as if to suggest that this is a place where they belong, a sympathetic stage for their sentiments to be aired. In this group are four couples, and none of them has managed to find the elixir they all seek. One man plays music for a lady who is looking elsewhere. Next to her a woman is thrusting away a lover who seems to have made a grab at her. Watching the scene is a man whose lady has wandered off with the dog towards the lake. The fourth pair sit at some distance one from the other while their children play.

207

Then, to the left, are two lovers who have found their secret: they walk arm in arm away from us, engrossed, unaware of the antics of the rest of them. And in the far distance, beyond the lake, is seated one last pair of lovers who have left the crowd altogether and discovered the peace of nature in which to be alone. They too have caught perfection – for a day, or an hour, or a minute, who knows? Here is a palette of love's colours, varying as seasons vary; and because these pilgrims of the heart are bound to the seasons their love will ripen and fall. Watteau sees the spring and the autumn in everything. Love casts its spell and time breaks it.

It is a sweet and melancholic vision, but it is always a serious one. Love *is* serious to Watteau, even when the pursuit of it is utterly absurd. A painting in the London Wallace Collection with the title (from a poem) *Voulez-vous triompher des Belles?* (Ill. 110) sets the solemn and the ludicrous side by side. In the background sits an extremely pretty girl being intensely wooed by a bevy of young gallants doing everything in their power to win her heart and – so it would seem – getting absolutely nowhere. In the foreground the masked figure of Harlequin writhes in a preposterous charade of love-sickness before a large and plain lady who has clearly never heard anything so wonderful in her life and is quite bowled over, clamping her hand to her breast to still the palpitations. And yet . . . look more closely: the comedy is another mask. He is a clown but he is also Romeo, and he has touched a chord in her.

It is something Watteau does so well. He knows how to paint that moment when time stops and people fall in love. It is the same moment, more romantically described, which he picks out in *La Gamme d'Amour* in the National Gallery, London – time stops, music stops, manners and affectations stop, as Watteau catches the magic of an interlude when nothing else matters but love. And in the picture in Berlin known as *The Shepherds* (Ill. 111) it is the same too. Here in the open countryside is a gathering of delightful nonsense – a girl on a swing as if she were in a Parisian garden – clusters of young people flirting and lounging about – a battered reprobate playing the bagpipes – and an exquisitely unreal couple dancing to his music, she garlanded with flowers, he with an ostrich-feather hat and stockings of different tones. Over on the right a real shepherd looks on in amazement and so do the sheep. And yet amid this something has happened: for all his effete posturings and his face set in a fashionable sneer the young dancer's eyes have become fixed on his partner, and hers – though she has her back to us and we cannot see – are quite obviously fixed upon him. Perhaps it is nothing quite as splendid as love; perhaps in another moment the dance will go on as before; but at this precise second a spark is struck between them, and this strutting mandarin and this enchanting girl we hardly see have set aside the ritual comedy of their lives and found each other's heart.

Watteau's genius lies in pinning the magic of fleeting experiences. His

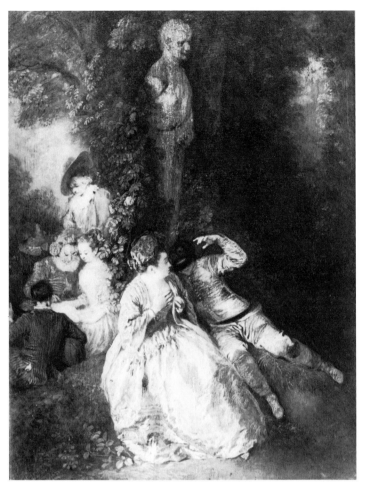

110 JEAN-ANTOINE
WATTEAU, *Voulez-vous
triompher des Belles?*
(Reproduced by
permission of the
Trustees of the Wallace
Collection)

111 JEAN-ANTOINE
WATTEAU, *The Shepherds*

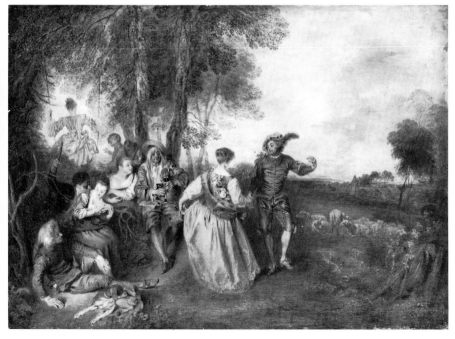

encounters of the heart are part comic-opera and part love-poem, but they are always convincing, and crucial to this is the fact that his women are always convincing. They are real. In a gesture, a glance, a tilt of the head, Watteau can convey mood and character in a way that is almost miraculous: he even has a special fondness for depicting women turned away from us as if to demonstrate that the essence he seeks does not have to reside in a pretty face.

Watteau's successors, Lancret and Peter, had no such penetrative gift, and no such interest in women as real. They copied Watteau's manner but they reduced his subject-matter to amorous sport, with young gallants playing love-games in front of wide-eyed dolls stupid enough to be taken in. So the legacy of Watteau degenerated into a kind of sexual playtime in which women were infantilised and love diminished. Watteau, by contrast, enhances love because he takes women seriously – usually more seriously than he takes men. It is always women who are courted, who hold the key to the heart. It is men who indulge in absurd antics trying to find it – no artist ever caught so well the self-indulgence of being in love.

In his most celebrated painting, *Departure from the Island of Cythera* (Ill. 112), in the Louvre, Watteau awards his young gallants the ultimate absurdity of being dressed as pilgrims to the tomb of St James at Santiago, complete with staff, water-bottle, and scallop-shells pinned to their hats; yet instead of a nine-hundred-mile trudge to the shrine of a martyred apostle, they have taken a short boat-outing, and then a few paces in their fashionable shoes, to the shrine of Venus. It is a piece of utter fantasy . . . and yet how poignant, how real, are the encounters they make. Here are the familiar Watteau themes – intimate moments and the passage of time. The couple closest to the statue of Venus are engrossed in one another. Next to them a second couple is preparing to leave. A third couple is walking away, she with a wistful glance back towards the moment that has gone. But the spell is breaking. The others are all chatting away down the slope towards the waiting boat. Little naked *amoretti* hurry them on board, their day's work done. The whole painting – indeed the whole of Watteau – illustrates that bittersweet philosophy expressed with equal sharpness by the seventeenth-century English poet John Donne:

> Love is a growing, or full constant light;
> And his first minute, after noone, is night.

Goya's women call to mind an aggrieved remark a lady made to me about *Anna Karenina*, which was that Tolstoy really had no right to know so much about women. Goya's portraits have a startling frankness of insight: he has a gift of revealing the fire that makes people burn. The most perceptive living writer on the artist, Sir Michael Levey, has put it in one sentence – 'Goya goes on gazing when everyone else has lowered their eyes.' It is

112 JEAN-ANTOINE WATTEAU, *Departure from the Island of Cythera* (copyright SDPMN/DACS 1984)

a comment I have also heard made of the photographer Don McCullin, and indeed the two of them have much in common.

People who lower their gaze do so out of embarrassment or out of fear. Goya is neither embarrassed by women nor frightened of them. He may be in awe, in love or in lust, or simply in empathy: whatever the response it is invariably intense. All Goya's paintings of women carry the overpowering impact of their physical presence, which is in essence the impact of their sexuality. A lesser man would have quaked, sought escape by pigeon-holing them – man-eaters, mistresses, clothes-pegs, sinners, wives. Goya never does, though the range of his women could be made to illustrate the entire gamut of these. He looks women straight in the eye, and they do likewise at him as if daring him to go on looking. His gaze is of such honesty that the confrontation is never aggressive, and never a game; it never feels like a bid for control. He wins his sitters' confidence and respect, and they in turn reward him with their secrets.

The result is an extraordinary trading of responses between painter and sitter – a mutual undressing of souls which makes Goya's portraits of women as much self-exposures as they are an analysis of the people he paints. And this confrontation between self and sitter ignites in some of the most vivid flashes of brushwork since Rembrandt a hundred and fifty years earlier.

211

Look at Goya's response to the arrogant beauty of a young Madrid lady called Francisca Sabasa y García, in the Washington National Gallery (Pl. XXIII). He sets her against a background of night-black and turns the light full on her. Strokes of diaphanous white flicker round the proud head; a shimmer of copper and gold flows across the shoulders and breast as if the garment is rippling, vibrating. Points of light play with the twists of hair that tumble down the forehead and the temples. And in the midst of all this agitation of paint stares a motionless face – prominent nose, lips thrust out with just a hint of scorn and of uncertainty, and those enormous mahogany eyes absorbing the artist as he paints them. Art offers no more vigorous and candid an acknowledgment of a woman's sexual presence than this.

The confrontation between Goya and Dona Francisca Sabasa is head-on: not aggressive in the least, and yet the portrait bears the imprint of a challenge – between the power of beauty and the power of art, between a proud young woman and a proud ageing artist. In quite a different key is Goya's response to another Spanish beauty – an aristocratic beauty – María Teresa de Borbón, Countess of Chinchón and cousin to the king (Pl. XXII). Goya had known her almost since she was a baby. His portrait of her aged two is a startling account of bright-eyed childhood as she stands in the gardens of the family mansion outside Madrid. Now, eighteen years later, he paints her again. The contrast with his portrait of her as a child is almost shocking. The contrast with the portrait of Francisca Sabasa is even more so: here is none of that vibration of sexual haughtiness which Goya captured with those excited sweeps of the brush. María Teresa sits quietly, wistfully, her gaze turned away from the artist towards some mirror of her own sad thoughts. She is pretty, dressed to look plain, and Goya has painted her pale dress with a kind of deadness which seems to match the deadness of her expression.

Prominent on her finger is a miniature of the man she has married, Manuel Godoy, the queen's favourite, a mountebank and voracious lecher who paid little attention to his young bride once she had brought him the social rank he sought. Godoy was Goya's patron (it was probably for him that the artist painted the *Naked Maja*) so he knew the two of them well. We only know what he thought about the marriage from this picture, and from it we feel we know it all. He paints her full-length, so distancing her just sufficiently to set her isolated within a cavern of her own loneliness, a beautiful woman from whom love has withdrawn. Again, Goya's response is unequivocally honest and open. She is his poor little rich girl, and the soft brushstrokes with which he sets down those features seem to touch at the sorrow of her life and at his sorrow for her. He treats her with the gentleness of a man handling an injured bird.

Goya's response to the famous *Maja* – Naked and Clothed (Ills. 113, 114) – is more blunt, as befits a subject painted to order as an erotic display

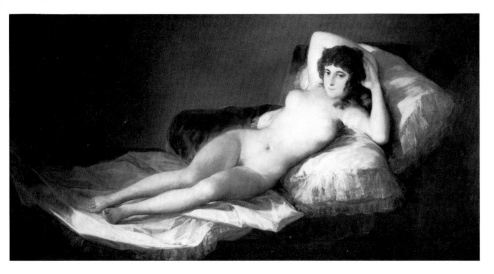

113 FRANCISCO GOYA, *Naked Maja*

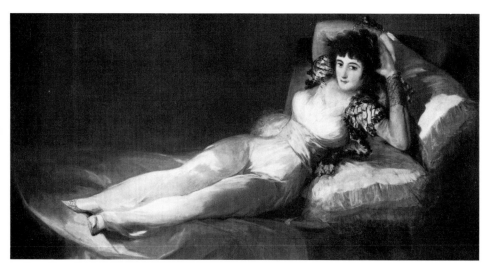

114 FRANCISCO GOYA, *Clothed Maja*

– probably for Godoy who certainly owned both pictures. They are quite clearly 'mistress' paintings, and were intended to invite only one response: lust. This was no occasion for subtle human perceptions, and Goya's brushwork is often as coarse as the commission. All the same, Goya never had a meatier opportunity to display his acknowledgment of female sexuality, and the result is not unjustifiably two of the most famous paintings of women in the world.

Nude painting was forbidden by the Spanish Church under penalty of death, so there was no tradition of it as in Italy, and Goya's *Maja* keeps

213

none of that safe distance from us that we come to expect in Italian painting where the nude is always to some extent the embodiment of a classical ideal. The *Maja* embodies nothing: she *is* a body. What is more, she is a very contemporary body: by Goya's day it had become a bohemian fashion among Madrid society ladies to dress as gypsies. To pretend to be a *maja* was emancipated and provocative. Even the queen dressed as one, and Goya portrayed her in the guise. So Goya's *Naked Maja* and *Clothed Maja* were painted in the context of a romantic fashion; and since the ladies Goya painted as *majas* were notoriously free-living (including the queen), it was a clear implication of such a fashion that a lady who dressed like a *maja* also undressed like one. And this, it seems to me, is the significance of what Goya is doing by painting the girl twice. Goya, as usual, is being extremely truthful.

Lying there, she hides nothing; and in his response neither does he. He dwells on the sensuous details of her body: the ringlets touching her shoulder, the breasts parted by their own weight, the shadow-line of hair down her belly, her hips and thighs rounded. The green divan like a hill of love on which she lies acts as a foil to the whiteness of her body – that diagonal swathe of flesh laid across the canvas life-size.

What rescues the *Naked Maja* from being lip-smacking is its candour. Goya is not pretending that she is the Goddess of Love: she is a woman who makes love. This is what she is – a real woman within a real social context who is just as appealing clothed as unclothed. In both roles she is perfectly at ease, and in both roles equally naked, as is Goya's response to her and indeed Goya's response to all the women he paints.

Even the queen. Perhaps, especially the queen. Goya's portrait of *The Family of Charles IV* (Ill. 115), in the Prado, is handled with exactly the same candour. There is no royal group portrait quite like it. So accustomed are we to seeing royalty flattered that such unglamourised realism announces itself to many people as quite shocking, almost an insult, a caricature, as if Goya were laughing at his royal patrons. He is doing nothing of the kind, nor is it conceivable that Spain's official court painter should have risked his neck in such a way. That the king was an amiable buffoon and the queen a termagant of no great beauty are judgments of history, not Goya's. There is no divine law which insists that royalty must be handsome, and no law of art which insists they must be made so. In Goya's eyes there can be no finer compliment than to place his skills in the service of showing them exactly as they are.

In fact this is a portrait of remarkable affection. Even the loathsome future King Frederick VII, prominent on the left, is made to appear no more than rather dull compared to his mischievous-looking young brother Francisco holding his mother's hand in the centre. And she, Queen María Luisa, is quite extraordinary. It is her presence that dominates the painting, just as it dominates her own family. Amused smile on her face, eyes hunting

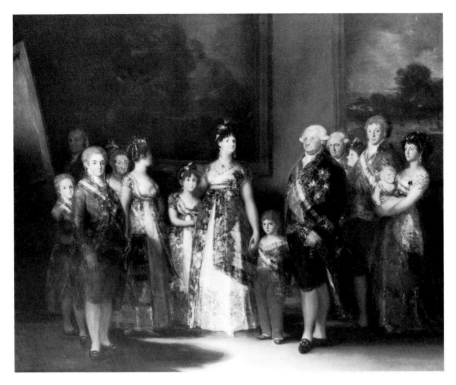

115 Francisco Goya, *The Family of Charles IV*

out the artist as he paints her, here once again is that open dialogue –
that trading of responses – which Goya invariably establishes with the
women he paints. To be unfrightened, even of the most frightening woman
in Spain, was in itself no small achievement. Its dividend here is the human-
ity he awards her, rather than the typecasting to which a more fearful
and sycophantic artist would have resorted. She is a wife without being
a mere adjunct of her husband, a mother without being a mother-hen,
and a queen without being a figurehead. Splendidly, powerfully,
humorously, she just *is*.

Through that dialogue with the man to whom she has entrusted her
portrait, like all Goya's women she becomes invited to participate in this
statement of who she is and how posterity will view her. In Goya we have
that rare thing, a creative act which is a kind of sharing.

Amid the flesh and greasepaint of Toulouse-Lautrec's underworld stares
a new face: woman alone.

She dances, she walks the streets, she drinks, she mocks, she despairs.
She is someone art has never shown us before. She is a woman who has
cast herself outside the decent orbit of man's world and yet has found a
kind of life for herself out there which is not a life of the entirely damned.

215

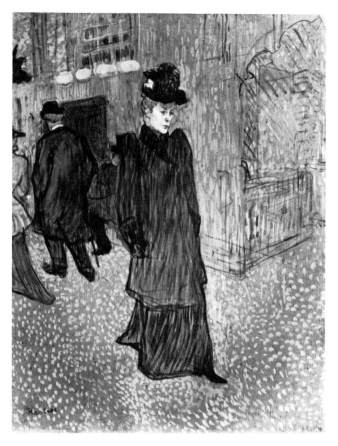

116 Henri de Toulouse-Lautrec, *Jane Avril leaving the Moulin Rouge*

She is not one of Hogarth's sluts from Gin Lane, nor does she lie in the black embrace of one of Bosch's monsters. Her spirit, battered maybe, is none the less her own rather than a clockwork mechanism wound up by some man. She may dance for men, whore for men, love men, but her identity is not defined by men. Lautrec's dancer/whore/acrobat/drunk stands apart from man's world and looks in at it – with a smirk of disdain. Being beyond the pale has awarded her the right to define herself, to compose her face not as wife/doll/mother/mistress/sinner/heroine but in accordance with her own desires and fears. It is her own face, and whether it is her fortune or her misfortune is nobody's business but hers.

This is what makes Toulouse-Lautrec's vision of women remarkably and deeply moving. His wit is never the wit of malice, it is a joke shared with his subject as the expense of those who might find it improper to make such a joke at all. Perhaps being himself beyond the pale gave the artist an insider's view of the *demi-monde* as a twilight place where anyone prepared to suffer its buffetings might discover something of the self that was at risk but at the same time intensely real. Lautrec looks at women

216

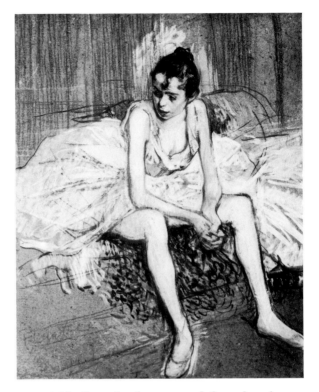

117 HENRI DE TOULOUSE-
LAUTREC, *Seated Dancer*

who have found their nature outside the rule of men – and the rules of
men – and he loves them for it. They are like an impoverished state that
has broken free of colonial rule, and he the reporter who is sufficient of
an outcast himself to have joined them. He recounts the sufferings and
the celebrations, and shares them.

It is an almost heroic perception of women which sets Lautrec radically
apart from the French Impressionists who preceded him. There is a painting
in the Museum at Albi of the dancer Jane Avril leaving the Moulin Rouge
(Ill. 116). It is a rich, bright painting: the paving and the shop-fronts are
speckled with light; the overall colour of the picture is a copper-red match-
ing the copper-red of her hair; her long dress and coat are streaked and
splashed on to the canvas with the haste of a painter who needs to seize
the moment when he caught sight of her passing him in the street. And
in the midst of this lively, sketchy brushwork is the pallid face of someone
entirely self-absorbed, alone in her own world. It is as if the artist has
entered her thoughts in order to paint her, placing his art at the service
of her privacy. Renoir's women in the street – pretty, smiling, part of a
jovial parade of youth – are never like this, they are identified as objects
of male admiration – they are always ripe fruit on the tree.

Lautrec's *Seated Dancer* (Ill. 117) is also an echo of Impressionism. It
reflects a profound admiration for Degas, and yet Lautrec's dancer exposes
a quite different range of feelings. A Degas dancer is always a creature

217

of the dance – she is fabric of the training she endures and the performance she gives. That is her magic, and Lautrec's dancer has absolutely none of it: she is merely a tired girl who dances. With her skinny arms and emaciated legs she squats inelegantly amid a whorl of muslin. Her mouth hangs open. She is watching others doing the same job she does. The very roughness of the painting feels like the roughness of her working world. Where Degas' dancers embody the idyll of ballet, Lautrec's *Seated Dancer* is a statement about being a woman and being exhausted.

It is not a flattering view of women. One of Lautrec's shrewdest insights is to perceive that male flattery of women is a guise of self-flattery which art has championed. Lautrec's night-club dancers – La Goulue, Yvette Guilbert, Jane Avril, and the rest of them – are ugly, even hideous, by conventional standards: Yvette Guilbert takes a bow (Ill. 118) as if she were an evil-looking gibbon swinging from the curtain to grin obscenely at the audience. But instead of judging her to be hideous, or employing his art to embellish her appearance, Lautrec awards her this tremendous welcome as a star in her own firmament – a woman who is intelligent, witty, funny, and successful. She is just as much queen of the *demi-monde* as Goya's María Luisa is queen of the *haut-monde*. Like Goya, Lautrec has an instant, open response to women who insist on defining their own personality, and in Parisian low life he found a world in which they could. Even in a brothel – perhaps especially in a brothel.

Lautrec's brothel paintings are like no others. They are not concerned to judge, condemn, ogle, or nudge: he offers no key-hole view because, after all, he was actually living in the brothel himself. Only superficially are they about prostitution: their true theme is female companionship – confraternities of women.

There is irony in the fact that an establishment existing solely for the gratification of men should have provided the artist with his most intimate view of women living without men, and his most moving account of their lives. But Lautrec's perceptions of women offer more profound ironies than this. He is observing a community of women who, either by choice or circumstances, are social outcasts; who are deprived of the usual comforts and securities of belonging to a world of men, and are therefore thrown back upon themselves – in isolation – to make what they can of their lives. It is not a world which excludes men altogether because they receive them, make love to them, are sustained by them; but in Lautrec's eyes men are essentially on the fringe of their lives, excluded from the bulk of it, necessary but not particularly welcome. Seen in this light a community of whores suddenly looks like the obverse of the familiar coin – of a traditional male-dominated community in which the real business and friendships of society are conducted among men, and women are kept on the fringe to perform useful functions like sex and having babies.

Here Lautrec's extraordinary empathy with women comes sharply into

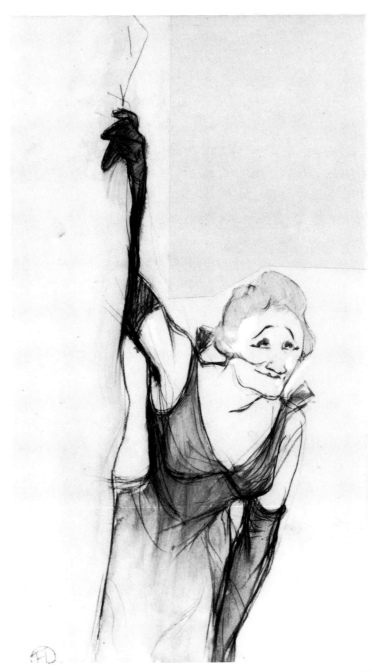

118 HENRI DE TOULOUSE-LAUTREC, *Yvette Guilbert taking a curtain call*
(Museum of Art, Rhode Island School of Design; gift of Mrs Murray S.
Danforth)

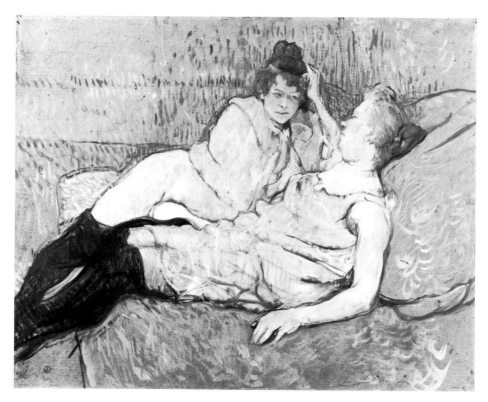

119 HENRI DE TOULOUSE-LAUTREC, *The Divan* (The Metropolitan Museum of Art, Rogers Fund 1951 (51.33.2).

focus. His studies of groups of whores, and of the various relationships among them, begin to look analogous to all kinds of other relationships which art has chronicled. The picture in the New York Metropolitan Museum called *The Divan* (Ill. 119) shows a couple of prostitutes relaxing on a huge orange couch, half dressed, in black tights. They are between clients, and they have faces that are hard with boredom and resignation. And yet this is not what the painting is about. Lautrec has focused on the tired intimacy and friendship that exists between the two women. The elder is slumped in exhaustion, eyes half closed; the younger is deeply attentive to her, head propped upright against her hand. They have both been making love, and whether they have been making love to men or perhaps to one another is entirely irrelevant. It is a painting about post-coital warmth and ease: this is what Lautrec has caught, and it is an observation that calls to mind the poverty in western painting of such tender moments between a man and a woman who have been making love. To my knowledge they simply do not exist. Lautrec's painting, which sets out to be no

220

more than an honest observation of two women off-duty in a whore-house, becomes in the context of art a comment *on* art, and therefore on man.

The analogies with traditional themes in painting which Lautrec's brothel pictures draw are the more moving because of the nature of the subject. Here are human relationships that are compensations for the real thing; they are forged out of human waste. Lautrec shows us women deprived of all the acceptable unions of love, who yet find a physical ease and trust among each other that are largely absent in conventional sex-relationships as art has recorded them.

Even relationships which *are* treated widely in art find poignant analogies here. Among the most moving of Lautrec's brothel paintings is *Two Friends* (Ill. 120), at the Tate Gallery in London. One prostitute is cradling another who is tired or sick. The arm placed around the huddled figure is so natural, so uninhibited a gesture of comfort and protectiveness, that the setting of a brothel ceases to be important. Even the fact that these are two women ceases to be important. This is a *Mother and Child*, or a *Pietà*. Here are two women who in all probability have no husbands, no children, no secret lovers, and Lautrec shows them engaged in an embrace more tender than

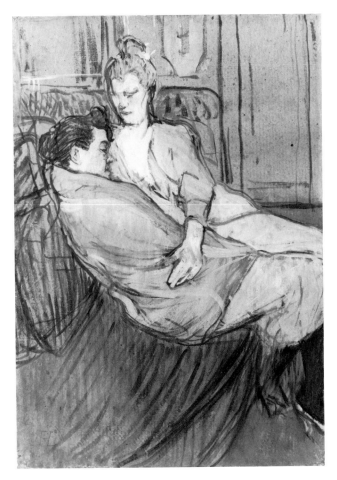

120 HENRI DE TOULOUSE-LAUTREC, *Two Friends* (Tate Gallery, London)

many a painting of a mother holding her parcel of a child – an embrace, what is more, in which no adult male would ever conceivably be depicted unless he were a heroic victim of a battlefield – or Christ!

This is the honesty and the openness which Lautrec finds in women, and which he finds available to them in a world to which they have been banished. Lautrec's women are – in a crippled but magnificent way – free.

Rembrandt. Watteau. Goya. Toulouse-Lautrec.

Something else binds them together. The lives of all four artists were overcast by the same shadow – affliction. Rembrandt was a bankrupt; Watteau was dying of a wasting disease; Goya went stone-deaf; Toulouse-Lautrec was a semi-dwarf.

Similar afflictions – you may say – have dogged the lives of countless other artists who did not paint women as these did. Clearly, then, it does not follow that suffering is the indispensable key to generosity of spirit of any kind. Here, none the less, are four major painters whose careers became dogged by appalling loss of one kind or another. I did not pick them out for this reason: they selected themselves as the great exceptions among iconographers of women, and I then asked myself what it might be that the four of them had in common. I cannot believe that this shared denominator – grave affliction – has no bearing on the pictures they painted, and therefore on the way they viewed the world.

Affliction robbed Rembrandt, Watteau, Goya and Toulouse-Lautrec of a certain kind of power. This was the power of autonomy, or self-reliance. No one who is bankrupt, dying, deaf, or crippled can stand proudly in a world of men and feel himself to be among the rulers of it. He is incomplete; he is in need. All sexism rests on the belief that one sex is superior and more powerful than the other, and therefore more fit to rule; which in effect means that men have generally considered it their right to control women. Furthermore, at all times in history works of art have been produced mainly for the benefit of those who – in one sense or another – are the rulers. Inevitably, then, the views expressed in art have tended to echo those of the people for whom art has been intended – views on wealth, on hierarchies, religion, property, and naturally on women. Hence, the view that prevails in paintings is of a female sex which deserves to be ruled; and to rule women of necessity means the denial to women of any qualities which, once acknowledged, might threaten the power of the ruler. And a woman's quality most threatening to that power is quite clearly her sexuality. That above all has to be controlled, negated, or condemned. The majority of art that deals with women reflects this view.

By contrast, what is most noticeable about the work of these four artists is the absence of any such bid to control, negate or condemn the sexual nature of women. On the contrary it is something celebrated; it is a source of joy; the world is enriched by it, and man's life enriched too.

222

The equation between this celebration of women's sexuality and the personal afflictions each of these four artists suffered is not, it seems to me, a coincidence. The connection is precisely that in losing the power of autonomy each of these painters forfeited the right and the need to rule women. Their need was in fact the opposite – to seek women's support and love in a world where they were no longer the rulers but the deprived. And being themselves deprived gave them access as equals to women who, after all, have always been deprived, so that they came to stand towards other men much as women have traditionally stood towards all men. It is this which gives their art a dimension of experience and of understanding denied to most other artists.

Art is not normally looked at in the way I have looked at it in this book. It is not intended as disrespect to genius to have done so; only as a plea that estimations of artistic merit are often made on inadequate grounds. To be brought up to care deeply for paintings is to be brought up under a certain hypnosis. It is the hypnosis of what are imprecisely held to be aesthetic values – matters of form and line, style and provenance, colour and brushwork, chiaroscuro and symbolism, or whatever it may be – as if those values were in some equally imprecise way nothing at all to do with life and with the human relationships round which life turns.

Art can only possess value if at some level it reflects who we are and what we hold to be true. And if it is admired principally for other reasons then it has been turned into a pretty toy, just as women have been turned into pretty toys by the men who paint them.

At the beginning of this book I seized on Germaine Greer's comment that 'Women have very little idea of how much men hate them', and I set out to look at how paintings might substantiate or contradict that claim, employing as currency Freud's perception that the artist is one whose gift is to express as a kind of reality fantasies which in all of us lie repressed. In other words I have turned to art as the principal historical witness to what men have really felt about women, and have tried to elicit what sort of evidence it offers.

Of course the evidence of art turns out to be neither as straightforward nor as accusatory as Germaine Greer's statement might lead one to expect. What is abundantly clear from any study of the work of great painters is that a banquet of emotions towards woman has fed man's creativity. He has garlanded her with art, and those garlands are indeed among the loveliest creations of mankind. Woven into them is so much love, desire, affection, need, tenderness, admiration, longing, friendship; and it is extraordinarily tempting – at least for a man – to see in those garlands only the sweetest of things, and women therefore as creatures cherished and valued beyond all else. Tempting, certainly – but not, unfortunately, true. By looking closer, quite another set of values is often seen to lie hidden,

and it is one that is nourished by an emotion generally more pervasive than all others when men have come to paint women. And that is . . . fear.

In its extreme form this fear does find lurid expression as hatred – women depicted as destroyers of man, as voluptuous sacks of evil, helpless fodder for sadists, rapturous victims of martyrdom. Much more often, though, what paintings exhibit is a fear of less hysterical kind. It emerges as a range of anxieties that are to do with a man's estimation of himself as a creature who is strong, dominant, decisive, good, virile, and wise. The accompanying anxieties are about how this vision of himself can be made to hold once he stands alongside his most natural partner, woman. It is in the most elaborate contrivances of art – the posturings, the mythologies, the grandiloquent allegories and sermons – that these anxieties commonly break through; the awareness that alongside woman he may cut a quite different figure, be submissive to her will, morally weakened by her, rendered impotent by her appetites, generally reduced, humbled, even made evil or destroyed, in fact not worth all that much at all. Hence the over-riding need, poured over the inventions of western art, to corral her, cosset her, control her, reduce her to manageable stereotypes. Viewed from this standpoint, so much art comes to look like magnificent camouflage behind which the dominant sex hides horrible doubts about his fitness to dominate.

Acknowledgements

A. C. L. Bruxelles: Ills. 10, 11; Accademia, Venice: 80 (photo – Mansell Collection), 81 (photo – Rizzoli); Alte Pinakothek Museum, Munich: 34, 61, 91, 101, **Pl. II** (photo – Artothek); Château Angers: 28 (photo – Caisse Nationale des Monuments Historiques et des Sites, Paris); Musées d'Angers (cliché – Musées d'Angers): 32; Collection of the Art Institute of Chicago: 90, 96; Ashmolean Museum, Oxford: 75; Baltimore Museum of Art: 78; Baltimore Walters Museum: **Pl. IX** (photo – Bridgeman Art Library); Musée des Beaux-Arts, Brussels: 20; Musée des Beaux-Arts, Dijon: 41; Musée des Beaux-Arts, Lyons: **Pl. VIII** (photo – Studio Bernard Lontin); Musée des Beaux-Arts, Rennes: 85; Musée des Beaux-Arts, Strasbourg: 29; Bildarchiv Preussischer Kulturbesitz, Berlin: 31, 49, 79, 108; Borghese Gallery, Rome: 7 (photo – Scala/Firenze), **Pl. III** (photo – Mansell Collection); Château de Chenonceau: 39 (photo – Valoire-Blois); Musée de Cluny, Paris: 64 (photo – Réunion des Musées Nationaux, Paris), 65 (photo – Caisse Nationale des Monuments Historiques et des Sites, Paris); Columbus Museum of Art, Bequest of Frederick W. Schumacher: 100; Martha Dix Collection: (photo – Galerie der Stadt, Stuttgart) 36; Museum of Fine Arts, Boston: 99; Frari Church, Venice: **Pl. XIX** (photo – Scala/Firenze); Gemäldegalerie, Berlin: 31, 49, 79, 106 (photos – Bildarchiv Preussischer Kulturbesitz); Gemäldegalerie Alte Meister, Dresden: 30, 83, **Pls. IV, XX** (photo – Bridgeman Art Library Ltd); Musée Granet, Aix-en-Provence: 40 (Caisse Nationale des Monuments Historiques et des Sites, Paris); Peggy Guggenheim Collection, Venice: **Pl. IV** (photo – Bridgeman Art Library Ltd); The Haggin Collection, The Haggin Museum, Stockton, California, USA: 48; State Hermitage Museum, Leningrad: **Pl. XXI** (photo – L. Bogdanov); Hiroshima Prefectural Museum: 47 (photo – Phaidon Press Ltd); Musée de l'Hôtel Dieu, Beaune: 33 (photo – Caisse Nationale des Monuments Historiques et des Sites, Paris); Iveagh Bequest, London: 54; Kunsthistorisches Museum, Vienna: 27, 35; Musée du Louvre, Paris: 14, 26, 42, 56, 67, 70 (photos – Réunion des Musées Nationaux, Paris), 71 (photo – Bridgeman Art Library Ltd), 76, 84, 86, 87, 88, 107, 109, 112 (photos – Réunion des Musées Nationaux, Paris), **Pl. X** (Bridgeman Art Library Ltd); Cabinet des Dessins, Musée du Louvre, Paris: 25 (photo – Réunion des Musées Nationaux, Paris); Mauritshuis, The Hague: 92; San Marco, Florence: 9 (photo – Mansell Collection); Menil Foundation Inc., Houston, Texas: **Pl. V**; Metropolitan Museum of Art, New York: **Pl. XII**; Minneapolis Institute of Arts: 17; Munch Museum, Oslo: 21; Collection, The Museum of Modern Art, New York, Philip Johnson Fund and gift of Mr and Mrs Bagley Wright: **Pl. XVIII** (oil and synthetic polymer paint on canvas, $67\frac{5}{8} \times 66\frac{3}{4}''$ (171.6 × 169.5cm)); National Gallery, London: 1, 2, 3, 4, 5, 6, 19, 38, 46, 60, 63, 89, 93, 94, 95, 105, **Pls. XIV, XVI**; National Gallery of Art, Washington: 12, 104, **Pl. XXIII**; National Gallery of Ireland, Dublin: 15, National Galleries of Scotland, Edinburgh: 18; National Museum of Modern Art, Madrid: 57 (photo – Arxiu Mas); Galleria Nazionale, Rome: 24 (photo – Rizzoli); Nolde Stiftung, Seebull: 16; Österreichische Galerie, Vienna: 58; Philadelphia Museum of Art, Collection of Mrs John Wintersteen: 59; Picasso Museum, Paris: 22, 23, 72 (photos – Réunion des Musées Nationaux, Paris); Pinacoteca di Brera, Milan: 98 (photo – Mansell Collection); Pompidou Centre, Paris: 43 (photo – Réunion des Musées Nationaux, Paris); Museo del Prado, Madrid: 13, 37, 52, 113, 114, 115, **Pl. I** (photo – Bridgeman Art Library Ltd); private collection: **Pl. XI** (photo – A. C. Cooper Ltd); private collection, Paris: 77 (photo – Bernheim-Jeune); private collection, USA: 117 (photo – Rizzoli); Museum of Art, Rhode Island School of Design, gift of Mrs Murray S. Danforth: 118; Rijksmuseum, Amsterdam: 102; Palazzo Rospigliosi: 8 (photo – Mansell Collection); Palazzo Comunale, Sansepolcro: 82 (photo – Mansell Collection); Collection, the Duke of Sueca: **Pl. XXII** (photo – Arxiu Mas); Staatliche Schlösse und Gärten, Berlin: 74 (photo – Bildarchiv Preussischer Kulturbesitz), 111 (photo – Jorg Anders); Staatsgalerie, Stuttgart: 36, **Pl. XVII**; Statens konstmuseer, Stockholm: 45; Tate Gallery, London: 97, 120; Toledo Museum of Art, gift of Edward Drummond Libbey: 55; Torcello Cathedral, Venice: **Pl. XIII** (photo – Scala/Firenze); Galleria degli Uffizi, Florence: 44 (photo – Bridgeman Art Library), 50, 62, 73 (photos – Mansell Collection), **Pls. VII, XV**; Victoria and Albert Museum, London: 51, 66, 69; courtesy, Wadsworth Atheneum, Hartford, Connecticut: 116; Trustees of the Wallace Collection, London: 53, 110; Wallraf-Richartz Museum, Cologne: 103; Yale University Art Gallery, gift of Susan Morse Hilles: 68.

The author and publishers also wish to express thanks for permission to quote from the following works: George Allen & Unwin Publishers Ltd: *Complete Introductory Lectures on Psychoanalysis*, Sigmund Freud; Granada Publishing Ltd: *The Female Eunuch*, Germaine Greer; John Murray Publishers Ltd: *The Nude*, Kenneth Clark; Penguin Books Limited: *The Second Sex*, Simone de Beauvoir; *Essays on Sexuality*, Sigmund Freud; *Woman's Estate*, Juliet Mitchell; *Madame de Pompadour*, Nancy Mitford; Phaidon Press, Ltd: *The Story of Art*, Ernst Gombrich; Thames and Hudson Ltd: *The Munich Gallery*, W. D. Dube; *A History of Italian Renaissance Art*, Frederick Hartt; *Rococo to Revolution*, Michael Levey; *The Body*, Edward Lucie-Smith; *The National Gallery*, Honan Potterton, with introduction by Michael Levey.

225

Index

227

228

230